Private Views: Artists Working Today

Private Views:
Artists Working Today

Edited by
Judith Palmer

Serpent's Tail

Library of Congress Catalog Card Number: 2003101112

A complete catalogue record for this book can be obtained from the British Library
on request

ISBN 1 85242 821 X

First published in 2004 by Serpent's Tail Publishers
Serpent's Tail Publishers, 4 Blackstock Mews, London N4 2BT
www.serpentstail.com

Printed in China

Published with support from Arts Council England
to celebrate Year of the Artist

Book designed at wall
Front cover image: Zoë Walker, **Dream Cloud**, 1997. Photo: Colin Kirkpatrick

Contents

Year of the Artist

Year of the Artist was an extraordinary, nation-wide event, which aimed to actively promote the individual artist, celebrate the value of creativity, and show the huge diversity of public settings in which artists work. Year of the Artist was co-ordinated by Arts2000, an organization established by the then Regional Arts Boards, with investment from the Arts Council of England, sponsorship from the New Millennium Experience Company and Coca Cola. In all, more than 1,700 artists were commissioned to create work in over 1,500 different public places. Over £5 million was spent directly on artists' projects, and those projects attracted in excess of 25 million visits from members of the public.

In this invaluable book, which has been commissioned to build upon the achievements of Year of the Artist, editor Judith Palmer gives us a rare insight into the private worlds of some of the most important and exciting artists working in Britain today; crossing generations and disciplines, and illustrating the diversity of contemporary talent and practice; from writers - poets, playwrights, novelists - to musicians and composers, and the full range of visual arts and cutting-edge 'interdisciplinary' activities. The sheer commitment needed to forge a career in the arts completely belies the notion that being an artist is 'not a proper job'. The candour with which these artists are prepared to discuss the highs and lows of their working lives, provides a refreshing and overdue challenge to conventional wisdom about what artists' lives are really like.

The message of Year of the Artist was clear: art can, and does, happen everywhere. And as we look to the future, increasing support to the individual artist - and finding more opportunities for them to develop their work - will be at the heart of Arts Council England's ambitions for the arts.

Nick Capaldi
Chair, Arts2000
Regional Executive Director, Arts Council England

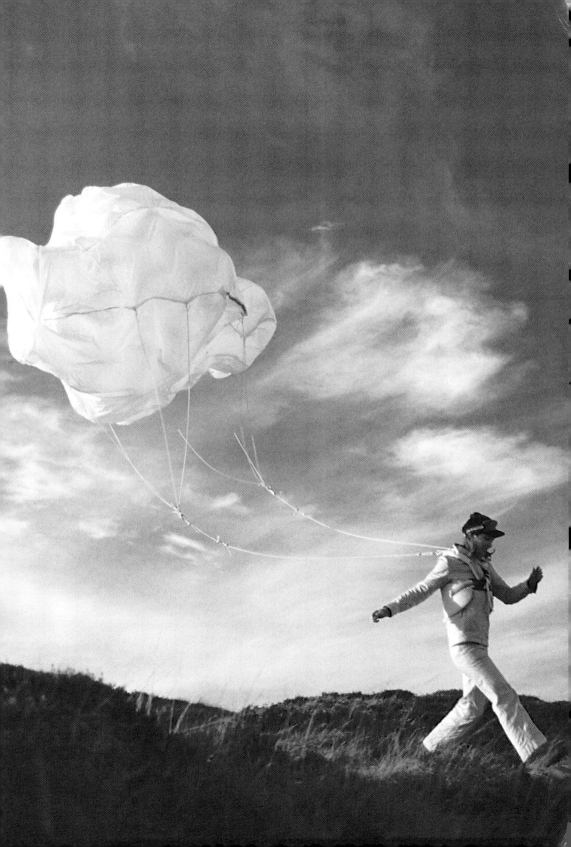

Judith Palmer is a writer, critic, curator and broadcaster. Born in 1965, she grew up near Windsor, studied English at Bristol University, and lives in London. She has written extensively about art and literature for *The Independent*, makes arts documentaries for BBC Radio 4, and also writes about travel, human endurance and natural history. She has collaborated on numerous interdisciplinary arts projects, including *The Field Hospital* at the Royal Botanic Gardens, Kew, 2003.

Introduction

There's a moment in the Tom Stoppard play *Travesties* where an English consular official starts ranting about the role of the artist in society, complaining:

> When I was at school, on certain afternoons we all had to do what was called Labour - weeding, sweeping, sawing logs for the boiler-room, that kind of thing; but if you had a chit from Matron you were let off to spend the afternoon messing about in the Art Room. Labour or Art. And you've got a chit for life?...For every thousand people there's nine hundred doing the work, ninety doing well, nine doing good, and one lucky bastard who's the artist.

A chit for life. Is that what it is to be an artist? A cushy sidestepping of the grit and slog of the ordinary mortal? A real-life exemption certificate? Well, it's a popular view.

The aim of this book is to look at the 'artist's life' as viewed from the artist's perspective, and to gather a selection of individual stories, from practitioners working across the artistic spectrum — from novelists, playwrights and film-makers, to composers, portrait painters and installation artists — in order to explore what it feels like to be working as an artist in Britain at the beginning of the twenty-first century.

We've been watching traditional disciplinary borders break down for decades, with artists experimenting across art forms, working in collaboration or switching media (sculptor in the morning, video artist at tea-time, writer by nightfall). And yet most books still continue to adhere to the standard art form demarcations. The arts have always been blighted by certain notions of fashionability. Of in-crowds and out-crowds. Of who it's hip to hang with, and who it's not. Not surprisingly, anthologies and group shows have a natural tendency to reinforce these tribal markers. The experiment here is to unbolt the corrals, recording individual experiences across backgrounds and outlooks, across art forms, across generations and to see patterns emerge.

The sculptor Henry Moore once remarked: 'It is a mistake for a sculptor or a painter to speak or write very often about his job. It releases tension needed for his work'. I'm glad to say that there were artists willing to take that risk — and the private views they give of their lives (through interviews and written contributions) make it possible to track a few career trajectories, via the pivotal choices and chance encounters, the sudden breakthroughs and the weary plods. There are insights into how they make a living, and how they prod themselves into action on the switchback ride between self-doubt and self-belief, the sorrow of selling work, the perils of living with another artist, the difficulty of being flavour of the month or yesterday's news, and what it takes to make the transition from Young Turk to elder statesperson. There's talk too of the freedoms, the privileges, the pleasures of the job. As Nitin Sawhney points out: 'I've got a passion for what I'm doing and I feel privileged all the time'.

Of course, it's debatable whether it's even possible to have a 'career' as an artist at all — Iain Sinclair, for one, would agree that it is, while Andy Goldsworthy insists: 'Art is not a career — it's a life'.

Many of the artists describe knotty battles with school careers tutors and the resigned disappointment of their parents (Cornelia Parker's mother, it transpires, was still cutting out job ads for her, even as her daughter's Turner Prize show was opening at Tate Britain). Nagging at the back of my mind was Miles Franklin's youthful novel about literary success, *My Brilliant Career*, and never far behind it the thought of the sequel, written in middle age, *My Career Goes Bung*. For an art career is a volatile thing – even the very definitions of the word 'career' underline the options: from the swift and radiant path of a heavenly body across the firmament, to the wildly veering course of an uncontrollable beast.

Writing just as her play *Humble Boy* opened at the National Theatre, Charlotte Jones captures the mixed emotions of being catapulted to greatness: 'Is this what I've been aiming for? Is this the zenith? Is it all downhill from now on?' There's satisfaction, of course, but confusion too, not least because the Irish Catholic in her realizes she hasn't had any training in learning to accept compliments, and her natural reaction is to lock herself in the loo until all the hullabaloo has died down. How much can you allow yourself to revel in your golden moment anyway, without knowing whether it's the first success of many, or the point where you'll sink without trace?

Coping with adulation is not a problem for the fictional protagonist in Janette Parris's *The Diary of the Unknown Artist*. The artist is 'unknown' in the sense that she's 'unidentifiable' and 'unknown' in that her work has repeatedly failed to make an impression. She's good at ligging her way into swanky art parties, but the little crumbs of success (a group show here, a competition there) fail to achieve any critical mass. Artists, like Olympic sprinters it seems, are allowed only so many false starts before they're asked to leave the field. The sculptor Richard Wentworth used to explain it to his students bluntly: 'If the travolator hasn't really started to move by the time you're thirty-five, it's probably not going to.'

When you know the clock's against you, it's even harder to stick to your convictions. Brighid Lowe's parable about the need for faith in one's work hints at the dangers for any artist of refusing to play up to the marketplace. Ultimately, is it better to be successful in other people's eyes or your own? Serve in heaven or reign in hell? Especially if the real option is to serve in Burger King.

The reality for most artists – even well-known ones – is the need to take on other paid work to supplement their directly art-related income. The most common option is teaching, even though there is agreement that it draws on the same energies as making work. Nevertheless, congenial employment can do more than bring home the bacon. Maintaining a double existence has been a shaping force in the work of John Mortimer (writer/barrister) and Faisal Abdu'Allah (photographic artist/barber). Talking us through a particularly surreal day where he had to combine some cutting-edge barbering with the opening of his exhibition and an appointment to meet Prince Charles, Faisal notes that sometimes his rival lives 'meet and have a love affair, and at times they are so far removed it jars the day-to-day nuts and bolts of earning an honest bread'. And yet, he adds: '...the day I cease to cut...that is the day I cease to create.' Despite the invigorating influx of ideas an outside job can channel, there's always the danger of being spread too thin. I remember reading a consumer survey on sofa-beds and washer-driers, which pointed out that although the multi-tasking item was a handy addition to the home, you couldn't expect it to last as well, or fulfil either function as efficiently as a dedicated appliance. It's worth noting that John Mortimer admits he gave up barristering about ten years too late and can't help wondering if he'd have 'written something much more wonderful if I'd given it up earlier.'

For Stuart Pearson Wright, the difference between working to commission and doing his 'own work' is also a double existence. (It's like that old Hollywood director's maxim: 'One for the studio, one for myself.') Although commissions

can throw up rewarding opportunities to extend into different areas, having your work shaped too much by whatever award scheme or commission is on offer is a clear and present danger. Catherine Yass has given up believing that you can bend a commission into what you want to do, and it is perhaps significant that she was nominated for the Turner Prize the year she decided to 'pull back and try to make sure I only take on projects that push my work in a certain way'.

Louise K. Wilson describes the nomadic existence of the perpetual artist-in-residence, 'employing the dubious passport of "artist" to gain admission to often inaccessible places'. Fun, if it weren't for the rejected proposals, the shaved budgets and the relentless demand for reports. For with publicly funded projects comes the need to fill in forms explaining your work in one paragraph. The need to meet shifting policy objectives. The need to be socially useful. For the funding we are about to receive, Oh, Lord, make us truly thankful. Tug forelock. Uneasy as she is about the need to sell her work, Zoë Benbow can see the straight-dealing side to a commercial transaction: 'you don't have to justify your existence as an artist'.

The title 'artist' can be an itchy one to wear, an ill-fitting hand-me-down title that seems as if it must have been made for someone else. Someone better (maler?), wilder. A prophet. A shaman. A genius. Paula Rego and Selima Hill both speak of needing to use a 'practical' word to describe what they do. Matthew Dalziel (who works with his partner Louise Scullion as art team Dalziel + Scullion) felt he needed to shake off 'that myth of the artist as "special unique individual" – the solitary Kafka-like personality working away on their own and in suffering'. The unease, I think, isn't so much due to a lack of belief in the work that's being made, but the difficulty of recognizing your own life as an 'artist's life'. Errollyn Wallen vividly remembers sitting at home as a schoolgirl in Tottenham, listening to stories of the dramatic lives of the great composers, but 'I never saw those lives as being connected to mine – not at all'.

Often the scale of ambition has to be modified to match the circumstances of life. Printmaker Anne Desmet, film-maker Andrew Kötting and composer Judith Weir all describe the endurance test of labour-intensive art forms, explaining how they have to balance out big projects with speedier pieces in order to stay sane. Despite the reputation-enhancing possibilities of large-scale works, Judith Weir admits that the exhausting personal toll of writing an opera is possibly too damaging to want to repeat. Cornelia Parker also reached a point where she decided she had to say no to 'the big stuff, which takes so much energy'. She explains: 'The small works allowed me a lot more freedom, because there were lots of ideas I wanted to explore, but I couldn't have had the time to make them all into large-scale works...It's all about trying to be as productive as possible'.

Once you've built your reputation on a particular signature style, it can be hard to wriggle your way out of the straitjacket of your own brand identity. After all, where does distinctively recognizable end and stalely repetitious begin? Martin Parr outlines the dilemma: 'People ask me to do things in my own particular way, and clearly when solving the problems of photography under pressure you're going to use all the language and the tricks you know in order to solve that problem. Whether you call that "rehash" or "using your experience", I'm not sure. It's probably a bit of both'.

Neophilia: the cult of novelty, the love of the new. The whole world's crazy for it. And it's become the artist's job to provide it. David Toop picks up the theme, pondering 'the gap that widens between novelty and longevity as life shuffles on'. What do you do when the ideas run out? Should a break of five years be mandatory between artworks? Maybe, if there wasn't the mortgage to consider. The irony is that the more successful an artist becomes, the more admin, the more travel, the more interviews, the more advisory committees, the more students writing a thesis on

you, the more just about anything except time to think. A secretary and time to think – the two things on every artist's wish-list. 'Right now I'd like to read for a year', writes Toop. 'New ideas emerge of their own free will if they are allowed to. If I spend one day in my garden, able to shed the imperatives and distractions that structure the administration of being an artist and the responsibilities of living within a family, then ideas start to rise to the surface.'

But how does it feel when the ideas that rose to the surface while dibbing around in your own back garden then become public property? Scanner admits it takes quite a reality check: 'It's very strange sitting here on my own working on a laptop, thinking that in three months' time 3,000 people will be hearing what I'm doing.'

Selima Hill describes being published as like having people rushing in to find out where she is hiding. Her essay *How I Became a Middle-Aged Werewolf* reveals the indigestibility of cannibalizing your life in your art. And yet Hill finds herself to be freer in her art than in the rest of life. She writes: 'All I do and say and think "as a poet" is much truer and more intimate than anything I say face to face'. Poet Selima is almost a corrective to person Selima, because what's frowned on in the home is positively an asset on the page: 'the weirdest part is that the very things I used to be told off for – daydreaming, exaggerating, making mistakes, wild guessing, contradicting, spying, being obsessive, being reckless – for these, suddenly, I am being praised'.

Carl Jung maintained that the creative side of an artist was so totally separate from the human being side of an artist that there wasn't any illumination to be gained from looking at an artist's life. Can this really be so? The stories gathered here do not set out to explain the artists' work, but they do hope to reveal what makes it possible – shining a torch on the point of intersection where life and art meet.

Artists have scarcely been more prominent in Britain – as likely to be found on a TV political panel programme as in the pages of *Hello!* magazine. And yet I can't help thinking that this stems less from a respect for artists than from a reverence of celebrity. Like Charlotte Jones, locked in the loo of the National Theatre, I suspect that many artists are experiencing quite a sense of dislocation from the brouhaha. Maybe we're all still waiting for that chit from Matron.

Images spring forward. Zoë Walker running across Orkney with a cloud-shaped parachute strapped to her back. Paula Rego wincing from the smell of human flesh in her first life-drawing class. Andrew Kötting mesmerized by Bruce Nauman's balls. Errollyn Wallen lugging huge sheets of metal across London in search of the perfect sound. Andy Goldsworthy laying a coloured line of leaves across the grass for his dying father.

It's a nervous life, an uncertain life, a life full of contradictions – and as Peter Wolf points out, 'You have to be thick-skinned and bull-headed enough to do the work, but sensitive enough to understand the human condition, and that's a really difficult combination'.

Judith Palmer

Essays

Selima Hill
How I Became a Middle-Aged Werewolf

Selima Hill was born in London in 1945 and lives by the sea in Dorset.
She studied Moral Sciences at Cambridge University. She has written ten
collections of poetry, including *A Little Book of Meat* (1993), *Trembling Hearts
in the Bodies of Dogs* (1994), *Portrait of my Lover as a Horse* (2002) and *Violet*
(1997) was short-listed for all three of the UK's major poetry prizes, the Forward,
the T.S. Eliot and the Whitbread. *Bunny* (2001) won the Whitbread Poetry Award.

1. Poetess in the Kitchen – A Pivotal Moment

My partner and his friends, all serious artists, were sitting in my kitchen talking about desert islands when I heard them say, to my astonishment – an astonishment so great and perplexing I can still remember it now as if it were yesterday – that if they were to find themselves on a desert island, even one supplied with artists' materials, they wouldn't continue painting.

I could only assume they painted in order to be public: that the possibility of fame was their only motivation, a status thing.

I didn't say anything at the time, but thought to myself how different it was for me, who was already stranded on the desert island of my kitchen and writing away to myself with great glee and without the need, I realized, of an audience. On the contrary, I was, and still am – at the risk of sounding churlish and obtuse – muddlingly ambivalent about this 'being public': it sabotages my freedom, devastates my innocence, corrupts my integrity, inhibits my great joy – and of course gives me further to fall. And great artists (great? proper? ground-breaking? true? good? whatever...), great artists are supposed not to be recognized as such in their own lifetimes anyway.

It is pride, therefore, I'm sure of it, not modesty, that makes me feel this way. Pride and paranoia. The whole point, for me, is being free. All I do and say and think 'as a poet' is much truer and more intimate than anything I say face to face. The things I say face to face are a pack of lies, because all I want to be is a pretty face. I feel much safer faced with a blank sheet of paper than I do with a real person. If I knew how to say it directly, I would not need to write poetry. I would just talk to people and be happy.

One of the reasons I don't is because of my curly hair. It makes me feel all wrong and inelegant. (Remember, I grew up in the 1960s when we had to have ironed-straight hair like Juliette Gréco, Sandie Shaw, Cathy McGowan and Twiggy.) But when I am writing I am free from all that. I step naked into the shower of truth – whole-hearted, bloody-minded, utterly selfish, no longer even pretending to enjoy or understand anything. Poetry is a big space and I love it.

All this talk of truth – or am I replacing life with language? What am I writing for anyway? Is it like dreaming? Is it a benevolent process? Something that moves the past forward? And what about those people who say all you get from looking at the past is a stiff neck? (Whether or not a writer is explicitly looking at the past, it seems to me that writing is bound to be informed and driven by the writer's past, the writer's life, because there is nowhere else for the energy to have come from...)

Left: Selima Hill
Photo: Jill Furmanovsky

2. Poetess on the Wolds

I tell you one thing: it is not about fun. Or money. Writers are like shepherds: people think we are quaint but they know that the real money is in polymers. (This is not my idea, by the way. I am not even sure what polymers are, or is, and I am sorry I don't know the name of the person who first said this.)

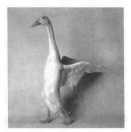

Selima Hill

Violet

3. Poetess in the Bar: Another Pivotal Moment

At about the same time as overhearing my husband and his cronies talking about art, I met the poet Jenny Joseph in a bar. I can still see myself sitting there and my jaw dropping. She said if you are a married woman and you want to be a writer, you have three choices: one, to leave your husband; two, to give up writing; or three (citing Anna Wickham, Sylvia Plath and many others), you commit suicide.

To give up writing didn't seem to be an option. It was like my curly hair – something I was born with and I've got to make the best of.

To leave my husband sounded more realistic. Lots of people were doing it, although I thought I myself was too well brought up. Besides, I think I thought that if I didn't mention my writing to anyone (and I didn't), I wouldn't be a writer, and therefore the problem would not arise.

The committing-suicide option was an interesting one. I had tried it before several times as an adolescent, rather in the same way I still annoy people by feeling free to leave in the middle of a film. The 'me' that did this seems to be the same me as the writing me: truculent, exacting, subversive and full of yearning. Someone who brooks no excuses. Refuses to be held back. Her happiness spreads instantly in all directions, and awareness leaps forwards, waiting to grab her. She takes chances. She grants herself authority. Nobody gives her the power: she just takes it.

4. Poetess in Her Study

But people say it must be such hard work. They say: 'Gosh, you've written ten books. It must be such hard work!' But what they don't seem to understand is that people live neither with Truth nor with Beauty but with other people. And this for me is what the hard work is. The books are just a way I have of doing that. I tell you it would be much easier if I just went shopping. Why don't I just go shopping?

Like Flannery O'Connor says: 'Writing is like giving birth to a piano sideways. Anyone who perseveres is either talented or nuts.' Nuts maybe, but also, like everyone else, above all human. I mean, if non-poets understood that all poets are also non-poets, then non-poets would be poets too.

5. Poetry in the Dark Forest

When I was invited to write this piece, I was reading a book about Romania (by the author of a book called *Sex and the Occult*, as it happens, which I plan to read next...) and I had just come to a passage where a woman in Transylvania reports seeing another woman disappear into the forest. And later that evening she comes across her clothes, left in a pile at the edge of the forest.

And she warns the author of the book not to pick up clothes that he might find, like this, on the edge of the forest, because they could belong to a werewolf, who would not be able, without her clothes, to return to her life as a human. She talks about the woman's growling, her depraved attitude, her hairiness...

And as it happened, I was also reading that week a letter by the Trappist monk Thomas Merton, and he too talks about a forest: 'one might say I have decided to marry the silence of the forest. The sweet dark warmth of the whole world will have to be my wife.' Wow! Is this why I'm a writer? Not just because of some hang-up about my hair but because I aspire to silence?

6. Poetess in a Bistro

I certainly took myself painfully seriously as a young poet – as a young 'poetess', one could say, a pretend poet, a female poet, who went around in my menstruating, lactating, bulging woman's body aspiring to silence; who turned for relief to the 'immense violet-coloured dragonfly' of poetry, to use Lorca's phrase, as it hovered over the backwaters of emotion'; a place where time and eternity intersect and possibilities are endless; where I and my reader could live together in harmony; where, in my own muddled way, I learned to experience love.

Writing helped to hold things in place.

I remember, for example, the line 'imagine you're a tidal wave's first lawn' suddenly coming into my head in a crowded bistro in Exeter when somebody happened to say the word 'forlorn'. And for some reason I thought 'lawn'. And I saw a little suburban daisy-bespangled lawn, and that was me; and a certain lustful man I had always hated was a wave. And I slipped off down to the Ladies to get it written down...

7. Poetess in a Greek Restaurant in Charlotte Street

(I usually retire to the Ladies to write things down. I remember once being taken out to a Greek restaurant in Charlotte Street by my father to have one of our rare and excruciating painful conversations, or lack of them, and slinking off down to the Ladies to escape and write. And after a very long time, not being able to face going back to the table, I bolted out into the street and ran away...)

But what good is that to me? Why can't I just relax? I like to think that I'm giving a voice to the silenced (not that they want my voice particularly); that I'm bearing witness; that I'm 'Saying ta to God', in Stanley Spencer's phrase. But I'm not so sure that the value of art is all it is cracked up to be, frankly.

The artist Joseph Beuys cites Schiller's definition of the function of art being to 'indicate how creativity can be applied to the political world'. Try telling that to your next-door neighbours. They are more likely to define a poet as Eavan Boland, the Irish poet, has said as 'someone who doesn't wash her windows'.

8. Poetess on the Unknown Sea

What I do sign up for, however, is Elizabeth Bishop's Racoon School of Poetry. Here she is writing to Robert Lowell:

> *My passion for accuracy may strike you as old-maidish – but since we do float on an unknown sea I think we should examine the other floating things that come our way very carefully; who knows what might depend on it? So I'm enclosing a clipping about racoons.*

9 Poetess in the Day Room

The place where I feel happiest as a poet is in the day room of a prison or a hospital. I feel understood there. That we are all in a sort of prison and that poetry might help. I am not there to share my poetry but to share my enthusiasm. In fact, I have a sort of messianic zeal about it. That it has helped me to survive and I hope I can help it help others.

So how come I became a writer in the first place? Well, in my case it was the best I could do by way of rebelling against the adults, all painters, who surrounded me with their turps and rags and easels ever since I was born. I was a secretive, wary, bad-tempered little person, and a notebook was an easy place to hide in. I could say whatever I wanted to say and nobody owns the truth and the truth doesn't care what you look like.

I suppose I was typical, *old-fashioned*, poet material, of the old-fashioned pensive kind: white, middle-class, classically educated, and from an academic and dysfunctional background. Where I learned that anything personal 'must be packed in ice and salt', to use Yeats's phrase. That that's what art's for. To be cool.

But I didn't do that. On the contrary, I used my notebooks as my private room. And when I was first published, therefore, it was like having people rushing in coming to find out where I was hiding.

Scary!

10. Poetess at a Party

When I mentioned this to a painter friend of mine, she said she felt the same. We agreed we always called ourselves 'painter' and 'writer' (not 'artist' and 'poet'). Because it sounds more like proper, i.e. manual, work, I suppose.

Another familiar response is 'Oh, I used to write/paint...' (i.e. when I was a tortured teenager and before I pulled myself together and became mature).

Is it a gender thing? I mean, about 'showing off'. I cannot underestimate the taboo against showing off. Against telling the truth. Against being public.

In this respect, to be a film director, a choreographer, anything rather than a writer, makes more sense. A writer is expected to be literal. To make a rather dreary literal kind of sense. But truth, as Margaret Atwood puts it, is vicious, multiple and untrue. And I have to use words to say it. Words that violate and betray what they seem to be making possible. Words, in other words, that are sadly not be trusted.

When somebody recognized me as 'Selima Hill' at a party recently, a kind friend quickly said, 'Oh, she's always being mistaken for her...' and I was saved. I feel so pretentious and pointless going around being a poet. Poets, like words, especially at parties, are sadly not to be trusted.

11. Poetess at the Seaside

But at the same time, of course, my life is enchanted. I wake up early to the sound of the sea; walk along the beach with various dogs and birds and have a swim; drink a cup of tea; drift into my study and twiddle about with words until I'm restless again and it's time for another walk or another swim...

12. Poetess on the Hill

Do you remember the story about the Red Shoes? Doesn't someone dance and dance and never stop? And when she finally beseeches someone to cut off the dancing shoes, they go on dancing over the hill without her, with the bleeding stumps of the ankles still inside?...Anyhow, it seems I can't stop writing.

Nor can I stop wanting to be published.

I tried that last year – cancelled my next book, moved house, changed my name, got a new job – but here I am wheeling myself out again as a poet. Weird.

13. Poetess at the Gym

I could try to explain it perhaps by appealing to the seductiveness of Lorca's violet dragonfly again. Or my friend's idea of soaring; my friend with the bad back came round and stretched out her arms *like wings* and moved around

in a special happy way and said she was soaring. She has always hated doing her exercises, but ever since her doctor called them *soaring* she's been enjoying them, she says. Why stand there doing 'arm exercises' when you could be *soaring*?

I could also explain it by referring to the space that you soar into, the space that you sometimes break through to, and hang in. A sort of gasp or gap. If I were to ask you, for example, what the difference is between a trailerload of treacle and a trailerload of babies, and you couldn't tell me, and I said, *You can't unload a trailerload of treacle with a pitchfork*, after that, there would be a little gap, wouldn't there, a sort of spaceless space before the meaning kicks in? And it's in that little gap in there that I think I operate.

14. Poetess in the Kitchen Again
And the weirdest part is that the very things I used to be told off for – daydreaming, exaggerating, making mistakes, wild guessing, contradicting, spying, being obsessive, being reckless – for these, suddenly, I am being praised.

Being praised as a poet only, of course. As an elegant one, even. And, of course, that praise is lovely. Puzzling but lovely. Embarrassing but lovely. And thank you.

But I'm not being praised for being nice and normal. I know that. For that I have to put my proper clothes on. And get back into the kitchen. And behave myself.

Charlotte Jones

Thoughts of a Humble Girl

Charlotte Jones was born in Worcester and educated at Balliol College, Oxford. She has written for radio, television and film and has completed four stage plays: *Airswimming, In Flame, Martha, Josie and the Chinese Elvis*, and *Humble Boy*. She was voted the most promising playwright by the Critics' Circle in 2000, and *Humble Boy* won the Critics' Circle Best New Play Award 2002. *Humble Boy* opened at the Royal National Theatre, London, in August 2001 and transferred to the West End in February 2002.

You have a play on at the National Theatre and suddenly everyone wants your opinion. They want you to write essays in books about your wonderful career. They want to know what you look like. They especially want to know (oh, and this is the worst – this is the writer's equivalent of the actor's 'how do you learn your lines?'), they want to know WHERE YOU GET YOUR IDEAS FROM.

And I sit in my modest one-bedroom flat in Putney and think, Do I have any opinions? Surely I do. I must have. I had them before all this hullabaloo started. But I'm buggered if I can remember them. And I think, Is this a wonderful career, then? Is this what I've been aiming for? Is this the zenith? Is it all downhill from now on?

And I think at least I know what I look like. That can't have changed. But then I have professional photos taken of me for the first time in my career as a writer. I need them now – for publicity, because I am hot and people want to put a face to the words. Of course, why not? So I pose. I want to look intelligent, thoughtful, insightful, witty but with a hint of mystery. I struggle to look attractive but serious; warm yet sharp; creative but accessible. I WANT TO LOOK LIKE A WRITER. A cross between Caryl Churchill and Yasmina Reza, perhaps. I get the contact sheet back. I do not look like a writer. And neither do I look like me. Or at least I look like a very tense and eager version of me (not an attractive combination). And so I sit at my computer and I try to work. Here at least I am safe. I spend a lot of time on the Internet. The twin towers fall and I become a news junkie. I use it as an excuse not to write. I do a lot of yoga. I develop tennis elbow from practising yoga (is this a medical first?). I do a lot of breathing exercises. I do not write. I chat to friends. I speak to my agent (oh, how accessible they are when you have success). I speak to my producer daily about the possible transfer of my National play to the West End. I still do not write. I start to think WHERE DO I GET MY IDEAS FROM?

This is a golden time in my career. I will look back on this time and think, Ah, yes, this was the moment my profile was raised (before I either went on to more success or sank without a trace). I will look back and feel happy about the wonderful production, the chance to work with a brilliant director and some of the finest actors in the country, in the best theatre in London, the (mostly) excellent reviews, the professional affirmations, the ticket touts selling tickets for £200 a go. I will be especially happy about the personal testimonies: the woman from California who queued and queued for returns and saw *Humble Boy* by relative newcomer Charlotte Jones six times, the elderly couple from Tunbridge Wells who came to the National Theatre for the first time in their lives to see my play because they had seen another play of mine at a regional theatre, the woman who had just lost her father and left in tears. Looking back, I will be so happy. And grateful. And deserving.

Opposite: Denis Quilley as George Pye and Diana Rigg as Flora Humble in the National Theatre production of Humble Boy, 2001 Photo: Catherine Ashmore

Previous page: Charlotte Jones Photo: Catherine Ashmore

And gracious. And humble. Boy, will I be humble about it.

In the meantime I am just annoying. I know I am. And my husband will vouch for that. It is not that I am trumpeting my success. Quite the opposite, in fact. I refuse to believe in it. When people congratulate me on my reviews, I say: 'But they weren't all good.' Or: 'The woman from *Time Out* didn't like it.' When people say they have enjoyed my play, it's all I can do to stop myself wrinkling up my nose and turning away in distaste. It is not that I need constant reassurance, because that embarrasses me too. John Caird, who directed my play, jokes that I wait in the Ladies at the interval until I have heard somebody say something negative about my work; only then will I be satisfied and feel I can watch the second half.

In fact, I do not go to see my play. I watch it twice in preview and find myself honing in on apparently disaffected members of the audience. On press night I do not go at all but stay at home and watch mindless television. I try to pretend it is not happening. I send spies – my husband and four of my closest friends. They ring me in the interval to say it's going well. I wonder whether to believe them. I phone a taxi to take me to the first-night party.

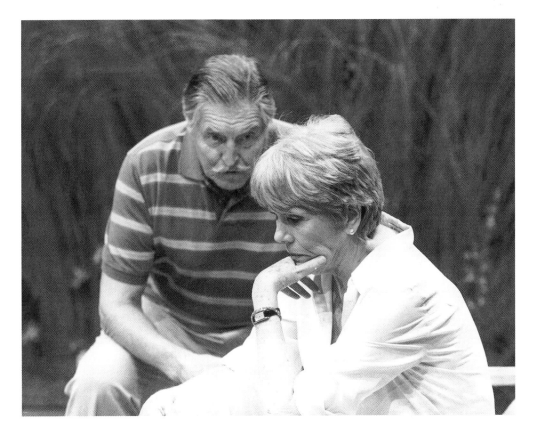

The taxi is late. I drink whisky and curse minicab drivers. I arrive as the audience is streaming out. I am like the proverbial rabbit caught in headlights. A casting director whom I do not know approaches me. She is smiling, warm. She takes my arm, she says, 'It was really...' but before she can finish I scream: 'I didn't see it! I was at home! I don't know how it went!' The poor woman falters and then moves off, thwarted. She probably starts to wonder if she did enjoy the play at all now she has met the bad-mannered author.

I get drunk, very, very drunk, on the warm, dodgy Chardonnay that is always served on these occasions. I wake up in a blur. The first reviews are coming out. I try not to read them. I fail. The first one I read is lukewarm. I feel terrible: exposed, raw, vulnerable, ill. I read others. Better ones. A rave. Another very good one with a few caveats. I wonder how many good ones I need to cancel out the bad one. I imagine people I met once on holiday six years ago reading my bad review. I imagine work colleagues, other playwrights reading my bad review and gloating. I feel sad for my parents. (Who are delighted even with the lukewarm review, which they consider to be a rave. My dad, who is a second-hand car salesman, is handing out photocopies of my reviews with hire-purchase agreements.) I feel sad for myself. I berate myself. I give myself a very hard time.

I am faced with the fact that I find it difficult to cope with any comments at all about my work – good or bad. It's all too up close and personal for comfort. It's like that old adage: only you are allowed to criticize your own family. But even when people have something good to say, I behave inappropriately. I was never trained to receive compliments graciously but I rebuff them with panache. A good Irish Catholic tradition. Oh, I know how irritating this is. I have a friend who is a very fine actress, but if you try to tell her how good she is she tells you sharply to stop being so stupid. Sometimes it drives me to distraction. I feel I must cure her of this. So I tell her that she isn't that good and she looks like she might cave in. I didn't mean it, I shout. But she's already convinced: no, no, you're right. And now, to my horror, I find that I am suffering from the same ailment. Terrible, terrible self-doubt.

No, that's not the whole story. Because sometimes I think I am a genius. Oh, yes, I have sat at this very computer and marvelled at my uniqueness. I have laughed at my own jokes. I have wept at my own touching moments. I have read and reread dialogue with pride. I have slagged off my contemporaries. I have felt a surging sense of self-belief. Of course I have. No one can be an artist without a little hard kernel of confidence at their core. For me, it's always great in my living room. When I am flowing. When I am in the grip of an idea. When I am tapping away at the computer, acting out all the parts myself. When the characters are starting to sing. When the plot is unfolding as I write. When it doesn't feel like work. When you can't believe your luck

that you're going to get a cheque at the end of it all. It normally starts to go wrong when other people read it. When actors and directors and literary managers and script editors come into the equation. And audiences. That's when the rot really sets in. But when I'm on my own, at my computer, in my front room, I can feel utter self-belief. When my husband is bringing me a cup of tea and I am too involved in what I'm doing and thinking to drink it. Yes, when the tea is left undrunk, that's when I'm really flying. That's what it was like when I was writing my first play, *Airswimming*. Except I didn't get a cheque. But my tannin levels dropped dramatically.

Let me fill in the background. I was an actress for six years – lots of repertory theatre and one solitary appearance on television. Well, I say I was an actress, but mostly I was a waitress. And then I thought I'd write a play. More out of desperation than anything else. I had had no literary ambitions up to this point. I was twenty-nine, but I started to write a play. The bigger picture was that I could probably play a part in it, get a new acting agent and get a life. Stop waiting for the phone to ring, blah, blah, blah. But then the writing took over.

I used to skip to my computer. No, really. In between shifts at the pie-and-cider restaurant where I worked, I would rush home and write. I would be cycling home from Pimlico, bursting with dialogue. I felt taken over by it. *Airswimming* is the story of two women, wrongfully incarcerated in a 'hospital for the criminally insane' in the 1920s, one for bearing an illegitimate child and the other for dressing in men's clothes and being wilfully eccentric. But really it is a story of emancipation. And that's how I felt at that time – emancipated by writing. I had found another skill that could free me from the scourge of wanting to be an actress. The first two 'friends' I sent it to didn't like it – I mean, not at all. One said it was 'womansy' and 'fringy'. The other said I should throw it away and start again. I still have the bruises to prove it. It's hard to remain friends with people who rubbish your work. And part of my surviving that experience was to find the people whose opinion I did trust, whose criticism I felt was valid and helpful. So *Airswimming* found its champions. There was a production at the Battersea Arts Centre, some wonderful reviews (I can say that now!) and suddenly I had a literary agent.

I had a literary agent but I wasn't quite sure what to do with him. At this stage, four or so years ago, I would not have put 'playwright' on my passport. Neither would I have put 'actress'. God forbid. I was in a strange transitional period. I look back and think I was very happy at this time. Of course I do. Experiencing happiness retrospectively is a forte of mine. But I was still enjoying writing immensely. If not a skip, then I would say a fast walk to the computer was in order. And in addition I started to get paid for my work. Which is always the biggest vindication.

I got a grant from the Arts Council to write my second play, *In Flame*. The first draft came out very quickly, like *Airswimming*, in about three weeks. I then got a bursary – the Pearson TV Theatre Writer's Bursary – to write my third play, *Martha, Josie and the Chinese Elvis*. This bursary involved me becoming writer-in-residence at the Octagon Theatre, Bolton, for a year. Thanks to a very understanding artistic director – Lawrence Till – I actually spent the majority of the year in London, as I found it impossible to write a play in digs without a computer. But it was a great experience for me to be in a theatre and to get used to saying 'I'm the writer'. It was also the first time my play was commissioned and programmed before I wrote it. And I enjoyed immensely the challenge of writing for a particular audience. *In Flame* was produced at the Bush Theatre in January 1999 and made quite a splash. I had hundreds of meetings with film and television people. I got a

*Simon Russell Beale as Felix Humble. Royal National Theatre Production of **Humble Boy** by Charlotte Jones, 2001. Photo: Catherine Ashmore*

few commissions. *Martha, Josie and the Chinese Elvis* premiered at the Octagon Theatre in April of the same year. It is a very feelgood piece, and the theatre was under threat of closure at the time and on the first night the whole audience stood and cheered at the end. It's probably still the most magical moment in my career to date. It's always a miracle when the things that make you laugh in your front room make an audience laugh too. And to see an audience emotionally connect with your work in a big way is priceless – the ultimate reassurance.

Humble Boy was commissioned by the producer Matthew Byam Shaw and the director Anna Mackmin. It took six nerve-racking and stressful months for the National to agree to do it. It opened on 9 August 2001 starring Simon Russell Beale, Diana Rigg and Denis Quilley. Four years after serving up chicken pies and flagons of Old Rosie cider at a restaurant in Pimlico, I had a play on at the National Theatre. When my parents travelled from Worcestershire to see a matinée, afterwards we went up on to Waterloo Bridge and my dad took a photograph of my name as it flashed up outside the theatre. I thought, I am a writer now.

On the outside it looks like a meteoric rise. But it never feels like that when one is on the inside. When the skipping to the computer has been replaced by dragging yourself to it to complete a deadline. When the honeymoon period is over and it becomes a job. Just a job. Which inevitably it does. A job that involves a tremendous amount of worry, self-doubt, rejection, unfavourable comparisons, exposure – putting something that feels very personal to you, your baby, that's no exaggeration, up for personal scrutiny. My challenge now is to enjoy it more: enjoy it in the here and now; enjoy being the flavour of the month because I am sure that I will face much bigger challenges when I am no longer 'hot'. And I'm persevering with the yoga, tennis elbow or not. I'm hoping it will help me get to a place where I can look at good and bad reviews with equanimity. Or even not look at them at all. To believe in the work. Yes, that's it. To remain connected to the work, regardless of all the externals. To be proud but humble. Yes.

Faisal Abdu'Allah

Between Salon and Studio

Faisal Abdu'Allah is a Londoner of Jamaican origin. He was born in 1969 and studied at St Martin's College, London, Massachusetts College of Art, Boston, and the Royal College of Art. He creates photographic portraits of his contemporaries, printed on to materials such as stone, copper, glass and steel, addressing issues of identity, self-perception and social reality. His solo exhibitions include those at the Horniman Museum, London (2001), *Heads of State* at Middlesbrough Art Gallery (1998) and *Revelations* at Bonnington Gallery, Nottingham (1995). His work has been in many international group shows, and he appears regularly on television. In 2001 he was commissioned to make work for the reopening of the Queen's House, National Maritime Museum, Greenwich.

Self portrait: Faisal Abdu'Allah

Childhood

Dickie Davies is introducing yet another bout with the infamous Big Daddy and Giant Haystacks. It's a sunny afternoon, and Mum and I are in the kitchen. She is preoccupied with frying her chicken and I with making yet another drawing – this one is of Asterix. My father enters the kitchen and ushers me to my feet: it is Saturday, which translates as haircut day. Since the last trauma of tears, bogey and resentment, he has finally decided to take me to a professional barber, so that my schoolmates will no longer ridicule me or my father's inept cutting skills.

We arrive at the shop, and my father and I wait patiently, but Mr Wright, in barber's couture, is in the bookie's shop. I glimpse on the TV that Giant Haystacks has won his bout finally – but it's not so victorious here, because it is in black and white. My only concern is my Asterix drawing. I left it on the dining room table, and my mother can be neglectful from time to time and dispose of my creations. My neck is still sore from drawing in that awkward position for an hour, but there is a sense of satisfaction as my obsession for line and colour appreciation has filtered into my daily life. All objects within my field of vision in Mr Wright's shop fall under the microscope of my imagination, and it feels great. It is only in this moment of realization that I look over my shoulder and see Mr Tee, the other barber, shaping a gentleman's hairline with a cutthroat razor – his movement, concentration and precision were like the act of drawing – the cool black line of separation between the skin and the hairline so reminiscent of my Asterix. Mr Wright's small figure crosses the landscape, contravening my imaginative muses: he's back and smiling. He beckons me to his chair: it's my turn.

Realization of Art as Nature or Nurture

Childhood experiences are possible inaugurations to the future we do not yet know. At the very tender age of nine, my obsession with drawing and elucidating my immediate space could only be best expressed as two-dimensional experiences resonating on paper as cartoon characters and still lifes. Many people ask me the question at seminars and lectures: 'When did you decide to do art?' After much cerebration I discovered that I never had a choice – the process chose me.

Search

My story began when I did a student exchange in Boston, USA. One day, desperate to acquire a haircut, I took to the streets to seek out a salon, but to no avail. As night began to fall I resorted to some guru tactics – stopping all the well-groomed Afro-Americans and asking them where I could find a barber. Eventually, success! But Danny's of Boston to my disappointment turned out to be like love, an overrated virtue. On my return to college that evening, where I was residing on campus, a student asked me if I had just had my hair cut and how much it cost. Feeling a bit dishevelled by his

inquisition, I answered with some caution. He then proceeded to enlighten me about his barbering skills, pointing to his own hair, which he had cut himself. My eyes widened with disbelief, as this young man looked very sharp. My curiosity got the better of me, so I asked him if I could observe his art of self-grooming whenever it was next to happen. He obliged with a wide smile and the rest was my future.

Salon and Studio Symbiosis

I entered my final year at Central St Martin's College of Art in London, no longer as this romantic Bohemian artist obsessed with abstract notions of line and form but as an articulate, politically charged young nineteen-year-old with an artistic language informed by a wonderful and eclectic history, and with a pair of clippers. I had learned the art also of the self-groom.

I was fortunate to cut hair on Saturdays at a local barber's shop. It was an experience every bit as amazing as all my weekly events in college, painting and discussing the merits of iconography. Now I was standing in the heart of my community, listening to De La Soul and watching the latest urban style and language roll in and out of favour in front of my very eyes, like the f16 click on my Hasselblad. The speed of a shifting culture and its language became the focus for my new art projects, based on themes evolving around self-definition and social reality. The material that was developing in front of my very eyes was too rich to surpass, so I had to find a way to document its enchantment and influence. *I Wanna Kill Sam* became my first body of work that involved models derived from the street and salon. *I Wanna Kill Sam* was

Faisal Abdu'Allah
fuck da police,1993
Double-sided photo-screen
print on etched steel,
computer text

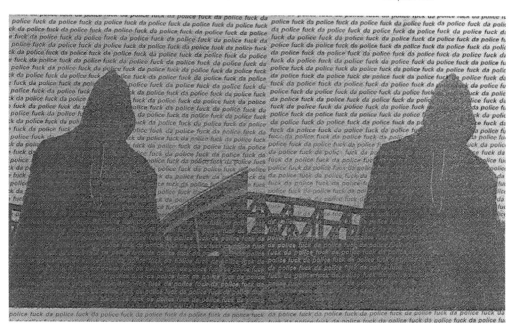

Faisal Abdu'Allah
Hasan, 1993
From I Wanna Kill Sam
Photo-screen print on mild steel,
on aluminium frame

an important work, as fundamentally it reflected the hope and aspiration of a collective, and most important it included them with all of their imperfections and attitudes. My models were recruited from the salon over a period of four months (to my surprise, with very little resistance). Each model was selected for their arrogance, architecture and intellect, each one representing an avenue of knowledge and understanding.

Rap, in the early part of the 1990s, was being misinterpreted for its cultural shift from articulating racial indignation to sexual profanity. With this, in hindsight, the orators of this new-found philosophy became singled out as public enemies of the state. If you analyse the lyrical content of black music across the genres, you will find that the cardinal component is the declaration of tyranny. Ice Cube eloquently reminds us of Uncle Sam's deceitful parlous pledge of a piece of the American pie that was never delivered. Ice Cube's paroxysm about the system was then caricatured in my Uncle Sam series to embody the ideology of black British youth via visual elucidation of the black body in popular culture. *I Wanna Kill Sam* opened a Pandora's box, in that the image is a parody of the post-modern Afro-American gangster.

The Community

My work is my lifetime biography; whether text or image or object, each one is a true testament to my uncompromising and critical analysis of the collective we live in. The work in the community is the perfect catalyst to summarize my work ethic. We are informed about the gallery space but never involved with it as being an extension of the artist's studio – a haven that purifies emotions through the evocation of fear, stimulation of thought and interaction. Questions of class, ownership and rights of passage are consistently volleyed around this creative playground. With issues of access and race tugging at the Achilles heel of local government, the young voices of the inner-city urban youths finally have their moment to direct their very own fantasy. During the last two years of my practice, I have formulated a number of projects that invite the viewer to collide, interact and dictate the outcome. A clear exponent of this ideology is the film *Blind Man's Bluff*, working with the youths of Hackney. Some people subscribe to a philosophy that any community-affiliated arts are likened to the artist morphing into a social worker, doing the impossible role of converting disaffected youth into normal human beings. Arrogance and intolerance are the two cardinal sins of the art world, and it is not until there is a radical shift in approach (i.e. more papers from the artist's perspective rather than from some nebulous academic), then and only then, can there be change.

The community projects have been a milestone for interaction with individuals and collectives whose filmic and curatorial skills lay comatose. All a seed requires is a shower, and it will grow. Invoking the grey cloud, sometimes, is my only function.

The Pipe Dream Collides with Reality

After graduating from the RCA, one waited with bated breath for the promises of fame and fortune always talked about in the artistic circle. But time is the greatest teacher. I waited long enough, then set out on a mission. Still keeping my part-time cutting post at the barber's, I set myself a financial target with the aid of the camera and the clipper money. It was all to do with my Asterix sketch and a new way of seeing. I had spent the best part of my artistic education being volleyed between two different lifestyles and cultures, each with its own code and language. Each one had brought acclaim and shame, but I was becoming tired and disillusioned with my purpose in life and my self-worth.

The highlight of my practice was to meet Prince Charles at the National Maritime Museum, with me (!) as the exhibiting artist. The low was not being there...

Acclaim and Shame

What happened was this. I agreed to cut one of my clients before the opening, and he agreed to drive me to the museum in Greenwich from Harlesden. Prince Charles was arriving at 2.30, so I left at one o'clock, leaving ample time. It was raining. Edgware Road, 1.30 p.m.: traffic at a standstill. Malachi, my friend and driver, decided the City route would be quicker. I rang Barney, the curator, just to update him: he was fine and told me it was good I was coming as the other artists hadn't been able to come down from Scotland. Film crews, royal photographers and the entire Maritime staff were buzzing with the excitement of the royal opening of the Queen's House. At 1.45 p.m. in the City: no sight of Tower Bridge; 2 p.m. in the city: no bridge. I frantically kept looking at my watch: if only I could slow down the minute hand that was ticking closer to the biggest embarrassment of my entire art practice. It was 2.20 p.m. and I had only just seen Tower Bridge: do I phone Barney now or do I wait until I get across, when at least I will be officially in South London.

My mouth was dry. Malachi kept going on about the virtues of women, and relationship analyses, but that was all going above my head. I rang Barney: he answered very quietly – my instincts told me something was wrong. 'So, um, Faisal, where are you? I am standing in line outside your exhibition with the cameramen and film crew. Charles is upstairs looking at the paintings and will be down in a minute. Just try to get here as soon as you can, as it will look extremely embarrassing if you're not here.' I put down the phone, looked at Malachi, looked at his haircut that had caused this adversity with a deep sigh, and all I could muster was 'fuck'. It was over. I was not going to make the museum. I was at least fifteen minutes away, and the earth opened up, chastised me, condemned me, put a cap with a D on me and swallowed me up. It was over. Sorry, Charles... I closed my eyes and thought of what could have been (as you get closer to your embarrassment, all seems so

Faisal Abdu'Allah
The Struggle is Ordained,
1995/2001
Selenium split tone
photographic print

Faisal Abdu'Allah
The Ascension, 1995/2001
Selenium split tone
photographic print

effortless). The phone rang for the last time. I looked at the screen – it was Barney. I knew what he was going to say – don't bother, fuck-face. You have embarrassed me at my first curatored show at the Maritime and you have let me down after all the faith I had in you, etc., etc.

'Hi, Faisal. Where are you? Charles is fashionably late, so if you're here in fifteen minutes we will be OK.' I closed my eyes again and prepared for the dash past security, helicopters hovering. There was a sense of surveillance and suspicion, but as I entered the Queen's House they were all in line, and looking relieved. I had made it. I composed my thoughts and words, as his bodyguards entered my space, one in each corner impeccably bespoke from top to bottom but expressionless. His aide came and told me where to stand, then, as I wiped the day's perspiration from my forehead, he came in...

Cutting out Schizophrenia

I stood gazing out of the window. It was 5 p.m., I was cutting Robin his usual, and he asked in his usual tone: 'What's happening, blood, how's ev'ryt'ing?' I smiled, and in reticent reply told him I had just met Prince Charles (my stomach no longer in a state of butterfly every time his name is mumbled). Robin looks at me in disbelief and scorn – his rebuttal was somewhat inattentive – but for me this is the pinnacle of my practice. Fact and fiction. Sometimes they meet and have a love affair, and at times they are so far removed it jars the day-to-day nuts and bolts of earning an honest bread. The banquets and private views are always at the peak times of the barbering work schedule, and I always end up leaving some of my best-loved clients still looking like the yeti, but I admire them for their patience and their loyalty over the years.

I was at the V&A, where I was delivering a paper on my dual practice, when the question was asked: 'Since it seems as if your artistic practice is on the up, will you eventually give up the haircutting?' I am never lost for words, but it felt like being given the choice between my father or mother. Each one has given me the opportunity to express who I truly am and what I represent. The cutting gives me the hold on reality, the interaction with individuals from every (and I mean *every*) corner – black, white, gay, lesbian, communist, racist, convict, celebrity, etc., etc. This template provided a plethora of events to invest into my practice.

The studio is the suspending of that reality: it helps me to reinvent the characters I have met and the events that have shaped them and me. Each area informs the other, so the day I cease to cut...that is the day I cease to create.

Louise K. Wilson

Perpetual Motion:

Nomadic Artists-in-Residence Between and Without Residencies

Louise K. Wilson was born in Aldershot in 1965 and lives in London. She studied Fine Art at the University of Northumbria and Studio Arts at Concordia University, Montreal, Canada. She has exhibited widely as a visual artist in North America and Europe and has undertaken a number of artist residencies and site-specific commissions in spaces including cinemas, museums, hospitals, industrial plants and sculpture parks, as well as galleries including the Canadian Museum of Contemporary Photography, Hayward Gallery, London, and SMART project space, Amsterdam.

I am always happiest in transit. Dreaming is easy between two places. I suppose I am for ever in search of other lands, that perfect place I carry in my mind's eye.

Zoë Walker, Cloud Aviator

The idea of travelling to a residency to research and make work is generally considered to be an attractive one. There's something luxurious about getting away from the vicissitudes of habitual life and temporarily immersing oneself somewhere new. Not just any place, but somewhere creatively and intellectually stimulating (of course) where even banal, quotidian detail seems more fascinating.

There are numerous opportunities and scenarios defined as artists' residencies – as opposed to site-specific commissions, for example – but I'm referring here to those situations where artists apply for and are offered time and space to think, research, speculate and then generally make new work away from everyday work pressures.

But if taken to extremes, what can be the psychological impact of the endless three-week, six-month or one-day-a-week-for-a-year residencies? What aesthetic and conceptual crosstalk might result if one is continually in motion, for example, spending a few days at home; then three months in an artist-shared rustic farmhouse in Cambridgeshire; two months in a nurses' home in Bexhill-on-Sea; a night in a satellite earth station; back to the nurses' home, then a week in a motel in a Canadian prairie city...?

Louise K Wilson asleep, at dream laboratory, Montreal. Research for video installation, Possessed, 1995.

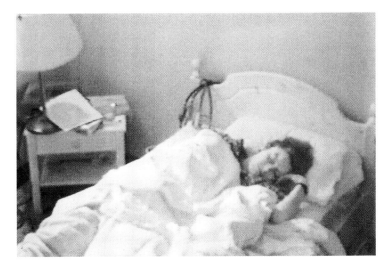

I am curious about the ways other artists work on residencies, particularly those who aren't fitted out with an electronic armoury for recording travels and observations. Away from one's usual resources, contacts, photo labs, edit suites and so on, art-making is inevitably shaped by the degree of dislocation.

My own modus operandi has involved employing the dubious passport of 'artist' to gain admission to often inaccessible places such as active military bases, restricted sites of technological research and development, hospitals, abandoned buildings, etc. Content has generally focused on the material concerns inherently raised by such places and the consequence of physically and deliberately putting myself into distinct environments such as brain scanners, sleep labs, avian habitats and so on. Finding ways of getting under the skin of a place and letting it get under mine.

Scientific environments have always been particularly alluring – I've been fascinated by the processes of research employed by scientists – and most especially all the fascinating information they necessarily leave out of published papers and so on. For me, residencies provide a crucial opportunity and financial safety net, allowing time and resources to gather, sift and transform the raw material of (artistic) research.

No doubt books and articles exist offering advice and case studies on how best to approach and 'use' artists' residencies. The trouble is, each residency is so idiosyncratic. Here I wanted to compare notes with two other artists about the experience of being in perpetual motion and to reflect on the process. Unlike me, both Elizabeth LeMoine and Zoë Walker have kept diaries of their times spent 'in residence'.

Home, Escape and General Relativity

The experiential aspect of residencies, that of visibly and physically putting oneself in a specific circumstance or situation, is particularly apparent in the work of Scottish-born artist Zoë Walker. In 1997–8 Zoë spent nearly half a year on Orkney's remote main island. As her taxi driver remarked: 'If you drive past Orkney, you drive off the edge of the world.' Her only respite and entertainment was the one night a week in the winter when she would go to a ship-in-a-bottle class.

Orkney was one of those open-ended residencies, without a requisite end product or exhibition. Zoë's plans became clear shortly after arriving on the island, however, and she set about building a singular means of escape. She worked painstakingly hard and, with technical support from a local man who had worked on the oil rigs, started to construct a helium-filled cloud balloon/parachute. She finally completed Cloud 1, but it got ripped off her and flew away in a horrible instant. She built another one. A video documents Zoe running around, jumping off the tops of hills with this cloud strapped to her back. It is hard to tell if she is trying to take off or stay on the ground.

She explains how Orkney is very flat. In fact, she was looking at the horizon all the time and looking at the clouds as other landscapes, other islands. She was trying to continue with a theme, a trajectory of escaping to a different space like a fantasy space – but there is an element of failure in it; this cloud is not meant to work. It's more the attempt.

Home-made escape devices previously made by Zoë include *Portable Paradise*, a desert island-cum-snowstorm that 'functioned' both as a mobile piece of territory and as a constant means of reliving the capsule holiday experience. Later on, travelling in the Australian outback, she brought her 'little bit of Scotland' with her – an inflatable snow-capped mountain – temporarily installed in the desert as a mascot. It is a tamed piece of the environment, a comfort blanket for a landscape feared by many suburban Aussies.

After months away as an artist, the time when one is home again can be both welcome and unsettling. I have sometimes experienced a tristesse and sense of anticlimax after returning home and put this down to the fact that the time spent away has often been very intense with new friendships and allegiances formed quickly. Zoë describes the fear that, as a 'serial resident', one is arresting one's development in not dealing with the mundane things of day-to-day life: even, in part, avoiding the reality of growing up or rather of settling down. 'I used to see things coming up and get very excited about them and think if I had a teaching job, I wouldn't be able to do this. It's easier just to keep moving,' notes Zoë. 'A phrase I'd use is "I might as well keep moving now I've packed all my stuff up".'

I prefer to see it more positively: that it's not unlike the principle that if you travel faster than the speed of light, you can go back in time – or at least not age so fast.

Paths of Collision
Canadian-born artist Elizabeth LeMoine makes exquisite miniature sculptures and animations that arise from the stirring of memories evoked by places and objects. In autumn 2000 she was offered a Year of the Artist residency at Sadler's Wells in London and decided to keep a diary of the residency: both a daily record and a repository for her recollection of memories. She notes thought associations from travels prior to spending time in the theatre. Revealingly, an animation once seen on a small monitor screen in New York's Natural History Museum provides an analogy for Elizabeth's thoughts on the nature of memory. She recalls the animated mathematical model representing the effects of collisions on galaxies and the different types of collisions (grazing or head-on) that exist:

*I think about the collision of memories, ideas or knowledge in the mind...
How experiences get filed as memories, attaching to, colliding with other
memories, modifying each, depending on the impact; grazing or head-on.*

The Sadler's Wells diary – which was eventually put on public show at the theatre – documents her complex observations on workspaces and dance performances, the continual administration of her practice, pragmatic solutions and discoveries. She writes about the idiosyncratic process of production, which is presumably considerably informed by her earlier career of theatre costume designer prior to becoming a visual artist. Objects produced at Sadler's Wells include a tutu, ironing board, iron and sewing machine. Her materials are often drawn from her immediate environment, such as the blue napkins from the theatre café.

Elizabeth LeMoine.
Iron and Ironing Board, 2001
Corrigated cardboard, paper,
cloth, sparkles
from That Shadows of Yours
Must be Such a Comfort to You,
Sadlers Wells

The slippage between tactile pleasure and the frustration of making are evident in numbered lists of descriptions. The construction of miniature garments, such as a silver foil spencer (an early-nineteenth-century high-waisted woman's jacket), becomes a source of learning: 'Realize you can't remember at all how you eased the extra material into the sleeve…Figure it out. Body memory. Seam up the left sleeve.'

The visual act of making these pieces is important. During a residency at Chelsea and Westminster Hospital, Elizabeth would bring an idea into the hospital and start working on it. She would make one thing in the hope of enticing people to have conversations with her, and then a second object that was stimulated by the conversations.

She makes a lot of garment objects, which relate to the body in some way and use stitching or basic repetitive actions. 'Knitting is one of the things you do in a situation when waiting, filling in time,' Elizabeth explains. 'In that way I thought people would be able to relate to the activity of knitting – it would be a familiar kind of thing. I also work with strange materials, like stitching a turquoise scuba diver's suit out of rubber balloons. I think the posture of someone who's sewing is familiar from painting – your head bowed down, just sitting there, quietly doing something.'

The Awkwardness of Making Work in Public

For Elizabeth, working in the cramped open-plan office at Sadler's Wells presented its own challenges, particularly for inducing self-consciousness. She spoke of how her process of working is in some ways emotionally so fragile because she makes things that just flash into her head:

> They're not considered for a long time, and so what I've got to do is either make them or not. Sometimes the decision to make them is, well, there's nothing else to do, and sometimes trusting the very tenuous impulse to make something is what gives the object an aura, gives it a quality that no amount of skill or fine materials could give it. If I'm in a public situation where someone's coming over to say 'Oh, what's that?', something about their response to an object that's failing might

give me more discouragement. It affects that whole process of whether I continue with something. If I'm by myself and I feel disheartened with something, I might still continue it and it might be rescued. It's a very hard thing to describe.

For myself, I think the hardest part is getting started. In some ways this should be easy – nobody expects work to be finished in week one. (Though I once heard that in the previous traditional wood/stone sculpture and check-shirt curatorial incarnation at Grizedale Forest, resident sculptors were told to go and make benches if they hadn't come up with ideas in the first few days of being there.)

Over a certain length of time, a workspace is important, a necessary retreat, a place to hang up a coat, make notes, stick pictures on the wall. At the Science Museum in 1997 I wasn't given a workspace of any sort but was allowed free access to the museum for thirty days. I began by reading every caption on every object in the Space Gallery. Ditto day two. By day three I felt guilty: was I using this residency as a free holiday? The guilt of that possibility jolted me into starting to think about what I was doing there and to 'read' the place more generally.

I made three pieces in the end. One was about impotence, or rather the impossibility of changing history. It reflected on the fate of the Soviet dog Laika which was blasted into space on board Sputnik 2 in 1957. The dog was only ever on a one-way trajectory since the means to bring her back down to earth had not yet been invented. She had been well prepared for her space 'residency', though, and was trained to be obedient and calm in the capsule while wearing her tiny spacesuit and fishbowl helmet. A snippet of telemetered grainy video footage, however, shows the distressed Laika barking furiously.

Avoiding Avoidance Tactics
Last year I undertook a fourteen-day YOTA residency in Leeds in a 'creative' agency, surrounded by mainly young advertising and PR types. The offices were open-plan, and one was made constantly aware of the effect the architecture had on the people who worked there. A panopticon indeed.

Upstairs, in relative privacy, we – i.e. the other resident artist and me – were given our own office for the duration. In retrospect, I should have requested a desk in the open section even though a public workspace can bring its share of performance anxiety. On the door was a printed sign: ARTIST IN RESIDENCE – PLEASE ENTER. Our times there barely coincided, however. On my days in, I headed straight for the office and set up a technological barricade, with mobile phone, iBook laptop and DV camera arranged in a semi-circle on the polished desk in front of me. I would make excuses to disappear to the office upstairs to make conspiratorial calls on my mobile, to gaze out to the parking space, back to the kitchen to make another cup of coffee, wander into the tiny room with the company's Web server to breathe in deeply and inhale the Freons.

In front of this arena of 'creatives', I withdrew into the office early on, then sought solace by driving off to Bradford one day to visit a senior lecturer in occupational psychology who, more important, was also the company's stress counsellor. The conversation was fascinating and, my stress subsided, I now had my 'subject matter'.

The Journeys Between
During the first residency I ever undertook – a short stint about ten years ago in a gallery in Winnipeg, Canada – I remember being struck by memories of being much younger. In these residency situations, I think one draws on strengths first used in early adulthood.

I can't remember how now, but while I was there I negotiated a visit to the Whiteshell Nuclear Research Establishment, some two hours' drive from the city. As far as I remember it was well known as a research facility for investigating how to bury radioactive waste safely. The car pool occupants were especially small in number that morning: it was just the two of us. The driver – I forget his name – was a nuclear scientist resembling (speculatively) a middle-aged Jim Morrison.

We left extremely early in the morning but stopped after an hour at a café somewhere in the unrelenting prairie countryside to drink numerous cups of watery coffee and eat thick hot pancakes with maple syrup. He spoke of the sociological strangeness of the community at Whiteshell. Many of the scientists who had converged from all over the world to work there lived in the small adjacent town of Pinawa. These scientists were accustomed to the prestige and status that their education, research and published work accorded them back home. But here their immediate neighbours – those living next door or on the other side of the street in Pinawa – were all eminent nuclear physicists. There was no vocational hierarchy. Apparently, this sometimes created resentment and stress.

Sometimes 'communal' artists' residencies can engender a sense of competition and the need for territorial pissing, as it were. At times this can be helpful, to kick-start creative juices. All sorts of complex social nuances and negotiations rise to the surface in the process of making work. I agree with an artist friend who has noted how residencies involve flirtation – of having to win over people to help. (There are also the more obvious flirtation possibilities that 'residential' residencies inadvertently offer, but there isn't the space to go into that subject here.)

Time, Motion and a One-Night Stand
Residency timeframes, of course, can vary dramatically. Does one always need to spend an extended period to gather 'enough' information? My shortest residency (or rather a very limited period of negotiated access) was the

twenty-four hours spent with Canadian artist Jen Hamilton inside the secure compound of the BT Goonhilly Downs Satellite Earth Station on the Lizard Peninsula, Cornwall, in late summer 2000. The immediate area of Goonhilly is extraordinary, a strangely colonized landscape with a wind-generating farm, Royal Naval Air Station, and then the more than thirty radio antennae of the Earth Station visible from many miles away on the approach road.

I had been curious for some time about this place – seemingly a switching centre for thousands of simultaneous phone, fax, data and video calls, with fibre-optic cable and overland microwave radio providing links to the nationwide communication and broadcasting network.

The day before our twenty-four-hour stint, Jen and I researched the terrain immediately outside the wire. We immersed ourselves as tourists in the Goonhilly visitors' centre before taking the short tourist bus trip inside the compound to a disused control tower to watch an explanatory son et lumière video describe the physics behind the invisible flow of communication. Later, we tried to find the small beach where Guglielmo Marconi had in 1901 sent the first live transatlantic radio message – three dots standing for the letter S in Morse Code – to a receiver on the coast of Newfoundland.

Louise K Wilson at Montreal Neurological Institute, 1994. MRI scan of artist's brain after participating in a sleep study.

WILSON LOUISE
484540 F
03-JUN-1965
PET/MRI-NEW
SAG T1-FFE
FC
SCTIME 10:11
256*256
NSA 1 M
TR 18
TE 10
FLIP 30

FOV 256
THK 1.0/ 0.0
SLICE 78/155
ANT 32.2
RIGHT 2.4

A

MONTREAL NEURO
15-DEC-94
07:32
SCAN 2

←

5
0
M
M

P W 1945
L 1079

WILL 6556 03??

GYROSCAN ACS-II

We wanted to investigate perceptual labour – i.e. the politics of perception in post-industrial society. We were curious about time cycles at the station, of the ceaseless observation and monitoring of screens and monitors, the waiting for something to happen.

Goonhilly Earth Station, though, is now run on a skeletal staff since automation has reduced the need for a large workforce. We interviewed the scant few engineers on duty that night, some of whom were watching late-night B-movies on screens in the main control room.

In the early hours of the morning, our ever-present chaperons, the 'modern apprentice' guides (two laconic teenaged boys), took us up into one of the massive antennae (was it Guinevere or Uther? This being Cornwall, the visitors' centre PR team had renamed Goonhilly 1, Goonhilly 2, etc. after Arthurian characters). We listened entranced to the slow creaking of the dish as it continually tracked its dedicated geo-stationary satellite. It sounded more like a nineteenth-century piece of engineering than something from the early 1970s.

Later we went back outside, and one of our guides phoned through to the main security desk, asking, at our request, for the spotlights to be switched on. We waited ages in the cold, video cameras poised, as the lights very slowly came up, illuminating the antenna's grey-white steel lattice. Unforgettably beautiful. Next morning we signed our names on the security forms at the main gate and left. Two months later we presented our resulting collaborative installation at the Space Camp symposium in Canada: a beeping, flashing array of television sets and DVD projections played back multiple narratives and anti-narratives about Goonhilly, the spaces, employees, and our own attempts to understand the physics...

There was, of course, a time limit on the liberties we were afforded at Goonhilly. One night was perhaps all we could hope for in the circumstances.

Elizabeth LeMoine has spoken of the desire to do a residency where one went into somewhere not as an observer to make work in response to an object or to the situation but to go and do the work of that place for a while, to find out what it's like really to work there. I wonder one day whether I'll find somewhere I do want to stay. Then I start to imagine Jen and me at Goonhilly, joining the apprenticeship scheme and, over the years, slowly working our way up the company ladder...

Right: Janette Parris
Self Portrait, 2002

Janette Parris

The Diary of the Unknown Artist

Janette Parris was born in West Ham, London, in 1962 and studied Fine Art at Camberwell College of Art and Goldsmiths' College of Art. Her work includes video, animation, cartoons, performance and theatre, using narratives that speak about the mundanity of urban life, troubled relationships, frustration and the ever-present fear of failure. Theatre pieces include *You're the One* (2001) and *If You Love Me* (1999). Her performance *Mezzo Soprano* at Hoxton Music Hall was commissioned by inIVA (2002). Solo exhibitions include *Small Talk* at International 3, Manchester (2001), and *Copyright* at City Racing Gallery, London (1998). Group exhibitions in London include *City Racing* at the ICA and *Century City* at Tate Modern, (both 2001) and *Independence* at South London Gallery (2003).

Edited extracts from several diaries found in a skip in South London, November 2002

1995

15 June

Tomorrow it's my final-year show. I've finally finished this MA. I must say the two years have flown by. Everyone says my drawings look saleable, so that's a good sign. Good time to showcase my work, as lots of dealers will be around over the next couple of days. Many of last year's graduating artists were taken up.

19 June

Unfortunately, didn't sell any of my drawings, which surprised a lot of people. Over half my year seemed to have had some interest from galleries. Lisa Manning has got a possible show at Photographers' Gallery and a solo show at Matt's. Hattie Nerving got selected for a group show at the ICA. Graham Jones has apparently been taken up by Lisson Gallery. Kathy and Freddie sold all their work to Saatchi's. I should have offered to swap my work with them when I had the chance. Had a small amount of interest from a possible buyer who might also want me to paint a mural in a bedroom.

8 November

Bumped into Lisa and Hattie at the Matt's Gallery private view. Hattie is off to do the Rome Scholarship next year and Lisa has just got back from Berlin – some group show in a museum, which included Matthew Barney + Bruce Nauman. Lisa says she's a bit frightened with the amount of attention her work is getting. At least she's getting some.

15 November

Managed to sneak into the after-private-view party at the Lisson with James. Food was brilliant. There's an after-private-view party at White Cube next week – must decide what our strategy will be to get in. James says if you walk in beside some art star they're normally too embarrassed to tell you to sod off.

2 December

Feeling good about my work at the moment and have decided to apply for a London Arts Board grant of £1,000. This should come in handy to pay for my studio as I'm behind with the rent. Think I have a good chance of succeeding this time as my work seems to fit the criteria they're looking for.

1996

30 March

Got my rejection letter from the London Arts Board this morning. Knew it

was a rejection even before I opened it – you can tell by the thickness of the envelope, as they have obviously returned your slides. Don't feel too bad about it. These things are a lottery, aren't they?

17 April
Bumped into Hattie at an Anthony Reynolds opening. She told me she'd got £1,500 from the LAB to buy a video camera. Simon Davidson said he's organizing an exhibition and asked me to be in it. This is good news. At least I can now say to people that I have a show coming up.

8 July
Gave up my studio today – seemed like a waste of money, as I have a spare room in my flat and I seem to be concentrating on video anyway. Plus the money I save can go towards making the work.

9 July
Received the EAST competition application form in the post this morning. Debating whether or not to risk the £25 entry fee, as my work is difficult to read in slide form, and it would be the equivalent of putting it on a lame horse in the National. Noticed that one of my ex-tutors is a judge this year, though. He always liked my work, so I feel the odds are stacked in my favour.

17 July
Almost forgot to sign on this morning and was an hour late, which didn't go down too well with the clerk. Had a bit of good luck, though – just managed to miss the TV licence detectors, who called while I was signing on.

21 November
James rang this morning because he hadn't seen me at any of the big openings recently. Said I'd meet him at Johnnie's Café for lunch. About time I ate something decent. Have been living on cheap pasta and tinned tuna for a couple a weeks. I'm looking a bit pale.

22 November
Have decided that my Bohemian lifestyle has now officially turned to poverty. I must find a job. I can't face shopping at Kwik-Save any more.

25 November
Asked friends who teach if there are any vacancies for visiting tutors or if they could arrange for me to do a lecture on my work. Managed to wangle giving a talk at East London Poly. It's only £90, but it'll keep the DHSS off my back.

26 November
Received rejection from EAST today.

27 November
STAYED IN BED.

1997

2 April
New gallery, Sadie Coles HQ, is opening. I should go to try and schmooze. Could be a way into getting myself a dealer. They might be looking to take on new artists.

10 April
Sadie Coles's opening was packed. I realized very quickly that I haven't got a hope in hell of being taken up by her. Free cocktails brilliant and the after-private-view party was held in some swanky new restaurant with an actual Damien Hirst spin painting on the wall. James and I just managed to get there early enough before they tightened up their door policy. Afraid Carol, David and Abi weren't quick enough in discovering the location and were turned away.

24 April
Applied to the Whitechapel Open — a long shot, but at least I don't have to pay to enter.

28 April
The group show that Simon is organizing is taking shape — a few successful artists are in the line-up. This bodes well. He's managed to get sponsorship from BECKS, so that should pull in a large crowd. It could even get reviewed in Time Out.

20 May
Opening night of Simon's 'Come Back, Caligula, All Is Forgiven' exhibition. Opening was packed, and my work seemed to go down really well. Maureen Paley from Interim Art actually said hello.

30 May
My work got a mention in Time Out. Shame they spelled my name wrong.

14 August
Received acceptance letter from the Whitechapel Open, so miracles do happen. I think things are finally looking up.

3 September
Went to Hattie's solo exhibition at Interim Art. She really is doing well.

I managed to get invited to the after-private-view party. It was like an MA reunion – everyone was there apart from the overseas students. Most people had seen the mention I'd got in Time Out, which was really nice, and they seemed genuinely pleased about my good fortune with the Whitechapel Open – some had even applied themselves and hadn't been successful, which made me feel even better.

1998

25 June
Didn't start working until 3 p.m. today. I must revive New Year's resolution and forgo Richard and Judy. If I must watch daytime television, then just restrict it to Kilroy and switch off at 11 a.m.

26 June
Switched off TV at 1 p.m. and went to my studio room to work. Will start working on new piece based on TV. I want to do an English version of Neighbours. At least I will be putting my knowledge of popular television to some use. Trying to justify it as art might be difficult, but if Michael Craig-Martin can put a glass of water on a shelf and call it an oak tree then frankly I shouldn't be worrying.

27 June
Got given an old Amstrad computer by Ian. It's a bit clunky, but it'll give me something to write my scripts on. I can't keep sneaking back into my old college and using their facilities – ex-tutors have given me the impression that the only way they would prefer to see me again is when I'm a successful artist or been invited to give a lecture. Obviously knew that I'd failed to succeed in either category so far.

15 July
Managed to get into Bruce Nauman opening at the Hayward – useful that Mila works there. Not too keen on Hayward openings, as you always have to pay for your drinks. Spoke to Mila about my idea to re-contextualize popular TV by bringing it into the gallery. She questioned whether it would be seen as art. I gave the example of Michael Craig-Martin's oak tree piece. She replied: 'Craig-Martin's a heavyweight conceptual artist. You just like TV.'

16 July
Went to Robert Prime opening. I never did find out who was exhibiting, but the after-private-view party was brilliant. The gallery had put money behind the bar, and there were free samosas. James and I got very drunk.

17 July
STAYED IN BED.

23 July
Borrowed video camera from Mila. Will start filming at the weekend. Have restart interview next week – must remember to fill in Looking for Work form.

25 July
Hull University asked me to do a talk. Pestering John has finally paid off. This will look good on my Looking for Work form.

22 September
Applied to the London Arts Board for help buying video camera. Got James to help me fill in the application form because I've always found it difficult to justify my work in a paragraph. I think I stand a good chance this time – my work has taken a different direction in the last two years, and now that I've exhibited in the Whitechapel Open the panel might know my work a bit better.

25 September
Received letter from a curator asking to see my work for a show geared around handmade objects. I think I'd be an odd choice, and the line-up of artists doesn't seem that interesting, i.e. I've never heard of any of them.

1 October
Met up with 'handmade' curator. Apparently, someone had recommended me from the Whitechapel. I gave her some slides and spoke a little bit about my art practice. I'm not sure about this show.

13 November
Received rejection letter from the LAB. What do you have to do to get money from these people? I thought they were supposed to help struggling artists.

14 November
Received rejection letter from the show about the handmade. Being rejected is bad enough, but being rejected by a show that you thought was crap is even worse.

18 November
Restart interview.

20 November
Enrolled on a computer animation course, as I want to try to make an animated soap opera. Lots of artists are doing work about digital technology at the moment. Plus I could even get some work as a Web designer.

1999

18 February

The animation course is going well. I finally understand what they're talking about with regards to computer programming. For at least four weeks the tutor may as well have been talking in German.

5 March

Heard from Hattie that one of our ex-tutors is organizing a group show at the Chisenhale Gallery. Apparently, the line-up consists of most of my graduating year. Hattie was surprised that I wasn't asked to be in it. I suppose my work didn't fit with the theme.

6 March

Borrowed £200 to buy a washing machine. Have finally had enough of going to the launderette and restricting my limited clothes-buying to colours that can survive a mixed-load hot wash.

10 March

John Lewis delivered my ex-display Hotpoint. I can't stop looking at it. I became quite emotional after I'd calculated that I hadn't purchased anything new for four years.

22 March

Last week of animation course. Have almost finished new piece. Might send it off to a few galleries. I should be more pro-active. I can't wait around to be discovered.

21 April

Spoke to Alan at Richard Salmon opening. He said that if you haven't had success as an artist by the age of thirty-five, then you're not likely to. I pointed out that history is littered with plenty of artists who weren't discovered until their later years. Name two in the last five years, he said. I'm sure this young artist phenomenon is just a British obsession.

22 April

STAYED IN BED.

1 September

Applied for teaching posts at Goldsmith's, Chelsea and Portsmouth. Also looked for admin work in Girl about Town and 9 to 5.

8 September

Signed on, then applied to the London Arts Board for a grant to purchase a computer. This time I'm quietly optimistic about my chances of success. My work fits in with the current obsession with anything digital - granted

it's not talking about the virtual space of the World Wide Web, but it's still utilizing new technology. Received rejection from Chelsea.

22 September
Met Carol at Serpentine opening. She says she's not making any art at the moment but she's taking a training course in sound technology. Hattie was there. She'd just got back from Switzerland, where she'd had a solo exhibition at the Kunsthalle. Couldn't talk for long because she was rushing off to the after-private-view party and it was strictly invite only. Said she'd give me a call and maybe meet for a drink.

20 October
Received rejections from Goldsmith's and Portsmouth. Signed on with temp employment agency. They're optimistic about finding me a job, but because I have very few secretarial skills I will have to accept the lower end of the pay scale, apparently. They assured me that this situation would only be temporary and once I've been working for them for three months I'd move up from £4 to £5 phr.

8 November
Got call from employment agency to start job in Post Office sorting depot in Farringdon. It's shift work, but the agency assure me I'll soon get used to it. Received rejection from the London Arts Board.

9 November
Started work at 8 p.m. last night. The job is relatively easy, but I had to keep drinking coffee and eating chocolate bars to stay awake. A few people there have been doing the same job for years. They look at least ten years older than they should do. Morrissey's song lyrics kept going through my mind...I was looking for a job and I found a job and heaven knows I'm miserable now.

2●●●
2 February
I don't think I can do this job much longer. I look and feel permanently tired, but if I resign I won't be able to claim Social Security. At least I now know why I want to continue to be an artist. When I die I want to be remembered for my contribution to the arts, not by how many letters I can sort in a seven-hour night shift.

5 February
Heard that the shipping heir Tristram Jones-Hunt has won the £20,000 John Moores sculpture prize. Hasn't this guy got enough fucking money?

7 February
STAYED IN BED.

8 February
WENT TO WORK.

9 February
STAYED IN BED.

20 September
Hattie's been nominated for the Turner Prize. What an achievement after just five years of graduating from an MA. I haven't bumped into her for a while at any openings, though. I must give her a call and see if she can get me an invite to the prize.

7 December
Watched the Turner Prize on TV. Watch in amazement when Hattie is announced the winner. I punch the air in delight and shout a well done at the TV. I'm really pleased for her.

8 December
Go to the doctor due to a bout of uncontrollable sobbing.

2001
11 January
Good news: the Post Office is implementing a cost-cutting exercise and laying off their temp staff.

12 January
Signed on.

21 May
Contacted by Marcus in Amsterdam. He's curating an exhibition whose theme is 'the everyday' and he wants to include my latest animation. Things are looking up.

22 May
Bumped into David in Eddie's Café. Goldsmith's have just rejected him for the third time of trying to get on to their MA in fine art, so now he's decided to do a teaching PGCE. He claims he wants to give something back to society and feels the art world is elitist and full of rich middle-class wankers. I wondered if he'd feel the same if he'd been accepted.

4 June
Spoke to Lisa Manning after a talk at Tate Britain given by Pipolitti Rist. Lisa is in lots of shows and she's in discussion with the Tate about their project space. I told her about my video exhibition in Amsterdam and a possible solo exhibition in an artist-run space in Vauxhall. She said that these alternative gallery spaces could kick-start your art practice to another level, and that's what happened to her three years ago. She also added that it was about time that I was receiving some recognition, because, as she succinctly put it, others had been around for a lot less time and had achieved a lot more.

19 June
Chelsea graduation show. Everyone keeps telling me I really must look at the work of a graduating student who's making similar work to mine. Except I've only been doing it for the past four years.

21 June
I find out that Interim Art has taken up that Chelsea student. Friends reassuringly say her work is not going to be the same, because I will always have a very different take on similar issues. This is fuck all consolation.

22 June
Have decided to try to see the positive side of the Chelsea student incident. Realize that if other artists are now doing similar work to myself then I am likely to be included in more group shows.

19 September
Went to Graham Jones's opening at the Lisson. Lots of my contemporaries were there, and we swapped career histories. I said to Graham how lucky he'd been with his art career since he graduated. He responded that luck had nothing to do with it and that it was all down to hard work. I said, surely someone could really work hard and still not get anywhere. Their work must be crap, then, he said. God, I wish I had his confidence.

20 September
Decide to apply to the London Arts Board for help with purchasing high-end digital camera. Everyone says if you keep applying, they'll eventually give you some money. Well, I'm certainly persistent. Feel I'm getting more known. I've been contacted by two curators, one for a show in Scotland, the other in Switzerland.

2 November
The Swiss gallery will pay for a copy to be made of my video, but there is no money for fares for me to install the show. Hope they follow the directions I sent on how the work should be installed. Posted my show reel

to the Scottish gallery — even though the curator doesn't know my work, the exhibition is about artists who use fiction, so I should have a good chance of being included.

10 December
Received rejection from the London Arts Board. Why do I bother?

2002
16 January
Spoke to Amy, another artist who graduated the same year as me. We were comparing our career progression since leaving college — seems both have been equally slow with the odd minor success. She's convinced all these young artists being signed up on the strength of their graduating shows won't be anywhere in five years time. Who wants to be a flash in the pan? It's better to be in it for the long haul. Yes, Amy's right: it's longevity I want. Not that I have much choice in this matter.

17 January
Found out from Marcus that my work was well received in Holland and was reviewed favourably. The review's in Dutch, but I make copies for my records.

18 January
Videos returned from gallery in Scotland with note stating that they were sorry but due to the balance of the exhibition they couldn't include my work, though this wasn't a reflection on its quality. They did suggest that they might consider including my animation as a multiple in their bookshop next Christmas.

5 June
Opening at the Serpentine. Lots of free beer, since the show is heavily sponsored. Talk to curator from Entwistle Gallery, who says he wants to visit my studio. First time this has happened without me having to instigate it. He's going to call to arrange a time. Finally things are really starting to change.

30 June
Still haven't heard from Entwistle...

The diary entries end here. Attempts to discover the identity of the artist have so far failed. Spoke to the head of the MA course she appears to have attended, but he cannot remember anyone fitting this description. Made contacts with artists Hattie Nerving, Graham Jones and Lisa Manning, but none of them can recall her either.

Brighid Lowe

Have This One on Me

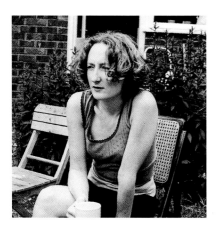

Brighid Lowe was born in Newcastle upon Tyne in 1965 and lives in London. She studied Fine Art at Reading University and the Slade School of Fine Art. Solo exhibitions include *Sequence* at the Photographers' Gallery, London (1992), *Collective Joy for the Masses*, Hales Gallery, London (1993), *Truth-Hallucination*, John Hansard Gallery, Southampton (1997) and *Unedited Confessions*, Galerie VOX, Montreal (2001). She has exhibited widely including *BT New Contemporaries* (1990–91), *Wonderful Life*, Lisson Gallery, London (1993), *England's Glory*, Ikon Gallery, Birmingham, *Post Neo-Amateurism*, Chisenhale Gallery, London (1998) and *Intelligence*, Tate Britain (2000). In 1998 she received a Paul Hamlyn Award for Artists.

Faith has been knocked down and knocked about during her career. Faith needs to have more faith in herself now. More than she ever needed when she was younger. Faith knows that taking a risk is urgently needed, and she suspects that what she requires is a nose job. If she had her nose changed from its current state to something straighter, with a more conventional and current profile, then she was sure that many other things would begin to go her way. She would certainly be taken more seriously and would gain in confidence. Her new nose would ensure that she had more control of her own destiny. This would mean less waiting around to be picked up by clients. Faith knew that the ups and downs and bumps in her nose, and likewise in her life, could be ironed out into a simple, straight trajectory skywards.

Wherever Faith was to find herself on this skywards trajectory, she suspected that she would always feel the need to be wanted. She would also be waiting to take her knickers off. How could she possibly reconcile these two facts? Perhaps she needed to take her knickers off but give up her desire to be wanted?

Now she was confusing herself. The touting for business, the competition and the rivalries had all taken their toll on Faith's sense of identity. She wondered if it was the giving of her most private of parts, endlessly, to complete strangers, which was so demoralizing her? Or was it, as the older and wiser Faith had begun to suspect, that her deep desire to feel wanted, to fulfil someone else's needs, was the true cause of her overwhelming sense of non-existence?

Why did Faith not feel real until consumed? What was the cause of her dependency, of her compulsion to satisfy the needs of a procession of individuals, without seemingly pausing to consider her own needs? Had they ever understood how much she was giving them? Come to think of it, had she ever understood just how much of herself she was giving away? When Faith was younger, she had never considered any other line of business. It was in the family, she had grown up around it and she had acquired the tricks of the trade at a precocious age. She was good at it; everyone used to say so. But recently she had been wondering why she continued with her profession. Faith had been forced into asking herself whether she still wanted to be in the business.

What if she was rejected even after the nose job? Faith's solicited acts always felt one-sided. She was unable to read the responses of strangers she had encountered. She became adept at classifying and coding them, but what they wanted and what she wanted never seemed destined to meet. Faith was supposed to have no desire except the compulsion to satisfy the desire of any other individual, each and every one of them. In the end, all their desires seemed indistinguishable to her. Faith's private fantasy was always of an

impossible moment of mutual understanding and respect – even tenderness. In her fantasy there would be no need for explanation, for coaxing, for delicate game-playing, for faked pleasure or for faked stimulation. This much she understood: it would never be a real love affair. But it would rather be a moment of profound understanding, which required a genuine equality of desire for its conception.

Equality was a soiled and dirty word these days. Equality was boring, redundant, stifling, value-free, unworkable and expensive to maintain. Nevertheless, Faith was mesmerized by the idea of equality because she was herself a perverse mixture of superiority and inferiority. Faith recognized both conditions as fatally flawed, but was seemingly powerless to reconcile them into a state of equilibrium. Faith needed to believe in her own uniqueness in order to maintain her sense of dignity and do her job well. Yet at the same time she could never afford to relax and take her assets for granted. Faith knew that as time went on, the increasing weight of her experience threatened to jade her performances and erode her vitality.

Day by day, even hour by hour, she oscillated between these two extremes of superiority and inferiority. The violence of the transitions destabilized her. What she needed was not this clichéd roller-coaster of a state of mind, but rather, like her nose, she needed a brand-new, balanced sense of her own rightness.

In turn, this thought made her feel like a delusional fascist with a point to prove. Faith was haunted by her very own Horror double, a stunted schizoid, locked into a swirling vortex of self-deception and disappointment. Faith's Horror double would continue to tout for business, oblivious to her decomposing desirability, barely covered by her threadbare professionalism.

Was she perhaps being a bit over the top?

Faith was not gifted with foresight. Her clients' inability to distinguish between the fake and the genuine had finally undermined her own judgement. Was she the hunter or the hunted? Should Faith love more or hate more? Should she be kinder on herself or harder on herself? After all, Faith's 38DD statistics were the real thing; they were not the artificially inflated, interchangeable, commodified 'assets' of the majority of the competition. Faith's vital statistics were the genuine article; they were rare, even revolutionary these days. She had to admit that the initial impact of her assets was not as spectacular as the fashionable fakes that surrounded her, but Faith believed that her genuine assets stood up to sustained scrutiny. Even though it was against the prevailing climate of the business, Faith believed that her attractions were deeper and more subtle than the dominant models. All she had to do now was convince her clients.

Faith had always found pleasure in defying the conventions of her profession. Although her line of business was supposed to be the ultimate in the transgressive, Faith had always found it to be as conformist and as governed by hidden rules as the mainstream. The difference was that she understood the rules, the deceptions and the manipulations of her profession far better than she would ever understand an alternative way of life. Faith felt that it was simply too late to change; she was unable to imagine herself doing anything else. She could not unlearn her profession, its skills, its hours of work and above all its relationship to the rest of the world. Faith was her work, and the work was Faith. To Faith this was an achievement, not an admission of defeat; it provided the source of any equilibrium in her life. Faith's instability came not from her profession but from her desire to maintain this sense of achievement at the highest level. Ultimately, she could not decide if it was better to be successful in other people's eyes or in her own eyes.

Faith collected quotes from books and cut true stories from newspapers as a way of constructing an image of herself. She found it helped to reconcile her inner and outer existences. In one of these stories, the editor of *Marvel* comics, after he died, had his ashes blended with ink and then made into an edition of comics. In another, a victim of child sexual abuse becomes an alcoholic and commits suicide at the age of twenty-one. In his will he requests that his cremated ashes should be buried in a can of Diamond White Extra Strength Cider. The desire literally to embody themselves and their respective senses of achievement unites these two public endings. But the two endings are separated by self-love and by self-hate. One is a celebration of a life's passion and achievements – the neat symmetry of its dispersal and accessibility almost verges on smugness. The fact that the body of the editor has become subordinate, dissolved into the body of the comics, is in the end funny. The Diamond White ending has a compact bitterness, a profound understanding of pathos and the intense power of imagined objects. There is no reconciliation here. The Diamond White story might well have been motivated by an empty gesture, but Faith believed that it wasn't. To Faith it seemed unbearably and recurrently powerful. She thought about the Diamond White story often, and she only remembered the *Marvel* comic story because of it. It was the Diamond White story that stayed with her, even though it was not intended for public consumption. It had found a place in her and its impact had never faded.

Yet Faith was tormented by the fact that nothing seemed to happen until it was consumed. Faith knew any remaining taste for innovation was diverted towards degraded, innocuous and confused forms of novelty. Novelty was far easier to consume and market. Faith did not understand novelty; Faith believed in passion. To Faith, passion could only arise from an awareness of the irreversibility and uniqueness of human actions. But nowadays people

wanted even uniqueness to be consistent, reliable and instantly recognizable. They wanted equivalence rather than equality. Equivalence meant a smooth, depthless, interchangeability, which was good for business.

Recently, business had not been good for Faith. Faith's flier looked more like a mourning card than a calling card. She was just not interested in marketing and self-publicity. She wanted to attract clients through her straightforward talents, rather than a seductive graphic lie. Faith had always believed that the quality of her past performances would drive her future success and reputation. Was Faith in danger of appearing naive and redundant? If so, there was always the option to make her flier look like all the other fliers – to remake it as a standardized glossy photograph. All she had to do was bend over and position the digital red stars over the intimate bits. Faith had always resisted, and she didn't know why. Faith simply knew that she wasn't like all the others, and she didn't want her fliers to be like all the other fliers.

She sometimes wished that she wasn't her own boss, and that she had someone to represent her interests for her. She had seen their classy back rooms in which she could show off her goods to rich, new and foreign clients. Even more important, they would be able to take decisions for her and give her unconditional support – as long as she did exactly what they said, exactly how they said, exactly when they said. On certain occasions this might be a good idea; on other occasions it would be a bad idea. It would certainly mean the loss of her autonomy: the doctrine that the human will carries its guiding principle within itself. For Faith, this was impossible to countenance – Faith had always understood that ultimately she was only answerable to herself. Nevertheless, how many opportunities had she missed by adhering so stubbornly to her instincts? Why did she expend so much energy on what she wasn't rather than what she was?

Maybe it was because Faith was unable to turn her honesty on and off at will. Faith had realized that to be internally unsure of her own worth, or the worth of her work, increased her susceptibility to outside influences. Paradoxically, this in turn made her more responsive to opportunities for success, but only success as defined by those same outside influences. It seemed to Faith that the advantage of lacking an intellectual conscience was the internal voice of opportunism. This persuasive voice appeared to create freedom, the freedom to concentrate on the most efficient means of achieving.

So what was Faith to do with her intellectual conscience? She had tried to bag it up and drown it, even burn it, but it kept resurrecting itself by clinging tenaciously to her Horror double. Faith was gradually becoming two people: two identical clowns, with one clown imitating and parodying the other clown's gestures. How could she have allowed fantasizing to possess her like

an evil spirit, while simultaneously regarding her own conscience as a parasite? So much so, in fact, that she constantly struggled to envisage the future.

Faith did not want to be so riddled with ambition that her intellect would leak away, straight out through the holes. Would it not be better to work for an imagined future and for an imagined community than one that Faith did not understand? Perhaps things were much simpler than she was making them. It wasn't about the future; it was about her future. The point of being herself, of being Faith, was that she was only answerable to herself. Faith could do anything that she wanted. Faith could change herself and her work; she did not need other people to do it for her. She could imagine her own context, her own community. She could decide how she wanted her work to be seen. Faith could learn from others. That was different from expecting other people to do it for her.

Faith remembered films that she had seen, things that she had read, conversations that she had enjoyed. Their significance had really become apparent only much later. Faith had always thought it miraculous how one thing in the world had the potential to explain another. She remembered a woman in a film turning to a man and saying that she did not know who he was. Then the woman turned to the audience and said: 'I don't know who you are, either'. That was what Faith needed to do. She had to look them straight in the eye and declare allegiance to her own perceptions of the world. Why should she have to recognize them and conform to their expectations? Faith had to learn to keep part of herself for herself, and acknowledge that her difference actually gave her power. She tried to keep repeating something that she had read: 'I think we're always responsible for our actions. We're free. I raise my hand – I'm responsible. I turn my head – I'm responsible. I'm unhappy – I'm responsible. I smoke – I'm responsible. I shut my eyes – I'm responsible. I forget I'm responsible, but I am'.

These fragments of her life would make a splendid whole, if only they could be put together with faithful patience. Instead, the world seemed to work by erasing one value with another and another, in a restless, relentless spin. Faith wanted to interrupt the spinning and provoke it with moments of stillness, of failure, of reticence. She could not rid herself of the thought that the more we speak, the less the words 'mean'. Faith wondered whether she had, at this present moment, encountered too much and spoken too much. She remembered reading about an archaeological site, where among the treasures a small, exceedingly well-preserved figure was found. It was inspected and photographed. Suddenly, without warning, it collapsed, and without a sound changed into dust. For 3,000 years it was intact, until the exposure to the light and air streaming into the subterranean chamber caused it to collapse. Maybe, Faith thought, withholding things was the only eloquence left.

Faith forced herself to imagine only the positive, to envisage what she herself really wanted and to experience it as vividly as the image of the Diamond White can. She needed to focus over and over again on a private image, the one buried deep in her imagination. One by one she had to remove the other images, the doubting ones that were crowding and jostling around her singular vision. This personal vision had to be worked at, protected and polished until it was dense and hard, a smooth shiny object which fitted exactly into the palm of her hand. Once grasped, this perfectly proportioned weight needed to be dropped down into Faith's own history and experience. Faith knew that people, herself included, are like deep wells – they take a long time to realize what has fallen into their depths.

Billy Childish & Charles Thomson
Lives of the Artists

Billy Childish left Walderslade Secondary School for Boys at sixteen, an undiagnosed dyslexic, and worked in Chatham Dockyard for six months. In 1977 the completely unqualified Mister Childish was accepted on the genius clause into the Painting Department of St Martin's School of Art. He left after only half a term because the only form of art that was allowed was Abstract Expressionism. He was re-accepted 2 years later but was very quickly expelled for writing poetry which was described as the worst type of toilet wall humour, when he was in fact quite serious.

Charles Thomson left Brentwood Public School in 1970 with five A levels including Latin. He then distributed underground newspapers such as *Schoolkids OZ*. After this he spent four years studying at the Painting Department of Maidstone College of Art, but foolishly believed the tutors' dictate to express his opinion and find his own creative voice. As a result, he was the only person to fail the degree in living memory.

Billy Childish's career as a poet nose-dived in 1981 when he was offered readings by the South East Arts Literary Officer on the condition that he stop writing explicit autobiography and instead concentrate on light verse, at which Mister Childish told him to fuck off.

Mister Thomson's career as a poet nose-dived when his desire to communicate on a popular level was dismissed as light verse.

Billy Childish refused to have his paintings shown on BBC television and spent twelve years painting on the dole.

Mister Thomson spent seven years working part-time on a hospital switchboard and broadcasting his poetry on Children's ITV.

Billy Childish is an international cult figure and champion of the amateur and the underdog.

Charles Thomson is a tireless promoter of alternative voices in art and poetry, especially in national press and television.

Billy Childish has made over two thousand paintings, published thirty collections of his poetry and featured on more than eighty independent LP records. His work has appeared in translation in several languages. He continues to work and live in his home town of Chatham.

For over a decade Charles Thomson was one of the country's few full-time poets. He has performed his work in over seven hundred schools at home and abroad, and his poetry has been included in more than one hundred major anthologies. He is now a full time artist living by his wits in Finchley.

Billy Childish and Charles Thomson met in 1979 when they were founder members of The Medway Poets, which ended in acrimony 2 years later.

1n 1999 Charles Thomson and Billy Childish co-founded The Stuckists art group which is against hedonism, conceptualism and the cult of the ego artist. Mister Childish has since left the group. Mister Thomson says that the only strange thing was that Mister Childish was ever a member in the first place.

The function of fashionable art is to give fashionable people a painless simulation of culture.

Billy Childish

I play once a month with my group The Buff Medways at the Boston Arms in Tufnell Park. Occasionally we go on tour to the USA and Japan. I have been playing music for twenty-five years but do not have a manager, a publicist, agent or record label.

On Sundays I visit my mother in Whitstable and paint in my studio which is her upstairs front room. There is not much room left because it is full of my paintings.

I do not much like loud music or art galleries. I have never gone to rock star or art star parties. I spend my days cooking, walking to the shops, writing and playing with my son.

A famous critic once said that I don't understand art codes but do understand rock codes. He was wrong. I understand both and get them wrong on purpose, which must have confused him.

When I was studying at St Martin's School of Art I was asked why I refused to paint any pictures within the college. I said that it was because I didn't want to become contaminated.

My biggest mistake in life was to believe that adults were adults. It took me until I was in my early thirties to realize that most adults are children, but mostly damaged ones.

A pressure that I feel is a constant lack of money. I have never really addressed this because I will not do anything that I don't believe in. I am hoping that the integrity of my work will eventually become so evident that one day I will be justly rewarded for it.

It is very frustrating not to be understood, but success to me is to come nearer to a true understanding of myself rather than to do what other people think I should do. I have had a number of close friends become famous and their work has become worse and worse. My ambition is to communicate with the yet-to-be-born.

I am lucky because I live in a terrace house in Chatham, which I rent from my mother. I have lived in Chatham all of my life and like the river especially. I shop in Sainsburys in the Pentagon Centre or travel to London and visit a

Overleaf left: Billy Childish
Overleaf right: Charles Thomson

health food shop. Eight years ago I gave up drinking lots of whisky and began to practise yoga and meditation. As a result I am not dead.

One of the most crucial things in my life has been to forgive the sexual abuse I suffered as a nine-year-old child and to learn to love myself. Art for me is to remember why I first drew a picture, which is because I wanted to and enjoyed the feeling.

I was on the dole during my twenties and thirties. I was painting two pictures a week, recording several LPs a year and publishing a collection of poetry every six months, yet my mother was still of the opinion that I wasn't really doing anything because I didn't have a proper job. The rest of my family have only been interested in my work since it has appeared in newspapers.

I am not happy to be an outsider and think that I should be an insider. The mainstream should be outsiders as that's what they pretend to be. I identify with my heroes, van Gogh, Dostoevsky, Munch and characters in strange novels.

When I was a kid I had a healthy cynicism, as I grew older I became aware that cynicism often turns to bitterness so I became much more careful about what I hated.

I am not sure why I am so prolific in painting, writing and music, but it feels natural to me to work fast with energy. If I don't, life is useless and not worth living.

It seams clear to me that it is an artist's duty to be on the wrong end of the see-saw. One of my biggest problems in life has been my inability to lie.

Charles Thomson

I spend most of my time in my front room which is my painting studio and office. I'm on the phone far more than I should be, sorting out my personal problems, organizing art events and promoting these to the media. The excitement and companionship of doing this make painting seem an unattractive, lonely pursuit. Yet when I am painting, the wholeness I feel makes any other activity seem hollow and superficial. Sometimes painting becomes so addictive that I once even painted for three days without sleep.

A ritual during my painting periods is a nightly stroll up Lovers Walk, a footpath which leads from my house to the High Street and to Tesco. I often shop at two in the morning and am on good terms with the night cashier who has a bad back.

In the late Sixties, when I started organizing art events, there was a cultural vitality that is altogether absent in today's art establishment. This has helped

fuel my drive to combat the artistic status quo and to provide a meaningful alternative. I can't stand anaemic art. Art for me has to have meaning and emotional resonance. Contemporary exhibits of conceptual installation, video work etc. I find have neither. I leave them with my life depleted rather than enhanced.

A lot of my ideas in life and art are derived from spiritual study, particularly of the Kabbalah. I have never found any occupation outside of creative activity to hold the slightest interest. My parents have been in turns appalled, discouraging, bemused, eventually tolerant and I think on some occasions mildly impressed by my errant course through life.

I've always had the need to communicate on a popular level, which Mister Childish finds vulgar and embarrassing. He is right, but how others perceive me on this point doesn't worry me. I carry on because I carry on. If I don't create, I don't feel whole.

My biggest mistake was to study for my A levels at school rather than drop out and join the editorial team of *Schoolkids Oz*. Since then I have taken up opportunities and done what I wanted to do. I think the worst regret is not what you have done but what you haven't done.

I drink lots of cups of tea during the day. I have a great appetite for experience in life: this includes marrying people I scarcely know and walking down by the brook that runs behind my three-bedroom semi in Finchley.

However, there are three difficulties that I have to contend with: financial modesty; getting started on something; and isolation during the day. I recognize in myself a fear factor which I have to overcome when taking a new step.

I have very strong emotions, though this is usually not apparent on the surface. I need depth and intensity in life, relationships and art. I write the poems that I want to read, and paint the pictures that I want to look at. I can't bear doing or experiencing work that doesn't meet these standards. I want a career and conventional success but despite such desires I am usually tripped up by my inability to stop saying what I really believe.

I feel very fortunate in life. I very much enjoy working in a group and promoting other people's work as well as my own. I am now completely acclimatized to the security of an unpredictable and insecure life.

I enjoy socializing with close friends rather than networking with useful people at parties, although I usually take up opportunities if they arise.

Career Manifesto

1. We paint pictures because that is what we like doing and we lack social skills at parties.

2. Some people view the contemporary art scene with fear and desperation because there is so much crap. We however rejoice because we think it is funny.

3. We are oblivious to how exciting and sexy the world of video, conceptualism and installation is.

4. Some negative responses to our work:

 Everything we do is motivated by revenge.
 We haven't got an original idea in our heads.
 We have no real substance or worth and are only interested in publicity.
 We are dead in the water.
 We have fallen into the same trap as the artists we purport to oppose.
 We are more interested in promoting ourselves than in producing work of profundity and sustained quality.
 You cannot look at a single one of our paintings and say that it is an opposition. It is not.
 Our work is so formally inept that we manage to communicate nothing.

5. We would like to win but have given up hope.

6. Giving up hope is the only way of winning.

7. We still want to give people hope and ideas.

8. A lot of people are scared of painting a picture in case someone tells them it is crap.

9. True artistic endeavour and exploration has been replaced by revenue-producing 'battery' artists.

10. A major fallacy is to assume that the new and contemporary are in anyway new and contemporary.

11. The function of fashionable art is to give fashionable people a painless simulation of culture.

12. The current artistic preoccupation with morbidity does not address the life and death issues which it purports to, but is an unintended confession of the practitioner's own artistic death.

13. When somebody produces something which is deemed art they are denoted an artist. Some poor souls subsequently suffer from the delusion that anything and everything they then do is also worthy to be called art.

14. Just because a particular medium has been used for making art it does not necessarily follow that any use of it is art, e.g. silence is an integral part of music, whereas a piece comprising of nothing but silence is not.

15. Sound in music is the equivalent of colour in painting. If the restriction that is put on current popular music were put on painting the only tube of colour available would be Euro-beige.

16. New technologies are rarely superior to old technologies: they are merely cheaper, disposable and a way of marketing uniformity.

17. Digitally remastering recordings made in the analogue age by past artists is the equivalent of improving a Van Gogh painting by sanding it down and touching it up with an air-brush.

18. In the interests of cheap programming major arts presenters have become the puppets of PR companies.

19. Artists who don't have PR companies aren't artists.

20. We acknowledge that we are in error.

Michael Bracewell

Taking Care of Business

Michael Bracewell was born in the suburbs of London in 1958 and lives in Manchester. He is the author of six novels, including *The Crypto-Amnesia Club* and *The Conclave*, which was short-listed for the John Llewellyn Rhys Fiction Prize. His most recent novel was *Perfect Tense*. He has written an exploration of British pop culture, *England Is Mine*, as well as catalogues for many contemporary artists, including Sam Taylor-Wood, Adam Chodzko and Gilbert and George. He has made two documentaries for television, about Oscar Wilde and Pevsner's Surrey. His selected essays, *The Nineties: When Surface Was Depth*, were published in 2002.

Thinking of brilliant careers, two scenes come to mind, although maybe they're only images – snapshots, even. The first is of F. Scott Fitzgerald, some time towards the end of his life (he was dead at forty-four). He's in southern California, sitting in an airless bedroom in the Garden of Allah Hotel. He's trying to keep off alcohol, so he's drinking cokes from a crate by the side of his chair. It's late summer, and the curtains are drawn against the afternoon sun. Not a breeze lifts the petals of a few paper-thin desert flowers; the cars bake in the parking lot, while the fabrics in the bedroom smell musty and scorched. And Fitzgerald is thinking: I've been a poor caretaker of most of the things in my life, including my talent.

The other scene (probably around the same time, towards the end of the 1930s) is of Cyril Connolly. He's sitting in his garden in the South of France, and he too looks more anxious than in repose – despite the remains of a dandified lunch: 'omelette, Vichy, a peach...' Cyril the anxious Etonian. In the last half-hour the sky has clouded over, which is pretty much unheard of in this part of the world, and seems almost...disturbing. Portentous, perhaps. He glances up. He's wearing a bronze-coloured straw hat. In his mind he's turning over a phrase from a book he's writing about writers and the art of literature called *Enemies of Promise*. The phrase troubles him, nagging at his peace of mind. He looks up again, thinking, The Charlock's Shade... – a spiky, suffocating, Gothic-sounding image which denotes a particular kind of creative exhaustion, and is borrowed from a poem by Crabbe.

Although he was describing the perils that beset a young writer's talent, Connolly's *Enemies of Promise* would hold true for any artistic career, whatever the hue. (At this point you might remember Graham Greene – a contemporary of Connolly – saying merely: 'For an artist to think in terms of success is like a priest trying to think in terms of success.' Deep down, we all know that art has nothing to do with careers.) But despite this parenthesis, Connolly's directory of paranoia – the *Enemies of Promise* themselves – is worth quoting in full (his own quotations are from Crabbe's description of an ailing landscape):

Let the 'thin harvest' be the achievement of young authors, the 'wither'd ears' their books, then the 'militant thistles' represent politics, the 'nodding poppies' day-dreams, conversation, drink, and other narcotics, the 'blue Bugloss' is the clarion call of journalism, the 'slimy mallows' that of worldly success, the 'charlock' is sex with its obsessions, and the 'clasping tares' are the ties of duty and domesticity. The 'mingled tints' are the varieties of talent which appear; the 'sad splendour' is that of their vanished promise. These enemies of literature, these parasites on genius we must examine in detail; they are blights from which no writer is immune.

Both Connolly and Fitzgerald were addressing the paranoia of artists: the ways in which certain creative-type people feel shadowed by insecurity. If Flaubert's 'ever hidden wound' – the artist's concealed damage and scar tissue, be that psychological, physical or both – is the catalyst within creative chemistry, then F. Scott and Cyril have nailed down between them the anxiety which stalks the artistic conscience side of things: the febrile grey areas – the artist's career, profile and sense of self-worth, so entwined with mythologies of suffering or lucky breaks.

Fitzgerald speaks of personal doubt; as a model of the creative psyche it's a classic: that time (those times) in an artist's career when they suddenly feel a keen, despairing nostalgia for what they believe to be their lost or abandoned creative selves. Late-summer sunlight, immobile and melancholy: this is the artist's audit of their own career, viewed almost financially, in terms of debt and credit, extravagance and bankruptcy – the accounts of the soul. Fitzgerald called this his 'afternoon of an author'; an anatomist of glamour, he was only too at home with fiscal imagery. His essays 'How to Live on $36,000 a Year' and 'How to Live on Next to Nothing a Year' – magazine pieces – are domesticated, low-cal versions of his sadder, darker memoirs, 'Early Success' and 'The Crack-Up'.

For Fitzgerald, this quartet of self-commentary burned off the petrol vapour of his self-hatred – or some of it, at any rate. Remembering his own big break – the novel that had been his 'ace in the hole', the call of the postman with a letter of acceptance from the New York publishers Scribner's, and then, and then...And then, in his case, the almost immediate mortgaging of a future to pay for an attempt at living in the present – 'when life was literally a dream' (as he recalled the springtime of his literary stardom, on a first visit to the French Riviera); the so desperately wanting to be 'a successful literary man', and the fatal belief in that being 'a romantic business'. (In the first flush of success, he'd actually leave banknotes sticking out of the pockets of his suit so that callers would see how rich he'd become.)

It is at this point that the image of middle-aged Fitzgerald (sitting there in his musty armchair in an airless bedroom in the Garden of Allah Hotel, west Hollywood) leads on to the image of Connolly, looking up at the suddenly grey-tinged continents of broken cloud. Here the personal meets the general, the individual case the broader rule – the mechanics of the classic model are opened up. For this is the moment when Fitzgerald's self-hatred and nostalgia for himself as an artist falls under Connolly's 'Charlock's Shade'.

If Fitzgerald had been 'a poor caretaker of his talent', then Connolly's 'enemies of literature' may well be pretty close to those that he believed had caused him to neglect his duty (the tending of that sacred flame which was going to put him beyond status – beyond the status of Hollywood or Long

Island Sound, even) to art above all. To have squandered the ace in the hole, the lucky break, the first view down to Cap d'Antibes!

Later, F. Scott would speak of having elected the critic Edmund Wilson as his 'intellectual conscience' and would seem to struggle against himself towards an almost priggish respectability (notably in his handling of his daughter Scottie's education) – as though this would somehow pay the bill for earlier recklessness. The desire to be cleansed runs high in late Fitzgerald.

Ironically, it was bearing the stains of debt and dishonour that he wrote some of his finest work – the first chapters of his last, unfinished novel, *The Last Tycoon*, and his 'Pat Hobby' stories. But there is no neat, romantic formula of the male adolescent notion of living wild to produce great art; the book resulted, if the biographers are to be believed, from sheer, dogged hard work, finding its place within traumas, crises, benders, dry-outs and boredom.

All change!

Cynics may note that, with the possible exception of the 'clasping tares' of domesticity, nearly every one of the qualities that Connolly cites as destroying young talent would have been considered by many in the 1990s to be the very things of which artistic success was comprised – sex, drugs, celebrity, hip to the three Ps of post-modernism: punning, plagiarism and parody.

What is proposed in the two little snapshot scenes, of Connolly and Fitzgerald, drawn from the end of the 1930s, is the modernist response (anxiety, above all, was or is the mainspring of modernism) to the classic – call it Flaubertian – notion of art as a 'sacred calling', or what Bridget Riley would later cite as 'an artist is a person who has an inner text they need to translate', with the word 'need' being stressed.

With this in mind, those artists who tend to succeed on a grand scale are the ones whose signature work – i.e. the first piece which they create that defines their voice as new, original and vital – articulates the *Zeitgeist* in a way that captures the public's imagination (Flaubert's own first published novel, *Madame Bovary*, would be a case in point), and mark, in many ways, the beginning of the modern template of an artist's career.

From the 1960s, further examples of this would be Bridget Riley's first black and white op art paintings (which, despite being meticulous developments of Post-Impressionism, from the artist's point of view, were seized on as *au courant*, trippy and mod) or Gilbert and George's 'Singing Sculpture' of 1969, in which the artists performed on a table, wearing metallicized face paint, to a recording of Flanagan and Allen singing 'Underneath the Arches'. In this piece – defining Gilbert and George's enduring sense of themselves as

'super-tramps' – the art world saw a crystallization of the artists themselves as the embodiment of a sensibility that was at once subversive and genteel, compelling and faintly comic with an edge of unease.

It would be a simple enough business to build up a chronology of those *Zeitgeist*-defining signature pieces that have heralded fame in the post-modern era, from David Lynch's *Twin Peaks*, through Irvine Welsh's novel *Trainspotting*, to Damien Hirst's pickled shark. But to what extent has the hyper-mediated commodification of culture in recent years – the 'worldly success' of Connolly's *Enemies of Promise* – intersected with the anxious modernist notion of the artist's vocation? Are artists now pitted against a cynical marketplace, in which it is merely the loudest voice that gets heard?

The 1990s saw a divide between those who believed that culture was dumbing down and those who saw that very dumbness as either a democratization or a kind of covert intelligence – which was, in fact, inspiring a new and important mode of artistic commentary: an art that played the cynicism of post-modernism off against itself. In addition to which, the last decade saw the conflation of art, marketing and celebrity on a broader scale than usual, but with the added amplification of a media ravenous for artists as personalities, to go alongside television presenters or models. This dalliance of art with the culture of *Hello!* magazine could be massaged to suggest some kind of cultural signage. But pointing to where?

What might be signified is another choice point within the artists' conception of their own identity, referring back to Connolly's directory of paranoia or Fitzgerald's nostalgia for his own artistic integrity. For when an artist creates his signature work – Riley's canvas *Blaze*, Gilbert and George's 'Singing Sculpture' or Hirst's pickled shark – he is then faced with the choice as to how to employ the cultural power he has suddenly acquired.

Artists hip to the idea of Andy Warhol's flirtation with mass media (if vague as to the reality of his largely studio-bound practice) have wanted to set themselves up as a kind of CEO of their own brand – ironically, of course. But this seems a short-term investment.

The cult of vacuity and pseudo-nihilism, which has pervaded many strands of creative practice over the last ten years, does not, ultimately, seem to challenge or make eloquent an overloaded culture of mindless consumption. Rather, such celebratory negation appears to represent a colossal failure on the part of the arts to either synthesize or articulate the anxiety of influence – in other words, to find new solutions to old problems. The Charlock's Shade spreads wide and dark, while success, in the long run, might not even exist on the terms we once imagined.

David Toop
The Quest for Novelty

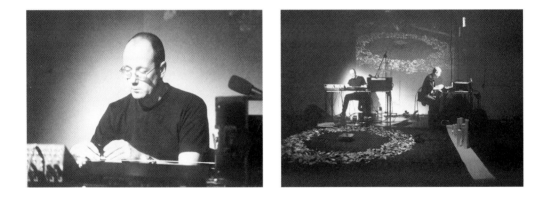

David Toop is a musician, composer and writer. He was born in Enfield in 1949 and lives in London. His books include *Rap Attack* (1984), *Ocean of Sound* (1995), *Exotica* (1998) and *Haunted Weather* (2004). His albums include *New and Rediscovered Musical Instruments* (1975), *Screen Ceremonies* (1995), *Pink Noir* (1996), *Spirit World* (1997) and *Black Chamber* (2003); he has also created compilations, written soundtracks, and performed and collaborated with artists including Brian Eno, Steven Berkoff, Jeff Noon and Max Eastley. He has exhibited many sound installations and in 2000 curated the sound art exhibition *Sonic Boom* at the Hayward Gallery, London.

Writing about the significance of novelty in the life of an artist is like finding a structural problem in your house and then building a scale model to replicate it. Like a fly uselessly bouncing off a closed window, I'm caught at a moment when the effort of finding new ways to perceive the world feels just out of reach for me. Logically, there is nothing new to say about The New. Or maybe it's just a problem of articulating unfamiliar perceptions.

The problem is common enough, if not ubiquitous. As a music critic, I listen to new CDs all the time, and what I hear illustrates the fact that most musicians run out of ideas very quickly. Each product is more empty of content than the last. Quite a few show no signs of content at all, being only gestures made to remind the listener that content may once have existed in a distant galaxy. Nobody wants to confess to such an absence, however, and so the albums keep on coming, wave on wave.

Sometimes I'd like everybody who is stuck, or lost, or vacant to stay that way and keep silent for as long as it takes, but that's the critic in me talking. Speaking as a composer, as a musician, right now I'd like to read for a year. Right now I'd like to work on my garden, locate some unusual plants I'm looking for, forget about music, go to see the few films I like, search out obscure books and videos, sit in darkness and silence, spend more time cooking, travel with my family to the places I haven't yet visited in South-East Asia, go back to drawing, live by the Atlantic Ocean in Cornwall. Of course, there's the mortgage.

I was born at the end of the 1940s. Growing up in the 1950s, then being a teenager in the 1960s, gave me a feeling of being saturated by the outpourings of creative revolution that defined that period of history. As an art student, I could live a single week in which pop art, kinetic art, psychedelia, free jazz, Motown records and Japanese films seemed an exhilarating yet quite ordinary choice of stimulations. Of course, those of us who lived near the epicentre were privileged. Maybe a little cultural aridity might have given us better insight into the gap that widens between novelty and longevity as life shuffles on.

The longer we live, the more we are obliged to confront the deeper meaning of what it is we do. That inner, often hidden meaning may not be compatible with the demands of a cultural industry hunting for constant supplies of fresh produce. Sometimes it's instructive to look outside the usual art references to discover how this problem can be addressed. Like a number of people, I'm a fan of Elmore Leonard's novels. Essentially, they're all the same. One a year. Some are better than others, most are brilliant. Once in a while he writes a book that really stands out; then once in a while he experiments with a theme that's just a little bit different. The experiments tend to disappoint me, even if I respect his need to try them. He has a formula, but

he comes at it fresh every time. The innovations are embedded in his adherence to a personal code of writing that's spare, rigorous and to the point, though never joyless. I'm aware that there's a kind of escapism in the act of enjoying this annual repetition of work that is totally familiar, but escapism takes many forms. Escapism doesn't have to equal negligence or apathy or chronic solipsism.

I'm also a big fan of the Isley Brothers. They managed to conform simultaneously to two antithetical versions of a career trajectory. One minute they were a shouting R&B vocal group, recording classics like 'Shout', 'Twist and Shout', even 'Surf and Shout' (innovate, then follow up with a series of cheap knock-offs); next minute they were making a string of glorious singles for Motown, then they turned heavy and psychedelic. So it went on, until one of the brothers died. Despite the dramatic stylistic shifts, every one of these distinct periods was formulaic. If you were a fan, you loved everything they did, except maybe 'Surf and Shout'. I don't believe anybody ever asked them about this particular issue, but I suspect that the Isley Brothers were happy in the genre of the moment, happy to exploit it to the maximum, then just as happy to move on to a totally different style.

I admire and envy that contentment (should I say apparent contentment, since for all I know they may have been utterly miserable?), but the capacity for eternal reinvention is a more desirable virtue. To grow up with concepts like 'the shock of the new' and 'permanent revolution' is to be implanted with an insidious condition of melancholy. After all, art that lacks any capacity to shock, disturb, unbalance or renew our vision is out of step with the twentieth-century modernist values that continue into the twenty-first century. On the whole, I believe that myself – which is why I wonder about the Isley Brothers and Elmore Leonard. The Isley Brothers aren't exactly Stravinsky, though profundity can be discovered in the most unlikely places.

One of the twentieth-century composers I admire more than almost any other is Toru Takemitsu. He was capable of making consistently interesting music that addressed the complexity and contradictions of being human – not just tranquillity, depth and complex abstractions but violence, sentimentality and humour – without compromising his integrity and seriousness. Then recently I read a criticism of his film composing that suggested he was a high-class hack, able to reproduce any style at will. The same has been said about Burt Bacharach, one of the greatest songwriters in popular music history. I don't agree, though I take the point. My judgement may fall short of the high standards a critic should apply to music, yet the way in which Takemitsu and Bacharach worked seems more true to twentieth-century demands than a lot of self-consciously 'artistic' art. A pall of decay hangs over the heroic late-life efforts of a composer such as Karlheinz Stockhausen, to take a significant example of an artist who has

never been described as a hack of any kind, as he labours daily over one magnificent, all-encompassing composition that may never be finished but will change the world if it is. That's his belief, though not many others share it with him.

The music I make flows from improvisation. That's the core, the source, the lifeblood, even when I'm building a piece made entirely from digital material in my computer. In my early twenties I was taking part in weekly improvisation workshops hosted by the late John Stevens, then spending long days at the home of drummer Paul Burwell, both of us working through a labyrinth of method in search of some unknown prize. If that sounds a touch magical, or alchemical, I'm not embarrassed to admit that I believe it was. With hindsight, we were engaged in uncovering the means to an ecstasy of improvisation, intense enough to be transformational, to go beyond what we knew and what we thought we could achieve. The tapes that recorded those sessions in the early 1970s are painfully low in their fidelity. Much of what transpired is fogged by bad audio weather. Our struggle to find this elusive state is transparent, but then there are moments when the communication clearly took flight. I can't imagine unleashing that degree of intensity ever again, and there are times when that acceptance feels almost as poignant as an athlete realizing that the peaks are in the past. But I'm not an athlete. Artists can run slowly.

John Cage disliked the idea of improvisation. He felt that musicians always ended up wallowing in their own habits, so he used divination texts, like the ancient Chinese Book of Changes, the I Ching, in chance operations designed to short-circuit such tendencies. In a way I think he was right, or half-right. Improvising raises particular difficulties, since instrumental or vocal techniques discovered at a young age tend to stabilize at a certain point. Counteracting the drag of entropy, the way we interact with others as we mature can develop in all kinds of ways. Most of the smarter improvisers use relationships with other musicians to refresh the novelty in their own work.

I've heard detractors say that improvising guitarist Derek Bailey always plays the same way and has done for more than thirty years. Listen inside what he plays, microscopically, and it's possible to hear variations that are as dramatic in their way as the difference between the Isley Brothers yelling 'Shout' and then romantically crooning 'Between the Sheets'. Listen superficially to Bailey and it's like reading two Elmore Leonard novels in a row and not getting it. But the inspired way he approaches longevity is to work with an endlessly shifting selection of musicians: rock players, jazz celebrities, a funk rhythm section, young DJs, unknown improvisers working in 'the tradition', classical virtuosi, tap-dancers, Butoh dancers, whatever. Every collaboration brings unfamiliar nuances to an instrumental language that has become highly developed and essentially self-contained. The issue

of novelty is actually a problem of age. If you run out of new ideas when you're very young, then it's a problem of talent; if you run out of new ideas when you get older, it may be that there's nothing left to say, or it may be that core ideas demand repeated attention, even if those core ideas are out of step with the *Zeitgeist*. The cultural and social environment in which we work makes age a problem. Like all the arts, music is pulled towards the marketplace by powerful forces, and the marketplace feeds on youth. Of course, record stores are stiff with old and dead musicians, but they tend to be upstairs, in the basement or at the back. A number of older musicians suffer neglect as festivals stop booking them. The gigs dry up, and the recordings drip more slowly as the tap is shut off. Without a public, musicians accustomed to the feel of a stage under their feet enter a condition of living death.

As a critic, I have an overview, a perspective on trends (or I'm supposed to), and that perspective makes me alert to any signs of impending drought in my own career. I say career, because careers are what they are. If it wasn't for the money, and the money follows intangibles like reputation, then it wouldn't matter if there was a five-year gap in the production of any artwork. Better, possibly, for a five-year gap to be compulsory, though musicians tend to thrive on continuity. In a different version of living death, moderately successful careers in the arts have a tendency to turn into administration, further degraded by lengthy periods spent waiting in check-in queues, departure lounges and desolate hotel rooms. Any search for novelty, let alone epiphany, is so drastically impeded by these turn-offs, the equivalent to wearing socks in bed, that the process of making music regresses to a strategic confrontation, a war game, between inspiration and the forces of mediocrity.

But this is the detached overview, unnecessarily gloomy and cynical, and as a more positive flip side there is an overwhelming need to stay connected to the source of inspiration that led to this obsession with sound and music in the first place. I don't really know about other musicians when it comes to this subject. There's a PRIVATE – KEEP OUT sign on the door. Musicians may locate the wellspring in their instrument, cleaning it like a gun, practising scales or arcane techniques, burrowing down into an intensely personal, timeless space where fashion trends and the pressures of the market are barely recognized.

Just over a year before writing this piece, I was invited to play a small gig in London, an evening to celebrate the eightieth birthday of sound poet Bob Cobbing. I couldn't do it on that date, so I ended up playing at the same small experimental music venue, the Klinker, with Bob and Paul Burwell, a few weeks later. Bob, Paul and I used to perform together regularly in the early 1970s, under the name of abAna. To some extent, it's a world I had left

behind. I became a full-time music journalist in the 1980s, only pursuing music in private, on a computer. Then in 1995 I wrote a book called *Ocean of Sound*. From my point of view, the book enabled me to articulate many of the ideas that formed my personal wellspring, ideas developed in that same period of rehearsing and performing with Bob and Paul over twenty years earlier.

Paradoxically, *Ocean of Sound*, along with the music I was making in the mid-1990s, found a much younger audience, more conversant with Detroit techno than English improvisation and sound poetry. The musical performances I was giving in Europe were heavily dependent on technology. The way in which the audiences responded was derived from their philosophy of listening: far less focused, concentrated or sustained than the highly active though seemingly inert deep listening that typified hardcore improvisation venues. The gig at the Klinker seemed like a release from theory, though this was probably an illusion. To look at it more closely, the physicality of playing at that level of intensity was a sharp reminder that music is of the body as much as anything else.

The sceptic in me says that a single gig at the Klinker in front of a dedicated, partisan audience is a holiday from the reality of my own career. Holidays can transmute into time bombs, and I devoted as much time in the ensuing months archiving the past as I spent thinking about or working on new music. A certain circularity emerges, slightly disturbing for seeming nostalgic in some way, or even retrogressive. This is something I've noticed in the trajectory of other musicians as they get older. They begin to make new shapes from ideas that emerged at the formative stages of their work. For me, it feels like dangerous territory, perilously susceptible to a descent into the past. Those cherished virtues of the 1960s – spontaneity and freedom – grow increasingly problematic as the years accumulate.

New ideas emerge of their own free will if they are allowed to. If I spend one day in my garden, able to shed the imperatives and distractions that structure the administration of being an artist and the responsibilities of living within a family, then ideas start to rise to the surface. Some of them may be variations of old themes; some may be useless and one or two may even be new. Whether that makes them novel for the world outside is another matter. The solid part of me couldn't give a fuck. Then again, how much can be solid in times like these?

Dalziel + Scullion
Primary, 2002
Video still on digital canvas

see pages 103 - 110

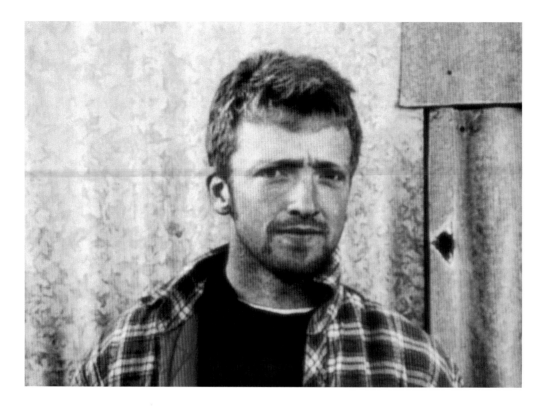

Above: Dalziel + Scullion
Another Place, 2000
16 minute video projection with sound

Below left: Dalziel + Scullion
Rain, 2000
*Installation. A temporary
pavilion for the contemplation of
rain, Newtown, Wales*

Below right: Dalziel + Scullion
Water Falls Down, 2001
Video installation

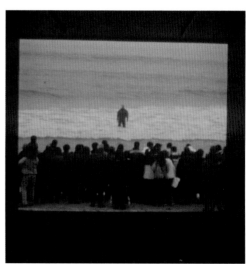

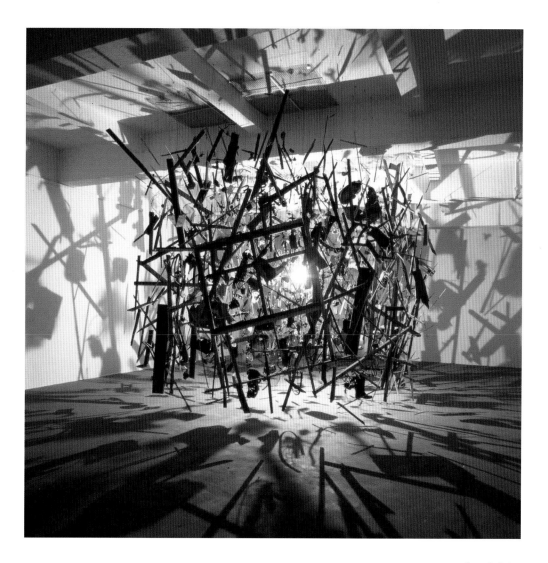

Cornelia Parker
Cold Dark Matter: An Exploded View, 1991
Exploded shed and contents

see pages 136 - 142

Opposite above: Andy Goldsworthy
Wall
Storm King Arts Center, Mountainville, New York
Autumn 1998

Above: Andy Goldsworthy
Leaves laid on a river boulder
held with water
green to yellow
dark to light
Cornell University, Ithaca, New York
9 October 1999

see pages 116 - 123

Opposite below: Andy Goldsworthy
Sumach leaves / up early /
still dark / cold hands /
each leaf stitched to another /
to make a line / held to willow with stalks /
finished just as the sun rose / calm /
returned the following day / windy /
line broken
Storm King Arts Center, Mountainville, New York
17-18 October 1998

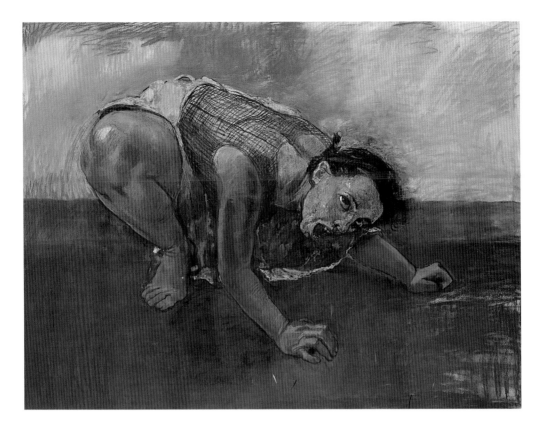

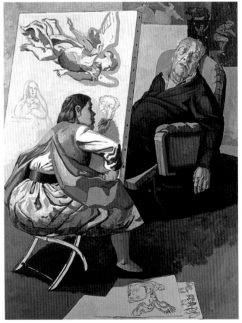

Above: Paula Rego
Dog Woman, *1994*
Pastel on canvas

Right: Paula Rego
Joseph's Dream, *1990*
Acrylic on paper laid on canvas

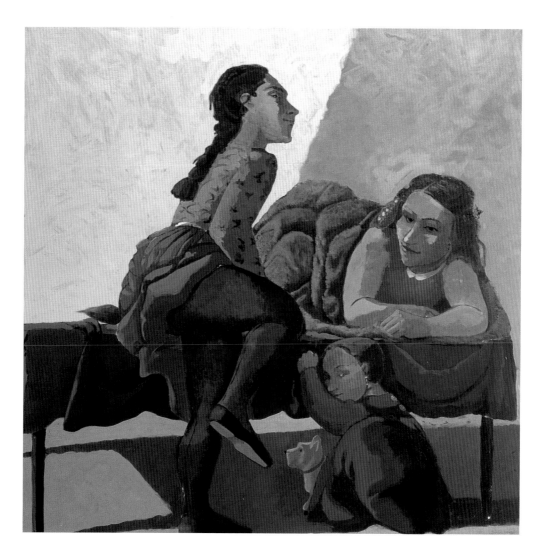

Above: Paula Rego
Looking Back, *1987*
Acrylic on paper on canvas
see pages 149 - 155

Above: Brighid Lowe
I Saw Two Englands Breakaway, 1996-7
225 books, perspex, c-type photograph
on flexibase

see pages 54 - 61

Below left: Zöe Walker
Portable Paradise,
1996/2001 c-type print
Photo: Neil Bromwich

see pages 34 - 42

Below right: Elizabeth LeMoine
Handbag and Cloud, 2001

see pages 34 - 42

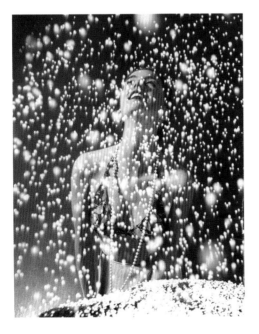

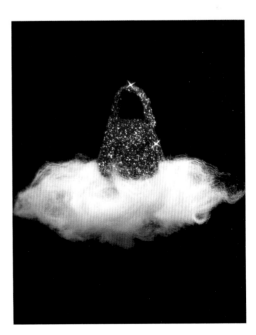

Stuart Pearson Wright
Middlesbrough, 1999
Oil on linen
see pages 195 - 200

Above: Martin Parr
The Last Resort,1985
New Brighton, Merseyside
see pages 143 - 148

Anne Desmet
Babel / Vesuvius, 2002
Wood engraving, linocut, flexograph
and collage on paper

see pages 111 - 115

Andrew Kötting, Giles Lane and Mark Lythgoe
***Mapping Perception**, 2002*
Film and installation

see pages 124 - 129

Above: Catherine Yass
Steel: Hot Strip Mill, 1996
Photo transparency in lightbox

Right: Catherine Yass
Double Agent, 2001
Ilfochrome transparency and lightbox

Catherine Yass
***Bridge: South**, 1999*
Cibachrome transparency, lightbox
see pages 201 - 205

Left: Zoë Benbow
***Scarp**, 2001*
Oil on canvas

Below: Zoë Benbow
***Desert Shore Drift**, 2001*
Oil on canvas
see pages 98 - 102

Interviews

Zoë Benbow

Zoë Benbow was born in Datchet in 1963 and lives in London. She studied at
Ravensbourne College of Art and Design and the Royal College of Art. Her richly
coloured paintings show the shifting planes of tectonic geological landscapes.
Her work is in many private and corporate collections, and she has created
several permanent public art pieces including a series of painted columns in
Royal Mint Street, London. Her work has been exhibited in London at the
Berkeley Square Gallery (1991), Factual Nonsense (1993), Delfina Gallery (1995),
Mall Galleries (2001) and Stephen Lacey (2002).

Do you feel a sense of loss when you sell a painting?

It makes me sad just talking about it, because every painting that goes out is a loss. I won't let a painting out of the studio unless it's good; therefore it's bound to be difficult. Some paintings I like more than others, obviously, and some become more seminal, so I feel those losses most. Often you feel a bit taken for granted in producing them. You couldn't really afford to buy your own paintings either - you're generally selling work to people who are quite well off, so there's that relationship to deal with as well.

But although there's a loss at them going, if they didn't go that would be a bit gloomy. If I kept them all, I wouldn't have any space left. They need to go out in the world and function. It's always really nice when you see them again, and they can still surprise you, even though I know every inch of them. I'm surprised by my memory of my own paintings – I can remember each one quite well, and there's quite a lot of them now after all these years.

The biggest loss, of course, was the paintings I lost in the fire at my studio in January 2000. What a way to begin the new millennium. I was working for a show, and had just made some very big pieces. I'd just finished one piece I was very excited about. It was the piece that made me feel I'd cracked the show – you reach a point where you know you've got a number of works that are going to carry the show, and you've got it sorted. I tidied up and went home, and got this call in the early hours of the morning to say there had been a fire. The whole studio had gone. (It's been put down to the spontaneous combustion of oily rags.) All the new paintings were lost, which had never even been photographed. Fortunately, all my documentation was kept separately from the work, but I lost all my drawings as well as all the work I'd been holding back. The most devastating thing for me was that other artists lost things in the fire as well, because of smoke and water damage to the neighbouring studios.

People say, Wasn't it a really cathartic experience? Wouldn't it be great to start again from scratch? But it's actually really boring. It's like being in a game of snakes and ladders and suddenly being shoved down the snake. It has changed my work, but not that much, because your work is a process, a language you're engaged with; it's a by-product of your thinking, and your thinking is still there. If I was a different kind of artist, I might have exhibited all the burned objects: but I'm not and I didn't. The studio got rebuilt, and I got going again. Other artists were very supportive, and I felt quite a strong sense of community.

People don't like to admit it, but it does motivate you to make work if you're selling it. There is a drive in that. I regard what I do as a professional occupation, and however difficult I find the world I operate in sometimes, I still feel motivated by the fact that somebody wants my work, and it has a

life outside. It's funny: people in the end always seem to know what your best work is. Line up ten pieces on the wall, and they'll always go for the same pieces.

Because you're selling work regularly, is it sometimes a problem holding back enough paintings for exhibitions?
There's a dilemma when you're preparing for a show. You try to hold work back for the exhibition, but there are people who want to buy that work now. You don't want to use up space in the exhibition, showing something that's already off somewhere, and also it's technically very difficult to borrow work back. Sometimes you don't know where the work is when you've sold it. Also, the work takes on a particular value once it's sold and you have to really take care of it, so there can be insurance problems.

I've become quite popular in the corporate market, specifically the kind of corporations which are modernizing themselves and now want some modern art to go with their new stripped floors and white walls, to make a statement about them being a modern company. It's one of the few identifiable markets, and I suppose my work fits in because it's not overtly political, and they are quite bold, calm paintings. After the fire I found it difficult to get a body of work together, because my paintings were going immediately into that direction of sale as fast as I was painting them, sliding out the door into a private space somewhere, and never getting exhibited. The trouble is, as an artist I really do need to have exhibitions, to have those points of focus in order to have the debate around the work. At the bottom line, what most artists want is the interest of their peers.

Have you found it a satisfying experience working to commission?
I enjoy doing commissions. There's a satisfaction in being asked, 'Can you produce a piece of work for this place?' and going off and doing it. But when you look back on those paintings, somehow they will never be the seminal works that push your work forward. They are like breaks in the paragraph, punctuation, or summaries, where you pull it all together. Sometimes I think, Why can't I produce work like this all the time? I always give a good-quality work, but there's something about the investigative process that isn't there. Instead of scrabbling around, not quite knowing what you're doing, and eventually a painting coming out, with a commission you pull out all the information you already know. It's important to run the meetings right when you're being commissioned, and I always say the more open the brief, the better the piece of work you'll get. I don't pre-design my paintings, or you'd get an illustration of a painting. It's the layered decisions, where things meander and fold back on themselves, which keep the process active and alive.

I've done a couple of publicly funded pieces (including a Year of the Artist residency with Southern Arts), and I've found them a bit disheartening. I've

Zoë Benbow. Four painted columns underneath the Docklands Light Railway (DLR), Royal Mint St, London 1997.

done them because, like anybody, I want to feel part of the community, and to contribute to that community; but it's so bureaucratic – you have to apply for the money, justify the money, put in a budget (then they cut that budget down), write reports, and with the amount of time that all takes, you end up with very little financially. There can be other problems too: for example, a project I did in the East End was supposed to be a summer project, but it ended up being in November – it was snowing, and nobody thought about the practical difficulties of being up a scaffolding tower all day, painting in sub-zero temperatures. Working 'in the community' can be a very isolating experience. There's this idea that you ought to feel so grateful for being funded. When you make a piece of work and sell it, there's a very direct relationship – you don't have to justify your existence as an artist.

Have you had to justify your existence as an artist to your family?
It's funny, boys always seem to say they knew they wanted to be an artist or a poet or whatever, but it wasn't like that for me at all. I came from a very straight background, and I didn't know you could make your life as an artist, but then a trendy art teacher arrived in the sixth form and she said, 'Hey, you can go to art school', and I said, 'God, what's that?' My family were a bit against it – my father thought I ought to be a greetings card designer or something like that, and I thought I might be an interior designer. But as for painting, I suppose they've accepted it now that I've been doing it so long, shown a commitment to it, and earn my living from it.

The studio lifestyle takes a lot of getting used to. At college you're always surrounded by lots of people, and in that academic environment what you're doing is automatically assumed to have meaning. It can be incredibly lonely working on your own and having to find your own sense of purpose and direction. People always assume artists stop working because of lack of money, but I think loneliness is probably just as critical a factor. One of my previous gallerists believed that the 'true artist' was someone who was 'just compelled to do something with their hands', and it was therefore best to leave an artist to stew on their own. I need a bit more feedback than that to keep me going. I find it important to know I've constantly got exhibitions and projects coming up so that there's some sense of structure stretching into the future.

Have you found it frustrating working as a painter in an art world which has seemed to place more value on other types of work?
I really feel I fought to make the kind of work I do. At art school I grew up with a rather macho 'attacking the canvas' idea – if you were actually good at anything, that was seen as really facile and unimportant, and what you really had to do was struggle and sweat. At the same time there was this minimalist, reductionist interest in getting down to the 'essential' in art, and somewhere along the line I decided that was crap, and what you ended up

with was nothing. I started making more aesthetic paintings, which is my own quiet rebellion. There are certain aspects of being an artist which I won't accept, such as the insistence on the 'cult of personality': I like to remain anonymous and just get on with it. I don't want my life to be the first thing you think about when you look at the pictures.

People don't talk about painting much these days, but I still use it as the medium for developing my ideas. I don't think you can have developed thought without a language of a kind, and the idea that artists don't need technique is absolutely bonkers. The British are particularly hung up on the idea that art is all pure emotion (there was such a hoo-ha when they suddenly found all Bacon's preliminary drawings because he was supposed to work from gut reactions). Technique isn't enough on its own – emotion has to come through – but when you've got the technique sewn up, that's one thing you don't have to worry about. For me it's important that if I want a particular colour, I can just get it. It's just there. If you don't know how to mix a colour (you want it, but you can't for the life of you find it), how can you use it? I've done a lot of martial arts, and it's a bit like that – you work through a highly structured framework in order to be able to improvise freely.

Zoë Benbow, painting mural
Photo: Joe Low

I don't believe people can live on that emotional edge all the time. A number of young artists work from physical energy alone, but it's very difficult to sustain that, and they never make the transition. I used to think a world like choreography was very far from mine, but something I've come to understand from the performing arts is the ability to produce something that goes beyond your own emotional state. It's not that I'm not questioning the world, but I don't just want to be commenting on the mundaneness of our urban life in the twenty-first century. I want to contribute things into the world as well, and introduce some positive energies, aspiring to something above the everyday. There are other, quieter voices.

Dalziel + Scullion

Matthew Dalziel was born in Irvine, Scotland, in 1957 and studied at Duncan of Jordanstone College of Art and Design, Gwent College of Higher Education and Glasgow School of Art. **Louise Scullion** was born in Helensburgh, Scotland, in 1966 and studied at Glasgow School of Art. Since 1993 Dalziel + Scullion have worked as a joint art practice using photography, video, sculpture, sound and installation with a distinctive sensitivity to its context and environment. Site-specific commissions include (1997) *The Horn*, M8 motorway; *Migrator*, Heathrow Airport; and *Bell*, Yesbaby Cliffs, Orkney (2002). Their work has been exhibited at the Venice Biennale (1995) and Expo 98, Lisbon. Solo exhibitions include (2001) *Home* at Fruitmarket Gallery, Edinburgh, and *Voyager* at Yorkshire Sculpture Park. Since 2001 they have been based within the Research Department of the School of Fine Art at DJCA, University of Dundee.

Politically, do you feel more comfortable with the idea of working as part of a team than as an individual artist?

Matthew Dalziel I think the most liberating thing is breaking away from that myth of the artist as 'special unique individual' – the solitary Kafka-like personality working away on their own and in suffering. I have also felt that it is just far more enjoyable to be able to discuss ideas with someone who has also invested in the work and to be able to progress these ideas more quickly.

What happened in the years before you teamed up as Dalziel + Scullion?

MD I left school aged sixteen and followed my father's footsteps into the local industry, which was coal mining. I served an apprenticeship as a turner and miller and worked there for seven years. It was quite dangerous, and I had a couple of accidents, and I thought, I'm not enjoying this, I'll have to do something else, so I went to night classes after work to get O-levels and Highers, and then applied for art school. My mum's father was a shipyard worker but also an amateur painter; and in the dim and distant past I had a great-uncle who had once painted a portrait of Prime Minister Atlee; so there was this little seed tucked away in the background which brought the word 'art' into our household. I guess once you've named a thing, it exists, and if it hadn't been named, to me 'art' would never have existed.

When I heard that I'd got into art school, I imagined how my life was going to change. I had this picture of myself living in the Highlands with this self-sufficient lifestyle selling crafts. However, it didn't work out like that. I seemed to gravitate towards sculpture and really enjoyed how easily I could manipulate things compared with the steel I had worked with at the Coal Board. I found the whole environment really challenging and exciting, completely different from my life before. During that time I came across many people who had a great impact on me. There was a tutor, Gary Fisher, who made me realize that the best art isn't always literal, and the revelation that art could be anything transformed the way I thought about things. A fellow student, Robert Torbet, was another big influence. He was younger than me and had bags of confidence. I'd watch the way he conducted himself and thought I don't need to be second fiddle – I can make confident statements too. He was a real role model.

Louise Scullion I suppose art for me was just something I was good at as a schoolgirl, and that my family encouraged me in. My older sister had been to art college, so I was following a path already trodden. My mum was a writer, and she would have loved to have studied English formally, but for her it wasn't an option, so she made sure that doing what we wanted was an option for us. At art school I thought I might go in for design, but I fell in with a group of students who were fine-art based. It's strange how you make these decisions. I remember thinking that the other students seemed far more clued up than me, many of whom went on to have successful careers in the arts:

for example, Christine Borland in the year above, and Douglas Gordon in my year. They were ambitious and energetic, and while it was quite a competitive environment, it was exciting and invigorating to be among them.

My first break came when the curator of the Third Eye Centre (now the CCA) in Glasgow saw my degree show and asked me to do an installation in their foyer, then invited me to be in a group show called Scatter. My first 'proper' job was a residency at the Smith Art Gallery in Stirling. Before that I was working from home in the garage and had been signing on. So it felt quite exciting, having a studio and a wage. It seemed less like a hobby and more like I was becoming an artist. It was only two years after I graduated that I got picked for the British Art Show in 1990, and that was a major leap for me.

When did you team up and start making work together?
MD We were both in the 1990 British Art Show, and because it was touring around we bumped into each other a couple of times and started chatting. We became a kind of partnership, but not an art partnership until later.

LS When we first started 'seeing' each other, Matthew had been working as artist-in-industry at the St Fergus Gas Plant and I was doing a residency at a psychiatric hospital in Aberdeen. Although I enjoyed the work I produced there, and liked exploring the locale, it was quite hard going, and I felt pretty isolated. By the time my residency had finished, Matthew had moved out to St Combs on the coast.

MD I said: 'I've got this nice cottage by the beach. Why don't you move in, and you can make your art and I'll make mine?' Sounds a bit like 'come up and see my etchings', doesn't it? But anyway, she did. And not long after that we were both independently invited to make pieces for a very interesting show at the French Institute, called Public and Private, and for some reason we thought we'd try an experiment and make a piece together. Later again, Louise was invited to enter a competition, and she suggested we did that one together, and lo and behold we won. That was *The Horn*, completed in 1997 and built on the M8 halfway between Glasgow and Edinburgh, which periodically speaks to passing cars. People were saying this really seems to be working, the two of you together, and we were enjoying doing it, so that's how it took off; but it started out as quite a practical thing.

LS Yes, we didn't have a manifesto or anything. One of the practical things was that I didn't and don't drive, and we were five miles away from a town, so even just getting simple materials was not always straightforward. I also saw it was going to be quite hard, trying to be supportive of each other's practice, giving the other help and inspiration with their projects, while maintaining one's own practice. Instead, we began pooling our energy into this one thing with no distractions on the sidelines.

It's been very useful talking thoughts over together. We question each other's ideas quite a bit, and just the process of articulating them is useful. You may think you know why you're doing something, but it's very different when you try to express it in a convincing manner. Quite often that means we can turf an idea out quickly, whereas if you're working on something on your own you could waste weeks on an idea before you realize it isn't any good. With the two of us looking at a problem, we can be more objective. Of course, having the idea is just one bit; you then have to convince a funder. I think I can make it sound more poetic, but Matthew will get to the point more quickly, so together we've got quite good at convincing people.

The work we make as a duo is quite different from what we did on our own. We had very different styles of work, so it would be interesting to imagine what we might have done separately. I ask myself a lot: Would I still be doing this on my own? I probably shouldn't say this, but Matthew is far more driven than me. I seemed to fall into doing art from school, but for him, leaving the Coal Board and everything, he had more driving him, and I've benefited from that. I don't know if left to my own devices, I wouldn't have thrown in the towel. There are many artists who are successful but who go through dark periods questioning their purpose and potential. Matthew and I seem to time our peaks and troughs, so when Matthew's on a downer, I don't seem so bad, and we can jolly each other along. Matthew has also been more strategic about how we place ourselves. As a younger artist, I wasn't as aware of how other people viewed what you did. I would just plough away, unaware of the bigger scene.

MD It keeps things fresh when it's not just you getting up in the morning and dragging up your own ideas. It's also useful that there are always two pairs of hands to do things. There are endless amounts of discussion and argument, which can be difficult, but you have to keep being rigorous and keep being critical, or the work would suffer. We both have to agree to a project. I can't just say: 'I really fancy this one.' Sometimes Louise will lead on it, sometimes I will, but I suppose we've got into a kind of habit with some of the roles. I've had quite a bit of training in photography and video, so it's always me who documents the work, and I keep the slides filed. Louise has got a good eye for the sculptural form of things, and she's better at writing. Most of the time, sixty per cent of the work is admin, and we seem to share it out quite naturally. At St Combs our studio was in the attic, and we'd each be at our tables beavering away, trying to get through the stuff that needed to be done.

We work very hard, but that's not difficult because we love what we're doing. When I worked in engineering I used to hate getting up on a Monday morning and going to work, but now we're in a brilliant situation. It's a very exciting life to lead. It does have its responsibilities, and when you put work

out for public examination (at an exhibition or something), if there are any bad criticisms it can be quite sore on you and it's hard not to take it personally. But it does lessen the pain if you've got someone to share your disappointments as well as your highs with.

Living out in the wilds, was it harder for you to make waves in the art world?

LS I've never felt being up North was much of a hindrance. While there are a great many benefits to being somewhere like London, it can also be quite draining and a struggle just to survive. In St Combs we were certainly more distant from the art world, but then we also had fewer distractions, and when we are down in London it feels like a more positive encounter.

In St Combs we were surrounded by an inspirational environment that was wild and raw, with wonderful bird life, but also a lot of high-tech industry with the gas plants, etc. It felt as though we were creating a body of work that was different from other artists. It was a unique situation, and the work we produced was singular. I feel a real affection for the people of St Combs. They were unusual, with fascinating skills and local knowledge of the land, combined with very contemporary lifestyles. Neither Matthew nor I are particularly urban people. The way we worked wasn't fashionable, but we felt it could be made so. Most of our audiences are urban, but we seem to be able to make them engage with lifestyles different from their own.

MD It's easy to get paranoid, worrying about how you are perceived by your contemporaries in the art world. Rightly or wrongly, we've chosen to keep a bit of distance from all of that. And sometimes it's more interesting being on the edge rather than at the centre.

What part have your neighbours in St Combs played in your work?

MD We had ten years there working in an intimate context. In a small village people quickly get to know your business, but it was a slow process getting to know these people as friends. In Scotland our piece *The Horn* is quite well known (the long-distance lorry drivers who took fish to France said they used it as a marker-post on the road to judge how far they've gone) – so once people realized we'd made that, they quickly understood we weren't painters.

We made photographs of Hector, who has a big chicken farm (80,000 chickens being reared for chicken Kievs), and Kevin next door, who worked in a fish factory, ended up in a little film for Channel 4. We also made a video piece called *Another Place*, which is a series of video portraits of local people. They were quite camera-shy and reluctant to do it, and if we hadn't lived there for ten years none of them would have considered doing it. We had become part of the village. They'd seen us filming other things, so we could make the transition to filming them.

Another Place is a piece that people seem to be moved by. We limited the information. We didn't say where the place was. We didn't show you what the people did, so it was different from a documentary. It implied that there are other ways of living, other choices, other places, other states. There's a kind of melancholy to the work as well, a sadness about the choices we make as humans.

Dalziel+Scullion
Water Falls Down, 2001
Video installation

We put the people in front of the camera and they were all twitchy and nervous and self-conscious. So we tried putting them in places they were comfortable. Robert, the guy with red hair and a check shirt with the corrugated iron behind him, is standing in front of the shed he built for his boat. Ruby, the older woman in the sand-dunes...well, she walks there every day. We would say to them, 'Look at a point on the horizon as if you're waiting for a friend, and keep looking as if you're waiting'; then we'd go off and let the camera run. An awful lot of the work was in the editing process. We were only looking for thirty seconds from each, and we ended up with eight portraits even though we had shot about fifteen. There were people who had a kind of charisma in everyday life, but put the camera in front of them and it seemed to disappear, whereas the least expected ones might come across. Sometimes that's what being an artist is – about recognizing things, being aware of when something is happening that is interesting, or moving, or transporting.

Is it hard making a living from commissions?
MD The last ten years have been pretty tough. We didn't seem to sell much work, so the only funds really coming in were from commissions. You can do only about two a year, and sometimes you spend an awful lot of time on something and then the funding falls through at the last minute, which can be shattering. It's an interesting life, but quite a nervous life. There are a few artists who make a lot of money, an awful lot who just get by, but many others who don't even do that and find some other way to subsidize making their work. We've got a lot of experience now in working out budgets, and we've had to learn how to decide very quickly whether an idea is realistic. When you're starting off your career, you're really pleased if someone offers you a job at all, but they can easily end up leaving you completely in debt. More recently we've started to sell a few works, and that has opened up some interesting possibilities.

LS We've learned a lot too. Early on, I remember taking on one particular project, just because we were stony broke. It was a good enough project (at the Science Museum) but not really in the vein we wanted to work in. The budget seemed really big at first, but, of course, it ended up costing us a lot to make the work and took longer than we thought, so therefore we weren't working on the things we should have been doing. But I suppose we then had a blue-chip client under our belts, which gave future clients reassurance.

MD Our rise hasn't been meteoric; it's been a steady plod. After ten years, we've got our first big publication this year, while quite a lot of our contemporaries have had three or four by this time. Having a solo publication is a big help in attracting new work, and we know we've lost out on other projects before without one. Also, we've not taken the one track. We've done the gallery work, but we also like making multiples and work for other contexts. The multiples are quite accessible and go into people's homes; the site-specific works are experienced in an altogether different way than they would be as art in a gallery; quite often it's unclear whether it is art, which can be kind of liberating in a way. You hear too of the hypocrisy of those who pooh-pooh commissioned work as though gallery works were more pure, less tainted by commerce – which is strange when you hear about who's buying whom.

After ten years working in your attic in St Combs you've just moved to Dundee, and have a new research studio within Duncan of Jordanstone College of Art. How will that affect your work?
LS In 1997 I remember our accountant saying we had to take a long hard look at what we were doing because 'It's just not a viable way of making a living'. The constant lack of money is really quite stressful and wearing. But it feels like a real watershed just now. The studio at the university gives us a lot more security (for the moment), and we feel we have the power to take on bigger projects, rather than a succession of tiny projects with no money, and gambling that they'll take you somewhere. It's becoming more like a small company now. We're able to employ an administrator, and what a difference that's made not to be doing all of the book-keeping, etc. We used to spend too much of our time on these types of jobs, limiting the opportunities for making more creative decisions.

Life's quite different now, because we also have a son. (We always find it very difficult to agree on the name for a project and spend ages debating it back and forth. But that was nothing compared with naming a child – we took the full twenty-one days permitted.) Before, everything in our lives was directed towards the making of the next art project, but now there's the new responsibility and happiness of having a child. Having Ethan has created another sense of purpose within our work as a whole, and we are conscious of trying to sustain a secure environment that he can grow up in.

MD We'd been research fellows at Dundee since 1995. Then one day I was having a conversation with Alan Robb, Head of Fine Art, and mentioned how we had just missed out on an exciting project in France because we didn't have the support mechanisms to deliver it. He suddenly said: 'We need to do something about this. Leave it with me.' For years the university had been supporting other types of small experimental businesses (mostly in the sciences and engineering), but this is their first foray into a fine art practice.

Combining funds from Tayside Enterprise, the University Enterprise and Initiative Fund, and the Fine Art Department, we are both paid a wage, and (as long as we generate moneys back in again) the university will support us upfront, enabling us to take on bigger projects. We don't necessarily bring in a lot of money, but we do bring in valuable research to the university. The contract is for only two years, so we can't get complacent, but it has opened up a lot of possibilities.

We're currently developing a project called Becquerel's Tree outside the new Nicholas Grimshaw building in Birmingham. Whether this is one that will happen or not remains to be seen, but the process has been interesting since we have been steering it much more ourselves, taking on the role of main contractor and creating a team of specialists around us to help realize the project. Artists are too often invited in at the last minute, which inevitably limits the scope of their involvement. And while many clients now recognize this, there's still a long way to go, though, before artists are routinely involved as equal partners.

LS For the purposes of the university, we had to give our 'business' a name, and we called it an 'Environmental Art Practice'. We felt that this best described what we do: we work a bit like an architects' practice, often responding to a client's brief, but the theme that we are most frequently engaged with is the environment. We feel now is a very exciting time to be making work in this vein, as so much is in flux. Mankind's future seems at once perilous yet at the same time has this unending continuity to more ancient times, to a pattern of life that seems to keep going despite the efforts of humans.

Dalziel + Scullion
Postcard, 2001
Video installation

Anne Desmet

Anne Desmet was born in Liverpool in 1964 and lives in London. She studied at the Ruskin School of Drawing and Fine Art, Oxford University, then did a postgraduate diploma in printmaking at the Central School of Art and Design, London. She is editor of *Printmaking Today* and co-author of *Handmade Prints*. Her wood engravings, linocuts and collages are in such collections as the British Museum, Victoria & Albert Museum and Fitzwilliam Museum, Cambridge. A major retrospective exhibition, *Towers and Transformations*, opened at the Ashmolean Museum (1998), toured to seven other UK museums and galleries, and concluded at the Whitworth Art Gallery, Manchester (1999).

As a printmaker, do you find yourself being described as a 'craftsperson'?

People always look at my pictures and say, 'God, that must have taken hours,' and that's true, so in one sense I'm pleased if they can recognize there's a lot of work in there, but the frustration is that I also want them to get past that. There's a problem with labour-intensive work if it ends up looking laboured, which is absolutely what I don't want.

After 'How long did that take?', it's then 'How did you do that?' So you end up in a great long discussion about wood-engraving tools and the kind of wood you use; so you have to produce a piece of end-grain boxwood and show how it works, and you do feel like you're just describing a craft. There's a craft to wood-engraving and it's a very specialist craft. I'm very proud I've learned the skill of my trade, and it enables me to make work that wouldn't be possible without it. You don't get pens that make the type of marks I make – you have to do it by engraving. But I would rather people were saying, 'What's that picture about?' or 'Where did the ideas come from?' When I'm doing them, I'm thinking of artists like Piero della Francesca or Masaccio, whose work also must have taken ages. I admire the still, timeless qualities in their work. That's something I'd like my own work to put across – to look as if it has existed for a long time.

A lot of my work has something about the passage of time in it, which is reflected in the process. It can be very frustrating that the engraving takes such a bloody long time. Sometimes you feel you've almost ground to a halt. You haven't, but that's how you feel. That's why I need to be working on collages at the same time: I work on those much faster. The prints are more planned and considered, and I work from detailed drawings. The collages (made out of pieces of my engravings cut up and reassembled) are more free-form and spontaneous, where I can work through ideas more quickly.

You have established a very distinctive signature style. Do you feel any pressure to take your work in radically different directions?

I've been doing mostly architectural work for the last ten to twelve years, and I've done a lot of towers, though the look of those towers has changed over the years. I'm not someone who thinks when it comes to each exhibition: What can be my latest theme? Each piece is a gradual evolution. My last exhibition included a lot of apocalyptic Towers of Babel, then just before my daughter was born I was making very tall towers, and, of course, since 11 September they have a chilling feel in my mind. I started making them before that awful event, and now I don't know where I'll go with them.

Do you find it dispiriting how little attention printmaking receives in the press?

My work falls into two unfashionable camps, because it is printmaking, which is definitely not trendy, and it is also figurative and representational.

Anne Desmet
Self-portrait with Towers, 1994
Wood engraving, pencil and
collage.

I hope it has something new to say, though. Printmaking is very much the poor relation at the art feast in terms of media interest. Newspapers like work that literally or metaphorically takes the piss, and what could a paper say about my work that is adequately shocking? When I go back to my family in Liverpool, it's very hard to get them to take what artists do seriously because all they read about artists in newspapers is the latest shock about Tracey Emin's bed or whatever. To them, that denigrates the whole profession of being an artist. My brothers' friends are always teasing me about 'still living at the taxpayer's expense' when I'm earning a living and paying my tax bill like anyone else. The way art is reported makes it very difficult for people outside the arts to consider visual art a sensible profession.

Do you think you have a particular personality which has led you to printmaking?

I do have a strong and obsessive work ethic, and I'm sure the fact that I make such labour-intensive art is all Catholic guilt complex. I was very academic at school, and the comprehensive I went to was very keen I did Oxbridge, so I did a fine-art degree at Oxford and came out specializing in printmaking. (At the time that was what the Ruskin had the best tuition in.) After doing a postgraduate diploma, I was trying to eke out a living and keep my work going, then I won a Rome Scholarship, which was a real turning-point for me. I lived in Rome for a year and came home with a lot of ideas, which are still feeding my work now. It was great to have that time to develop ideas without the pressures to make money or pay rent.

How important has it been for you to keep on some kind of part-time job?

Since coming back from Rome, I've always had some sort of part-time job, which was initially my main source of income. For eight years I worked two days a week at a gallery and five days a week on my own work without any time off. Since my retrospective exhibition at the Ashmolean in 1998, sales of my work have remained high, and I could give up the part-time job if I wanted. But as well as the security blanket of a regular income (as opposed to a big chunk of money every two years when I have an exhibition), a job helps to keep me sane. It can be quite lonely working on your own with just Radio 4 in the background. I now edit a quarterly magazine, *Printmaking Today*, and it can be a hard slog (because it's too big a job for one day a week, really), but it keeps me in touch with what's on, writing about what other printmakers are doing, and going to a wider range of shows than I otherwise would, which gives me ideas for my own work. Without it, there's the danger of ploughing your own furrow too deeply.

It's a joke among my friends that I married my picture framer. He's also a wood-engraver and painter. I can remember when we got together I was apologizing to him that I didn't think I'd be bringing much of an income into our partnership. It would have been difficult at times if he had been a

full-time artist and hadn't had the framing shop. My income was so erratic, and I didn't imagine things were likely to change. I haven't changed what I do, but more buyers have come to me, so in fact now I bring in as much as he does on average. I wouldn't like to be financially dependent on anyone. It's a great advantage to have a partner who understands the time and concentration I need to do my work. For years we'd spend all our holidays drawing. I have friends married to non-artists, and they haven't done any sketching for years, because their partners won't sit around for hours while they go off drawing.

I've always tried to have a studio in my home. I work on quite a small scale, so this 16 x 12 foot room is a perfectly adequate space for two printing presses. I know a lot of artists who work five days a week to pay for the studio they theoretically use, but in practice they never have the time or energy left to get into it – they're too busy with the job to pay for that studio. When I first came back from Rome I was working in a small bedsit, printing engravings at home by burnishing them with a teaspoon to see how they were going, then going to a friend's studio to edition on her press. Other artists are really good at times like that, letting you use their facilities, then hopefully you get to a position where you can return the favours in subsequent years, which I've been able to do.

Is it harder to work from home since you've had children?
Even though my studio is in the house, my children need to be at their child-minder's if I'm going to work sensibly; otherwise I might work in the middle of the night while they're asleep. I might be able to do some paperwork, but I couldn't concentrate to make prints or collages. You have to keep in your head the whole idea of what the piece is going to look like when it's finished, and multiple distractions aren't compatible with that. You can't change your mind with an engraving – you can't rub out what you've done – you have to be decisive. For the last four years, since I've had my son and daughter, it's research time I'm lacking. I work from detailed drawings made over a period of several weeks (perhaps in Italy, or of London buildings covered in scaffolding), and you can't do that if you have a small child in tow. Fortunately, I've got a large stockpile of drawings I'm still working from. I know it sounds bizarre, but because my ideas take a long time to turn into finished artworks I can still be looking back to drawings I made four years ago – but I'm aware there will come a point soon where I'll run out of drawings I can maintain interest in. I'll have to make time to do more drawing or the work will become stagnant. I don't want to be repeating myself. I worry a lot whether I'm re-treading old ground.

Do you find it difficult to price your work?
I've had a very good gallery for twelve years, which has been very useful in helping me price my work. The first thing they said to me was that my work

Anne Desmet
Leaning Tower, 1991
Wood engraving, linocut, stone
lithograph and collage

was much too cheap, and they more or less trebled the prices; then that has gone up incrementally every two years, each time I've had a solo show. On my own, I don't think I'd have dared to charge several thousand pounds for a collage. That's been really valuable in giving me a pride in what I do, to price them at an appropriate level. Compared with other wood-engravers, my work is more than averagely expensive, but I know it's worth what I charge for it. I invest hours of time and skill and energy into it, and if I cost it on a per-hour basis, it's still ridiculous. I do try to be businesslike and cost it as a business. Every time you add a significant amount, you wonder if it's going to sell, and my experience is, it's sold much better as soon as the prices were put up.

Printmaking is very much associated with reproduction, and that's partly a problem of the English language that we use the same word 'print' to describe some watercolour reproduced in 5,000 copies, or an engraving that exists only in that form. I've had people say, 'Where are the originals?', which is very galling because my prints are the original artworks – there just happen to be more than one of them. If I did an engraving and printed only one of it, that would probably be seen as more 'valid'. But it's a nonsense to do something that has the facility to make an edition, and print only one. I also couldn't make a living if I did that. If one block takes me three months to engrave, then the sum of money I'd have to ask if I printed it only once would be silly: I'd never sell it. It's a financial fact of life that I need an edition of about forty in order to sell at a price people can still afford, and that I can recoup the amount of time that went into it. Things that are one-offs do have a particular cachet that things which are multiples don't have. When I make a one-off collage out of multiply printed bits, it seems to be regarded as more important and I can ask higher prices.

Presumably the higher price of the collages also reflects the greater sadness implicit in parting with work that isn't a 'multiple'?
The collages have got much more complex and elaborate, and the longer you spend working on something – loving it into being, almost – you get more and more attached. I have to keep a decent photograph, although it's not the same. It's silly, but you do hope they go to good homes. There have been one or two occasions when I've not taken to people who've bought my work, and I've felt a bit sad. The hardest thing is when they're sold and you don't know where they've gone to. A very good collector of my work died recently. He had a lot of my prints (and a collage which I think is one of the best I ever made), and I can't help wondering what will happen to them when they're dispersed. In many ways I make them for my own satisfaction, so maybe if I was super-rich I wouldn't sell them at all. Maybe that's why I make prints: I can always keep one, so you don't get the same sense of loss.

Andy Goldsworthy

Andy Goldsworthy was born in Cheshire in 1956, grew up in Yorkshire and lives in Dumfriesshire. He studied at Bradford College of Art and Preston Polytechnic. Most of his sculptures are made in the open air, using natural materials such as stone, leaves, ice and sand. Permanent site-specific works include sheepfolds at Casterton, Cumbria, and the stone sentinels at Digne Geological Reserve, France. He has exhibited widely in the UK and internationally. His exhibition *Time* at the Barbican, London (2000), was accompanied by an installation of thirteen giant snowballs, placed on the streets of London on Midsummer's Day. His books include *Stone* (1994), *Wood* (1996), *Arch* (1999), Wall (2000), *Time* (2000) and *Midsummer Snowballs* (2001). He was awarded an OBE in 2001.

Do you still make ephemeral sculptures in the landscape every day?
The ephemeral sculptures are the mainstream of my work. They are the nourishment which allows me to get to the heart and essence of what I do. On a typical day I get up and walk, not knowing what I'm going to make, but I may find heavy rain has created a pond, or some elm leaves left on a tree turning yellow. By touching the leaves, I can understand yellow in a way I couldn't just by looking. I have to be a participant. What I learn through my hands is so much more than what I see from a distance. I make sculptures with no tools other than spit and thorns, and there's a fantastic freedom to go to a place with nothing but your hands.

Once I've made a work in the morning, I'm fine, even if it's bad work. It's making the sculptures that's important. They can be bad technically because they fall down, or bloody awful sculptures that look horrible, but they're an attempt at something, and they can grow into something interesting. I have every work that I've ever made in a slide cabinet in chronological order, one of each, going back to 1976, and I can see the progressions, the failures, the things that start off so tentatively and then emerge later in a much stronger way.

Were you rearranging things in the landscape from early on?
I can't remember doing any more than any other child, though memories of digging holes in the beach and sticking bracken into them are very strong in my mind. I think it was working on the farms that gave me the strongest sculptural experiences that fed into my work: the construction of haystacks or ploughing a field or laying a hedge, making a wall.

It was the brutality of farming too. The death. There's a very romantic view of agriculture sometimes, but if you live in the countryside you can't walk a few yards without coming across something that's dead or decaying. Farmwork gave me the physical ability to construct things and taught me not to be frightened by hard work or working for long hours doing monotonous things. But art has always been the only thing that I could ever do in my life, right from the beginning. I had no choice.

Did you find it stifling working inside an art college?
I began working outside the college, doing installation work on the streets of Bradford. I was very influenced by the rawness and unexpectedness of performance art and happenings. There was an enormous difference between the energy that I felt present making work outside, and the lack of energy in things done inside. Within three or four months of my degree course I was very disillusioned. Throughout my art education I've been taught that art is the means of self-expression, and that is very difficult for someone of my nature, because I don't have all these things inside that want to come out, I am more interested in exploring a way of looking and understanding.

*Left: Andy Goldsworthy making the **Midsummer Snowballs** in the Lowther Hills, 1999. Photo: Julian Calder*

*Right: Andy Goldsworthy **Rain Shadow**, City of London*

I was rejected from foundation college, which is relatively unheard of, and rejected three times for a degree course, which instilled in me a fierce independence and mistrust of the establishment and the art school. It was in the foundation year that I realized I had committed myself to being an artist for the rest of my life – and that meant there would be no other career. I still really dislike going into studios at art schools. I find them claustrophobic: the small cubicles, the restriction and isolation. I still remember being faced with this little cubicle with white walls and a white canvas and the dreadful feeling of what shall I disgorge on to it? I lived at Morecambe, and every night I caught the train back from art school and saw this huge expansive beach. One time I went out and worked on the beach and watched the work flushed away by the tide, and from that moment there was a sudden sense of learning. Not in an academic way, but real learning about important things, an understanding about the tide, the quality of the sand, the light, the land, myself.

I come from a tradition of inarticulate artists. I could hardly put two words together. I just had to make work. Twenty-five years later, I've been given two honorary degrees and I'm a professor at Cornell University in America, and I think why? When I wasn't even put in for my eleven-plus, why can I now write? Why can I now explain these ideas? And it's art that's taught me to think and to write.

How did you live immediately after leaving college?
There was a farm I was going to live on, and my plan was that I was going to work there two days a week and make art the rest of the week, but in my final year at art school the farmer died, and six months later his wife died too, so that structure collapsed. It was a major hiccup. So I stayed on in my flat in Morecambe and signed on for a couple of years and continued doing my work on the beach. Within a few months of leaving art school, North-West Arts gave me a grant of £350 to print up photographs, which became my first exhibition (in 1980) at the LYC gallery in Cumbria. The Arts Council bought a group of works that year, and I remember their purchaser talking me up from £30 to £60 a print, which was an enormous amount of money for a young student. That was the last sale I made for years.

I don't think I felt at any time that I should expect to make a living out of art. I was always looking at the alternatives – farming or gardening or anything – so that I wouldn't compromise the work. The trend to teach art as a 'career' causes me concern. Art is not a career – it's a life. You can't go in for it and treat it as if you could have been a doctor or a nurse, because it just seemed like an interesting thing to do. I'm someone who has to make work. I have to: I can't not make work, and that's just the fact of it.

You've become known to a very large audience through your books.
To make art publishing work it has to be done on an international level, so that you get a big enough run to make it economic. That's a tough thing for a book to achieve. The books have been interesting and quite successful but not without their problems. A book like *Time* is quite deep and rich, showing some of my thought processes and the rationale for making my art. But the first books were just a collection of images really, and I think they actually reinforced the idea that these were just nature pictures. To some extent I've had to fight against that superficial perception of my work ever since.

I seem to have informed a very superficial attitude to nature: 'let's make some interesting shapes in the garden', or 'let's have a sculpture trail'. A woman wrote to me, saying she had made some clay spheres on wire and that she realized she'd probably been influenced by the cover of my *Stone* book, so she wanted to ask my permission to sell a small number. I wrote to her and said, well, I'm not going to stop you, but I'm not happy with what you've done. You've taken what is a balanced sculpture about tension and energy and balance, precariously so on the edge of the tide, and you've reduced it to a garden ornament. They're totally different things. It weakens your work when it's taken up by popular culture, and the work has to be strong to survive that.

I see my work plagiarized in gardening programmes and decorating programmes and car adverts, and I suppose I have to accept that's just the way art gets assimilated into culture. We're dealing with a very savvy commercial and graphic world that gets into contemporary art very quickly. I don't like it being used for commercial purposes, but you can't stop things becoming part of the language. As you grow older you realize that art has an enormous effect. It's frightening sometimes to think of the effect that we can have.

There is a perception that I'm this fabulous self-marketing person, when in fact I'm doing an anti-marketing job most of the time. I was mortified when I saw my works being used as advertising by a book club. A book club in itself is no bad thing, but their heavy marketing was very bad for me. I know someone at the book club thought they were supporting my work, but I was hurt and really offended to see my work used in that way. The only postcards I have ever allowed are those where the proceeds go to the charity Common Ground, an organization I really believe in. Can you imagine how many people want to make calendars of my work and the amount of money I could make out of that? But I don't do it. I suppose the books' titles can give them the feel of a commercial series, but I chose those titles because I like the simplicity of them, and I stand by them. *Stone* was about change, *Wood* was about growth, and I always said that if I had to describe my work in one word it would be 'time'.

You have described your ephemeral work as breathing in, and your permanent works as breathing out. Early on, were you more tentative about 'breathing out' and leaving permanent marks on the landscape?
There might be an element of that, but it was also about not having the ability or opportunity to do it. The first work that could be called permanent was made in 1984 in Grizedale Forest (I should explain that they were called 'permanent' at the time, but they lasted fifteen years and they're no longer there). I felt then that there was this other side of the work that would complement the ephemeral, which would use tools and involve other people (the people helping me, but also the people for whom the pieces were being made, and the people who would come across them afterwards). There was also an uncomfortable sense that the life of the work should not just be viewed through photographs, but that there should also be something that could be tested in the flesh.

There is a pressure on me now to do the permanent works, and I have to be very careful about getting the balance right. It's not unlike having a bank account. The ephemeral work puts something in: the commissions are 'withdrawals'.

What are the things you find most draining?
People. Meeting farmers, spending a couple of hours with people from the parish council trying to explain the sculpture and fighting for the sculpture and getting nowhere – that can be hard. Farmers are not the easiest people when it comes to contemporary art, and working in an area like the Lake District, for example, there is a deep conservatism that loathes anything new in the landscape.

Having to do an installation inside a building drains me too. Outside, it's so alive that it fills you with life. (I suppose other people may get the same buzz from other people being around, but I've never been that sociable. I like to meet and work with the same people many times, so that you can get to know them and they become like family.) I try to treat galleries like being outside, drawing on the walls with clay. I make no compromises whatsoever for the galleries that represent me: I make works that cannot sell. I have had some unbelievably generous and supportive patrons. Sometimes the perception of a collector is of someone greedily investing their money into something they will sell later for an enormous sum – but my collectors aren't like that. They often have to live with the idea of a work that isn't going to last, and my sculptures can't be moved – they belong to the place, not the people.

There are various things I've had to do as self-protection to enable me to carry on making the work. The office has moved out of my house now, and I've had an administrative assistant for about eight years. The first thing you

Opposite: Andy Goldsworthy
Wall
Storm King Arts Center,
Mountainville, New York
Autumn 1998

have to do is stop answering the phone. If I pick up the phone and I have to talk to someone trying to persuade me to do something for an hour, I'm just exhausted. The only advice I ever give to students is: do your art first. I do make my work first, and that does mean that there are lots of things that I don't attend to administratively. In every corner of my office there are piles of angry people. I can see it in my filing tray. The worst thing is having a pile of letters from school kids that I don't ever have the time to respond to. When they re-did the curriculum, they actually named artists and encouraged children to contact them. (Yet they didn't get in touch with us, or offer us support.) It really hurts me that I can't respond. And yet, they've got all these books, how much more do they want? I answer all their questions in the books, but they're supposed to include something in their coursework that shows they've written to me.

You don't always make your stone sculptures yourself. Is it difficult letting go of that part of the process?
I love to make things and find it very difficult to abdicate the making to other people. The big work this year was a stonework at Stanford University (a great wall dug into the ground that used old bits of university buildings which had been destroyed by earthquakes) for which I brought a team of eight wallers over from Britain. It's difficult to be an overseer and a worker at the same time. You don't have the distance or the authority. I also have a sense of respect for their skills and their territory, and when it comes to walls they work stone better than I do. (Though a sculpture can often be more interesting for being a less accomplished piece of stonework; and for the first time, I'm about to make a piece alongside them, where they will be doing the walls, and I'll be making the cairns in front of them.)

Before I start a commission, I try to spend two weeks making ephemeral work there first, getting to know the place. And while the wallers are working, I often make little things in leaves and stones alongside them, to give the large-scale permanent sculpture that ephemeral dimension. I keep a diary that connects both – a dialogue between the big stonework and the tiny thing that is blown away in the dust. That's very rich.

You make a phenomenal amount of work within a very condensed timeframe, and often have many projects running alongside each other. Do you think you have a particular ability to stretch time?

When I'm making the throws, throwing material in the air, or making beach cairns, time stops. You slow time down because of the intensity of the experience. You can see everything. When I had motorbikes, I remember once hitting a car and going over the bonnet – and that moment is still happening, the slowness; the detail in which you see everything lasts for so long.

Your home location seems very important to you.

The first gallery that ever represented me told me I'd have to come and live in London, but I said no, and moved further north. Living in a small village in Scotland may appear to be a statement of withdrawal from metropolitan centres, but in fact I see in the visits I make to major cities how provincially minded the people are there. Living in a big city like New York or London gives you the illusion that you're of the world. That's an illusion you just can't have, living where I do, and in some ways I have a broader outlook on the world.

I'm much happier if my children are with me. I miss my children enormously, and I arrange my schedule each year around the school holidays and projects that will accommodate the children. Art is fortunately one of those occupations where 'artists' whims' (if you can call it a whim to want your children with you) are accepted. I bring my children to meetings in galleries where they can run around and play or sit and listen in a way that a businessman could never do.

My home place is the most important place to me. I travel a lot, but I don't particularly enjoy it. There's always a feeling of regret when I leave home and a sense of relief when I arrive back. I've made sculptures there piece by piece over a long period of time, and when you lay it down stone by stone, a little bit of you gets embedded in the sculpture. 2001 was a difficult year with foot and mouth: I couldn't go out of my garden, so I started making works with wool on the boundaries. I also projected my shadow into a frosty field, standing there until my shadow was burned in: so I was in touch with the field even though I couldn't go inside it. My art is about change, and change is best understood by staying in one place.

It really hurts coming south in the spring and seeing the leaves out before they are at home. I've seen these trees all winter, and I spoil it all by coming south and jumping the gun. There's a big difference between seeing leaves come to life in your home place and somewhere else – you don't see the context, the continuity. My wife never tells me if it's been snowing at home: it physically hurts if I'm away working on a stone piece, and I know it's snowing and I'm not there. The prospect of going anywhere north, into the ice or into the cold, gives me the only thrill when I travel. South is very, very difficult to understand.

How does the disappearance of the ephemeral works make you feel?
Even the permanent works have a sense of uncertainty about them, which sustains them in their own way. One thing my art has taught me is the fragility of life and the element of chance in everything – being born, being alive, breathing. Life is such a rare thing, and you shouldn't squander that, not just accept it and take it for granted.

I'm dealing with the most important things there are: life and nature. If this doesn't work, if this doesn't sustain me, I can't go back to nature. I'm right there. There's nowhere to go to, and that frightens me. If I get disillusioned with this, there's nothing left. Beauty is very important to me. 'Beauty' has become a very dirty word, and artists don't like to use the word 'beautiful' – but I do use it. Beauty, for me, is what sustains things, although I know beauty is underwritten by pain and fear. All those things are just there hovering, and make sense of each other. I can't make something beautiful without also knowing it's frightening. Because beauty is frightening and it does frighten me.

Understanding the materials I work with – the different yellow of the elm leaves because of a warmer or wetter summer, or how one stone works with another – gives me a deeper understanding of my place. And it's helped me make sense of the changes that are happening to me as I grow older. My father died just after all the carnage with the twin towers. I was making art throughout his illness and his death, and somehow it made sense of what was going on. Twenty minutes before he died I made a shadow in the rain, outside his room. I'd be making the sculptures in tears, and it was the only way I could unlock the grief, for his death and for the mass deaths. I made a coloured line of leaves for my father, and it lasted longer than he did – leaves going from brown to green to yellow leading to the tree where he watched the birds from his bed. People can look at that and say: 'Oh, that's pretty. Pretty leaves.' My mother saw that and she said: 'No, that's life.'

Andrew Kötting

Andrew Kötting was born in 1959. He lives in London but makes frequent trips
to a family home in the French Pyrenees. He graduated from Ravensbourne
College of Art and Design and the Slade School of Art. He has directed two
feature films, *Gallivant* (1996), for which he won the Channel 4 Prize for Best
Director 1997, Edinburgh, and *This Filthy Earth* (2001); and a film, installation and
website, *Mapping Perception* (with Dr Mark Lythgoe and Giles Lane, 2002). His
many short films include *Klipperty KloPp* (1984), *Smart Alek* (1993), *La Bas* (1994),
Jaunt (1995), *Invalids* (2000) and *Kingdom Protista* (2000).

What does it feel like being locked into such a long-term project as making a feature film?
If ever there was a medium that was contingent, then it's the medium of film. You've got to accept that it will never 'be' what you imagined and in particular when working with a feature-length project. It is permanently in a state of flux because the time period for 'realization' is so long. There's the gestation, and then pretty quickly it turns into an endurance test. It really is like flogging a thing you love, and come the end, sometimes you hate it because it's taken up so much of your life. It's the nature of the medium: it's a beast.

When you're making a feature film, you use up a lot of mental disk space and the hard drive gets pretty full up. Everything starts breaking down a bit, and it can be hard to keep focused on what it is you're meant to be doing. When you're in the middle of a production, there's no stepping away, no hard shoulder to cry on. You come to realize how much stamina and focus are involved. You also begin to appreciate the support systems that have been designed to carry you through: the line producer, the production manager, the first, second and third assistant art directors...It is a military operation.

The only way I remain sane is to go off and bring back new ideas to a project conceived and invariably written many years earlier. I then subvert it. It's during the editing period that you can start to throw new things into the mix and begin to 'sculpt'. Of course, you end up with an even vaguer approximation of the thing you set out to make in the first place, but that's what's exciting. I embrace that – otherwise it's like film-making by numbers. *This Filthy Earth* had to adhere to certain industrial processes, which becomes very tiring. The film 'industry' likes you to gather all the right ingredients (the right director of photography, the right scriptwriter, the right actors) and go and bake a very predictable cake. I choose to do things differently, and apply my 'fine-art techniques' to film-making.

Do ideas for different projects spill over into each other?
I like to work through a process of assimilating, collating and then regurgitating ideas that have been hanging around in notebooks or on the cortex for a very long time. It's a very sculptural process, connecting ideas that are shooting across the highways and byways of your head, asking: Where does this connect? How can I make it work? Which project is it pertinent to? All the work is part of a continuum. It's never finished.

The ideas cross-fertilize. They're breeding when I'm not looking. I know that in the dark corners they're busy copulating and begetting more ideas, more chimeras. I look at them and think, What's that? and put them back in the box. When I started working on *This Filthy Earth*, for example, I'd start

Andrew Kötting with his daughter Eden

opening those boxes up and doing a bit of spring-cleaning, and would find ideas that could work really well there. For example, I stumbled across a Breton folk singer in an FNAC record shop in France, and before I'd shot a foot of celluloid I knew that the sound of his voice belonged to one of the characters. You rely on your intuition, and sometimes you're let down.

I'm incredibly eclectic. I get a lot of ideas from literature, but there aren't enough hours in the day to keep abreast of it all. Music is also a great transporter, connector and revealer. When I listen to music, ideas are invariably thrown up. You can get a more immediate fix from music. But within film you are helped on the way by so many people, regardless of their discipline. It's collaboration. You find kindred spirits – people who share your language – that notion from American philosopher Richard Rorty of your 'final vocabulary'.

It was Ben Woolford from the film production company Tall Stories who kept the machine going on *This Filthy Earth*. The reason it is now opening at the Curzon Soho is as a result of his determination to keep banging on funders' doors. It was Ben too who managed to enable my project *Gallivant* (a very personal piece of psycho-geography about my daughter Eden and my grandmother), which ended up being a feature-length experimental road-movie documentary. In the wake of *Gallivant*, it was strange to have lots of people asking me if I had any ideas for films. I pitched the idea to Channel 4 of a film inspired by Emile Zola's *La Terre*, and suddenly I found myself embarking on a project that almost five years later became *This Filthy Earth*.

This Filthy Earth, 2001.
Directed by Andrew Kötting

I wouldn't have been able to keep sane through those years if I hadn't been able to keep on creating other work. I made two animated films, a couple of short films, and I started work on another big project, *Mapping Perception*, a film installation in collaboration with a paediatric neurologist. Then one day Ben gets phone calls from the Film Council and the Yorkshire Film Media Development Agency saying that they are going to fund *This Filthy Earth*. I have to down tools on *Mapping Perception* and commit to a linear narrative. It can make you slightly schizophrenic, slightly psychotic, because with each project you're speaking a slightly different language.

This Filthy Earth is an experimental film, yet it opened in a West End cinema alongside Harry Potter. Did that context make the work feel vulnerable to attack?
Of course, if your film is shown in the West End, it will be assessed as mainstream cinema. *This Filthy Earth* came in for some wonderful damning criticism from some of the press, who just couldn't locate it – they balked at the audacity of a film like that to exist. Werner Herzog has said something along the lines of film not being the work of scholars but the work of illiterates. So I was happy. There are people who believe you go to the cinema just to be entertained; you don't want to be transported or moved to think, worse still confused. So, yes, that can make you feel vulnerable. I take on board the criticisms and hold my hands up. If I get another chance to make a mainstream linear narrative piece of work, I will try to do it *properly* next time. It might then be a little less demanding on the audience. There can be turmoil and crises in presenting a piece of work, but I'm never in crisis for long, because there are more important things to do, like get on with your life. Sex.

I don't belong anywhere in particular, and it can make you feel very inadequate if you're put in a particular arena to be judged. I would use the word 'factotum' to describe myself – a jack of all trades and master of none. I suppose factotum-ism is the post-modern predicament. I have always been reasonably good at applying magnolia or barley-white emulsion to a wall with a roller, and was very good at cutting in with eggshell or gloss, but beyond that my skills as an artist weren't particularly good. I can't play music very well, although I was in a band and would go on stage and make a spectacle of myself. Those are the insecurities and inconsistencies I love about being an artist. Dare I define myself as that? Indeed I do.

But you haven't always felt comfortable with the idea of being an artist?
At school, drawing had been the one thing that consumed me, so I went and did a foundation course in fine art. But I was nineteen and wanted to play rugby and I also wanted to be working class, so 'art' seemed to be too highbrow, too sophisticated and posh. (Abstract expressionism was still in vogue and I couldn't connect with that.) So, I just disappeared and went to live in Scandinavia for a year, working as a lumberjack, reading Samuel

Beckett and listening to the Slits, while I rethought who and what I was. I think it was that year of isolation in a very foreign place which opened my eyes to different ways of seeing. I came back a lot more confident, and after painting and decorating, and dabbling with scrap metal, I got the nerve to go back to art school and see what kind of mayhem I could create. It was the early 1980s, and punk helped give me the confidence to know that an institution was something to fight against rather than kowtow to. So there I was, under the perimeter fence. I discovered the work of Joseph Beuys and a film of Bruce Nauman, flicking his testicles up and down in slow motion, and I thought, If this is art, this is right up my street.

It was while doing an MA at the Slade that I began to take myself a bit more seriously as a cineaste, and I made contact with the Film-Makers Co-op in Camden. It was an exciting period to be a fuck-wit, and I was definitely a fuck-wit. I was dipping my artistic feet into a lot of things. The Co-op was cold, damp and miserable but exciting. I'd organize shows, screen films of mine like *Hubbub in the Baobabs* and devour anything by Stan Brakhage. (We'd be trying four-projector screenings, before there were video projectors.) This was pretty hardcore experimental work with the moving image, long before the gallery space became a possibility.

To see Isaac Julien nominated for the Turner Prize inspired me and gave me a lot of hope. I'm very invigorated to think perhaps some of my work might be relocated in a gallery, and I'm currently experimenting with reconfiguring *This Filthy Earth* for a gallery in Sigean, France. I haven't gone out of my way to try to infiltrate the art world, but it's quite nice every now and then that some of my emissions have hit that particular target. There is, however, a lot of work located in galleries and put on a pedestal that wouldn't hold its own on the film festival circuit, where it would be seen as very surface and shallow. The thing that's suffering now is art-house cinema – especially in Britain. There are fewer and fewer venues that will back work like that (unless it's from 'World Cinema'). Where once you'd see the work of Derek Jarman and Peter Greenaway, now they wheel out the next Guy Ritchie or Tarantino.

What gives you the stamina to continue making films in such an inhospitable climate?

One of the defining and seminal moments of my life was when Eden was born: the realization that we had a severely disabled daughter. It's been a celebration, but with bringing up a severely disabled child there's a humility that overrides everything else. It encourages and inspires you, demands of you to be patient and to be humble. I think that's where a lot of my stamina comes from. I have physical stamina and abilities of endurance – to endure a lot of pain.

Gallivant **and** *Mapping Perception* **are both about Eden. How has it felt having such personal work out for public and family scrutiny?**
When *Gallivant* opened, my dad came to the premiere. At the end, I saw he'd been crying, and in that moment I knew I'd affected him in a way I hadn't before. I think that he understood for the first time what it was I'd been doing for all those years. He died in December, but I think after *Gallivant* he took me a bit more seriously, and understood what the nonsense was possibly about. He could see on the big screen the trees I'd been barking up.

It's difficult to work in isolation. You see your film play at the Curzon Soho and know that that wasn't your ultimate goal, but to some extent it makes the journey worthwhile. It doesn't fuel that journey, but it's nice to have been considered, and perhaps be in a position to touch and inspire other people, to make them reassess their 'final vocabulary' and affect the way they might navigate through this malaise.

This Filthy Earth, 2001.
Directed by Andrew Kötting

John Mortimer

Sir John Mortimer was born in 1923 and lives in the house his father built in the Chilterns. He studied law at Oxford University and was a practising barrister, becoming a QC in 1966. The first of his many novels was *Charade* (1947); others include *Paradise Postponed* (1985), *Summer's Lease* (1988) and *Rumpole Rests His Case* (2001). He adapted many of his own works for television including *Rumpole of the Bailey* (1978), which won the BAFTA Writer of the Year Award. Other scripts for television include adaptations of *Brideshead Revisited* (1981), and *I, Claudius*. Film scripts include *The Running Man* (1963) and *Tea with Mussolini* (1999). Stage plays include *The Dock Brief* (1958), *The Wrong Side of the Park* (1960), *A Voyage Round My Father* (1970) and *Naked Justice* (2001). Volumes of his autobiography include *Clinging to the Wreckage* (1982) and *The Summer of a Dormouse* (2000). He received a knighthood for his services to the arts in 1998.

When did you decide to be a writer?

My father had always intended that I should be a barrister, but I frequently said to him that I wanted to be a writer. He said: 'Writers' wives have ghastly lives because the writer's always at home wearing a dressing gown and stuck for words and brewing tea. For the sake of your wife, get a job that gets you out of the house.' I was about ten at the time. He said: 'Go and divorce a few people. It's not very difficult – all you need for success in the law is a certain amount of common sense and relatively clean fingernails.'

I knew I wanted to be a writer, but I thought I couldn't just go and *be* a writer; there was nothing in the world I'd have liked less than to be a schoolteacher, so what else could I do? Could I be an actor and be a writer? And then gradually I thought possibly I could be a barrister and be a writer. I went to Oxford and read law, but then the war came so I went into the Crown Film Unit, and the first job I had was with Laurie Lee, being a scriptwriter on propaganda films. I had a uniform with 'scriptwriter' on it: it was on the shoulder on a sort of khaki battledress. I had £11 a week, which was a fortune, and I lived in Chelsea and went out to dinner every night with my girlfriend and had a very nice war.

When the war ended, I wrote a novel called *Charade*, which got very good notices. It was about my life in the film unit. I thought I might write scripts for commercial films, but it was the Margaret Lockwood era of films and I didn't want to write that stuff, so I said: 'OK, I'll be a barrister.' Then I married Penelope [Mortimer], who was a novelist, and she had four children, so there I was with £5 a week from my father, and a wife and four children to support. I wrote a lot and barristered a lot, and did them both at the same time, which was quite difficult because when you're a junior barrister you do an awful lot of paperwork and you're always drafting petitions for divorce. So I used to get up at four o'clock every morning to write novels (at home at first, and then I used to go to the chambers and write). I wrote about five novels during that early period.

Is it hard to live with another writer?

I don't think it's a good idea at all. Actors have it worst, because actors marry each other, and there's always one who's successful (usually the woman) and one who isn't. Penelope and I were both moderately successful, but you write about your life, and if you're having the same experiences as the person you're living with, and both writing about them, then there isn't enough to go round, really. Also, when one person's writing, you hear this typewriter clicking click-click-click while you can't think of what to say.

It's quite difficult to live with a writer because writers are very, very selfish and live in a world of their own. You need someone who lives in the real world – two writers living together is too much. We had lots of children, but they all seemed to get sent away to school because Penelope needed quietness to write.

Did you ever think of giving up the writing to concentrate on the law?
Being a barrister was always a day job, like people go and do waitressing while they're waiting to be an actress. But it turned out to be the best day job a writer could have.

Many of the writers I like best are people who did other jobs: Chekhov was a doctor, Conrad was a sailor, Dickens was a court reporter and journalist, Trollope was a civil servant, Chaucer and Dante were diplomats, T.S. Eliot worked in a bank. If you're a seaman in a storm, a doctor, or a barrister, you will meet people in moments of distress – imagine Dickens walking through the night, going in morgues and looking at corpses. The good thing about Shakespeare was that he had these blank years where nobody knows what he did: I'm quite sure he worked in a lawyer's office or was sent to fight in the Low Countries or whatever.

It was very hard work, but being a divorce barrister when you're young is a wonderful thing because all these middle-aged ladies come and pour out all the secrets of their sex lives to you and you learn all about bedroom behaviour in London suburbs, which is startling, and it's a constant source of material. But that was what it was; it wasn't my lifetime's ambition. My lifetime's ambition was always to be a writer.

If you have a jury, you tell them a story so their attention will be gripped. What you've got to do in a book is make them want to turn over the page. Crime is very exciting. That's why people commit crimes. It's better than standing about waiting for the dole; it beats standing on the edge of the street doing nothing. I'm sure people who have climbed into somebody's house feel a real adrenalin flowing. And if you're doing a criminal case and talking to a jury and then waiting for the result with your heart in your mouth, it's very exciting. That's what I got terrifically from the very early days in films – the business of working with other people, being with carpenters and electricians, not just sitting alone in a room. The theatre is so wonderful, because of the rehearsals, being with a company. And a murder case trial is the same: you're with a little collection of people, all dedicated to the same aim, and all working together towards a point of decision. If you're just alone in a room, you don't get any of that.

How did the play–writing and film–writing and barristering fit together?
The BBC asked me to write a radio play, and I wrote *The Dock Brief*, which was about a hopeless barrister and an unsuccessful criminal in a cell together. It started off as a radio play, became a television play in the early days of live television, then became a stage play and then became a film. Technically, there are vast differences in those things, but the basic idea, the characters and the message behind the piece remain constant.

I was asked to write another play using the same cast, to go with *The Dock*

Brief, and those two plays were on at the Lyric, Hammersmith, with Harold Pinter's first plays, where they were very well received. So I decided I was going to be a playwright and wrote my first long play, *The Wrong Side of the Park*, directed by Peter Hall. If you do anything successful in the theatre you get immediately asked to write films, so then I began a long history of writing films (working with people like Billy Wilder and Franco Zeffirelli). If you write films, only one of every ten ever gets made, but you can live quite a prosperous life on the films that never get made, because film producers can't read books, so they have to have a script written in order to say they don't want to do it. They pay for the scripts, so the writers are always the people who get paid while the actors don't get paid unless the film gets made. Films were profitable, and I always was stage-struck, so I stopped writing novels.

In the middle of the 1960s I had two plays on in London and was wondering why on earth I was doing the Bar business. I was very bored with divorcing people, and it had got less interesting because the law had changed and you no longer had to prove adultery. I decided I'd leave the law, but my father still had such a powerful influence on me that I decided to become a QC. That was considered a very dangerous thing for a junior barrister to do, because as a QC you get only big cases, so you have to be more successful in a way. Soon my whole legal life changed, and instead of doing very dull divorce cases and wills I went down the Old Bailey and started my criminal life, getting into murder, drugs and pornography. I did the appeal for *Last Exit to Brooklyn*, the *Oz* trial, and *Inside Linda Lovelace*, all very public cases. At the same time I did the first Rumpole, and *A Voyage Round My Father* opened at the Haymarket. It was 1970, and the peak of both careers in a way. I met my present wife, we had our daughter, and I was finally married to someone who wasn't a writer, which was a great relief.

After I'd written the script for *Brideshead Revisited*, I thought that instead of adapting someone else's novel I'd try to write a novel and a television script at the same time, which was *Paradise Postponed*. All my novels have been destined for television really. The great luxury you have in novel-writing is all the wonderful ways you've got of telling the story – going in and out of time and in and out of characters' heads. What's most interesting about a stage play is the discipline, the restrictions – you've got to tell the story by action and dialogue alone, and it has got to be so interesting that the audience stops coughing and eating sweets.

I couldn't possibly have written *Rumpole* if I hadn't been a barrister. It was easy to be a writer at the same time because being a QC is like being a vaguely starry actor – you do a big case and then perhaps you do nothing for the next three weeks. You don't have to go and do something every day. I often went to Hollywood for a fortnight and then came back and did a murder. I tried desperately not to have to sit in Hollywood writing scripts,

which is enough to kill you (the best thing is to go, give it to them and go away again as quickly as you can). Switching between the different bits of work was easy because it's a kind of barrister habit. I got used to running between cases in two different courts, leaving one courtroom when somebody else was making a speech to start a case in another court, and still knowing all the addresses and times and everything.

For a while I made about the same out of being a barrister as I did from the writing. (I wasn't like these QCs now. I didn't earn huge sums of money.) Then I began to make much more out of writing, and the terrific responsibility barristers have over people's lives finally got to me, and I thought, Why am I inflicting this on myself? I didn't think I could go on being called 'Rumpole of the Bailey' every time I did a case for the rest of my life, so I gave it up and went to Hollywood.

Do you regret not giving up the law earlier?

Yes, I sometimes think I gave it up ten years too late. I sometimes wonder if I would have written something much more wonderful if I'd given it up earlier. But I probably wouldn't have. I never woke up in the morning saying I'm very sorry I'm not being a barrister today. I'm glad I wrote *A Voyage Round My Father*; I'm glad I wrote *Clinging to the Wreckage*. I'm quite proud of Rumpole. I'm sorry I wrote a lot of film scripts that perhaps I shouldn't have written – all that time expended with no result seemed a waste of time.

What type of writing has given you the most satisfaction?

Earlier this year I was in the West Yorkshire Playhouse with *Naked Justice* – and when you're in a big theatre full of people who have paid to come and see what you've written, and you hear the whole audience laughing at the same time – no other medium gives you that extreme experience. There's nothing to equal the disasters that can happen in the theatre (I've been booed in Germany). I was always taken to the theatre from the age of ten in a dinner jacket, and I was brought up being such a stage-struck little boy, so writing a play stays at the top. Secondly, I think I'd put writing novels because that's a really fascinating thing. But then you never catch anybody reading one. (Except there's a story I tell about a friend of Alan Bleasdale's. He got on the tube train at Green Park with the intention of getting off at Piccadilly Circus but there was a girl sitting next to him reading one of his novels and he knew that at page 200 there would be a joke, so he sat on until Cockfosters in the hope of getting a laugh, which never came.)

Writing for television was good, but now the world of television has collapsed. Writing films is the least satisfactory thing because everybody changes it and tells you to rewrite it – the producer, the producer's aunt, the lady who brings the tea, they all put in their ideas. Graham Greene said he'd watch films he'd written scripts for, and about every ten minutes he'd hear a line he'd actually written.

I'd much rather walk into a room full of actors than a room full of novelists. The novelists would all be talking about money and themselves. The actors would all be telling stories of disastrous evenings in Worthing rep (or bitchily plotting). I did one opera, and if you went down to the canteen underneath Covent Garden there were all the opera singers eating huge meals, drinking mugs of beer and roaring with laughter, and there were all the ballet dancers crouching, nursing their legs in pain, looking miserable and haggard and drawn. The film world can be very boring – they just all talk about business and returns.

How do you think you kept up the energy to sustain so many parallel careers?
The sheer horror of getting bored. I can still do all those things really; what I can't do is have nothing going on. I used to say that I had a really good life because I'd have breakfast with a murderer, lunch with a judge and dinner with an actress.

As a writer you don't meet anybody. It's very cold: the book comes out once every two years and you get a few days off to go and sign books somewhere. In court you get either regular adulation or regular obliteration, which is why I also do all this performing and raconteuring, because a regular dose of adulation is essential. I don't think you ever feel a success really because everything could always be done better than you've done it, but I'm very glad when things get good notices. I think success is good for the character.

I don't have any trouble writing things; my problem is thinking of things to write. The important time for any work of art is when it occurs to you, and it occurs to you not when you're sitting having time to think about it, but when you're on the loo or on a car journey or just washing up. So you don't have to give time away to thinking because these things just come sailing into your head. Once it's in your head, it's in your head all the time. You write about your life, but it's quite easy not to have one when you're old, so you've got to keep on doing things. I just gave up the board of the Royal Court and being chairman of the Royal Society of Literature because I'd done them for long enough, but maybe I should find a small theatre to interfere with. I like to fill up the time. That's what was wonderful about being a barrister really, just meeting every sort of person. It's invaluable.

Cornelia Parker

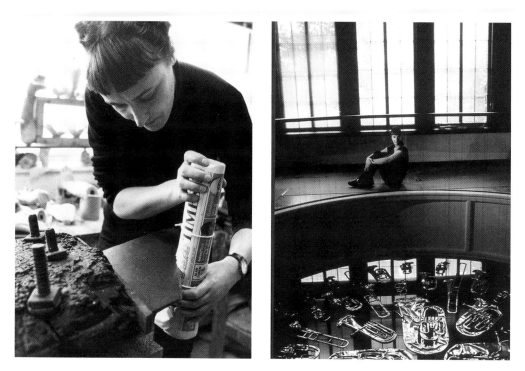

Cornelia Parker was born in Cheshire in 1956 and lives in London.
She studied at Wolverhampton Polytechnic and Reading University. She was
short-listed for the Turner Prize in 1997 for her exhibition *Avoided Object*. Other
solo shows include the Serpentine Gallery in 1998 and exhibitions in 2000 in
Philadelphia, Chicago and Boston. Her collaboration with Tilda Swinton, *The
Maybe*, was at the Serpentine Gallery in 1995. She was artist-in-residence at
the Science Museum from 1998 to 1999. Her work is held in many international
collections including, in London, the British Museum, Tate Gallery and the
Saatchi Collection. Her commissioned installation, *Breathless* (2001), is in the
New British Galleries of the Victoria & Albert Museum, London.

Was becoming an artist an act of rebellion?

When I was a kid, my mother used to say: 'You always want to be different.' I couldn't work out what she meant. I was just trying to be myself. When I was a teenager I was always wearing black crepe dresses, flamboyant headscarves and over-the-top 1930s outfits. I remember being in a Cardiff pub, and all these guys surrounding me because I was such a curiosity; they'd never seen anyone dressed like me. I was wearing something I felt comfortable in, yet being made to feel weird.

I grew up in the country in the middle of nowhere, but at the age of fifteen we moved into a small town, and I was taken to London for the first time with my art class. That was when I decided I wanted to be an artist. When I told my parents they put a lot of pressure on me to be an art teacher. It seems like there's a bigger place for the artist in the contemporary world now, whereas then it was a real 'ivory tower' kind of thing to be doing. My parents still haven't reconciled themselves to my career choice. My father worked on a smallholding, and my mother (who is German and came here after the war) did everything from cleaning to being a dental nurse. They were both working class and wanted me to have a proper job. When I was nominated for the Turner Prize I brought my parents down to London to show them my stuff in the Tate, and my mum looked around and said: 'Ooh, why don't you try set design?' On another occasion I had a show somewhere, and the curator was leaving his position, so my mum said: 'Why don't you apply for his job?'

I had two great art teachers at school, but even they tried to tell me it was too hard a world...but that made being an artist even more attractive. At that age you want to be a rebel and do the thing no one else wants you to do. At Crewe Grammar School for Girls, the idea of going to art school was really shocking. I hadn't got a very good portfolio, and I only just got into my last-choice college, Wolverhampton Polytechnic. I was a pretty bad painter, but meanwhile I was secretly nipping off to these derelict houses next to the art school and making installations (not realizing that's what they were), rearranging the wallpaper, and making secret works which I didn't think of as art at all. (It was like the things I'd do as a child, making tree houses and hidden environments.) One of my tutors found out what I was doing and said perhaps I should be working in 3-D. As soon as I was working in sculpture, and making things with my hands, I suddenly felt very liberated. Looking back, the work I did was pretty bad, but I used materials in an enterprising way. Art school is a bit 'clock on at nine and knock off at five', but doing the other stuff I was absconding, escaping, doing something naughty and furtive.

Moving to London was a big thing. If you were living in Reading or Wolverhampton or wherever, there were only a certain number of

*opposite left: Cornelia Parker cutting up objects for **Shared Fate** 1998, using the guillotine that beheaded Marie Antoinette. Madame Tussauds, London.*

*opposite right: Cornelia Parker with her work, **Breathless**, 2001. Silver-plated brass musical instruments suspended on stainless steel wire.*

like-minded people you could surround yourself with. When I came to London I met a whole different set of people, and I found it so stimulating and mind-blowing that I got excited about my own creativity. They made me feel creative because the conversations we were having were up a few notches. I prefer the idea of being a small fish in a big sea, surrounding yourself with people you admire and are in awe of. I didn't like feeling under-stimulated and bored, and feeling like this freak who'd opted for this weird lifestyle – I wanted to feel normal and disappear. There's something about being in the country that makes you stick out like a sore thumb – you're an anomaly. But in London there's always someone wilder and woollier.

Did you identify yourself, then, as an 'artist'?
I'd moved to London in 1984, after my MA, and squatted in a house in Leytonstone, where I started making suspended installations, knitted into the fabric of the home. I think I convinced myself that what I was doing wasn't 'art', and then it felt fine. I didn't want to make a self-conscious object which was an 'art object'. I was almost ready to give up 'art' at that point – I wondered what function it had. The things I was making in my kitchen felt like therapy; they didn't seem to link with my real life. When I went to art school, I had a very vague notion of what art was. You didn't realize it was a political decision to be an artist. You didn't realize that the emotional input was huge, and you didn't realize it all had to come from you. Immediately after leaving Reading in 1982, I actually thought I wasn't an artist, and I joined a theatre company, but after a year I was desperate to do my own work again. I felt very claustrophobic about the very idea of a nine-to-five job, and I've been an artist ever since.

Once I started reinventing for myself what being an artist was – not going into a studio, but making things on my own terms in response to being out in the world – I started to really enjoy it. I realized that everything else for me was hell. There's such a freedom about being an artist. I think things have become freer and freer and freer for me. You're not accountable – you're this renegade thing. I'd taken a lot of pressure off myself by making things that were indefinable, and after a couple of years of making stuff in the house I started inviting people in to come and look at it, and wondering if it was transferable to an exhibition space. My first big break was getting into the New British Sculpture Show at the Air Gallery, and from then on I started to be a part of the exhibiting art world, as it were.

What have been your major transformational moments?
I had a car-crash in 1994. I broke my pelvis, spent six weeks in hospital and several months recuperating. I could easily have died. It was a bit of a wake-up call. That was when I realized that none of my work was owned by anyone. I'd been showing in public galleries, and non-gallery spaces, like up trees. I'd been very suspicious of the commercial gallery world, and had

turned down any offer of being represented. I made my money from teaching, which liberated me from having to engage with the commercial art world, and when people asked to buy my work I always said no. I'd had this rather rarefied idea that I didn't want money to be going through my head while I was making work. I made my own identity, and got as far down the track as to get nominated for the Turner Prize without having a gallery to represent me – so at least when a gallery did take me on I wasn't pandering to the market, but was making work with some integrity. Before the car-crash I wasn't interested in leaving my mark anywhere, but just in doing the stuff. After that, I grew up a bit.

Another turning-point was making small work. For years I just made large-scale installations, and it seemed to be all one tempo. There was all this fine crevice stuff I wanted to do (like collecting the tarnish from the inside of Henry VIII's armour, a feather from Freud's pillow, or stretching a teaspoon to the height of the Niagara Falls). It took a long time to say no to the constant demand for the big stuff, which takes so much energy. The small works allowed me a lot more freedom, because there were lots of ideas I wanted to explore, but I couldn't have had the time to make them all into large-scale works. I really had to fight to do it – both with myself and other people's demands and expectations. I think you have to do that every so often – to give yourself enough elbowroom to manoeuvre – and not to be forced by your circumstances into a niche.

I could have sold hundreds of the big suspended pieces by now if I'd wanted, but I don't want to make them to demand. I didn't want to become an interior decorator making nice installations for people's houses. I remember ten years ago a bank trying to commission me to make a piece for their new building. I would have made £20,000, but the negotiations were taking so long, and they wanted to compromise my ideas so much, it was driving me bananas, and I ended up turning them down. Instead, I did *Cold Dark Matter*, my exploded garden shed at the Chisenhale Gallery (which I got paid £250 to make). I'm so glad I did that instead because it was a turning-point, a real adventure, and the piece has ended up at the Tate. Private collectors offered to pay more, but at the Tate it's had so much exposure and been seen by so many people. Following my instinct and intuition really paid off.

Are you good at knowing when to extract yourself from projects which are becoming uncomfortable?
I don't find it too difficult. If I'm not doing the work I want, I usually suffer a psychological allergic reaction and get ill. It niggles when things get out of my control, which is why I don't like my big-scale work to go to private collectors. I had a really beautiful piece in Italy, with casts of squashed grapes done in lead, just hovering above the floor. It was in a beautiful orangery, where it really worked. Then the owners moved it to the foyer of some

factory, where it is really badly compromised. I'm not so precious about the small work. A small framed piece is a much more movable thing which can hang on a blank wall anywhere. Often the work is about confronting fears – almost like laying ghosts. My response to getting pregnant was to buy the nightdress from *Rosemary's Baby* that Mia Farrow gave birth to the devil in.

What kind of experiences have you had with collaborations and commissions?
I've done some collaborations which have ended up like Chinese whispers, but the most successful was *The Maybe*, which I did with Tilda Swinton. She lay sleeping in a glass case, like a relic, like a tiny splinter of the true cross. Together we transcended our previous work and made something better together than we could have done apart.

The only commission I've ever done was *Breathless*, which I made for the Victoria & Albert Museum. It's like a suspended ceiling rose, made out of flattened brass band instruments, hovering between two floors, in its own little no man's land. It's for a place I love, so I was very happy doing it; but everything's controversial if public money is spent on it, and I had to go on Radio 4 to respond to criticisms from this outraged colonel-type. (He had me incandescent with rage demanding I account for using instruments I'd legitimately purchased. The very reason you become an artist is so you aren't accountable to these people.) I don't mind if people feel slightly hurt by the squashing of the instruments. I want a mixture of emotions. You've lost something, but you've gained something else. There's a pathos for the object which has lost its life, but it's suspended and given a new life. It's a resurrecting thing. I don't want it all to be pretty – it's a combination of loss and gain. Things are born, die, live and hang in limbo. That's what life's about, and that's what I'm trying to come to terms with in my work.

Having made so many site-specific pieces early on in your career, how do you feel now when your work shifts location and you have to reinstall it in different spaces and contexts?
I think what I like about the work I make is that it changes. An installation will have different resonances and meanings depending on the place that it is shown in. So my piece *Mass (Colder, Darker, Matter)* – made from charcoal from a church struck by lightning – will have a different resonance if it is shown in London than if you see it in Texas, for example, where black churches get burned down all the time by arsonists (although mine was a white Texan church). *Thirty Pieces of Silver* has never been up anywhere long enough to tarnish before, but now it's up at the Tate for nine months. Hopefully, it will get less and less shiny and turn black. The audience always changes too, so it's always living. You make an open-ended proposition and the audience completes it somehow. That's what you hope an artwork to be – a constantly living thing.

I'm used to doing it all myself, but I've got a piece going up in Phoenix, Arizona, now, and normally I would have gone out to install it, but I've just had a baby, so I can't, really. I'm having to delegate for the first time, and that's probably a turning-point for me. It's quite exhausting putting up pieces.

After my car accident there was a one-in-four chance of chronic arthritis setting in within two years, and I still don't really know if that's going to happen. Both my parents have got chronic arthritis. It just feels like you want to produce as much work as you can, and if you're always struggling with money, teaching all the time, and financing all your work yourself, there's only a certain amount of works you can make. I think people often don't realize that artists like Anish Kapoor, Antony Gormley and Tony Cragg have got quite big production teams behind them, which can up your output enormously. I still haven't got to that point, but I do have to think that I might be less able to make these big physical installations in a few years' time, so you have to make only the ones you really want to make. It's all about trying to be as productive as possible.

The economic climate has changed here a lot in the last ten years in terms of contemporary art. We haven't got a lot of collectors in this country, but a lot of people come to this country to buy artworks. I've shown a lot in America, and that has made a huge difference. When you left art school in the 1970s you didn't really expect you'd be able to make a living out of your work, because only a handful of artists could. Now there are a lot more artists who can do that.

Have you ever been tempted by the idea of refining one technique, rather than experimenting with lots of different ones?
I'm crap technically, but I like that cack-handedness. I think my work is deliberately anti-technique. If I do use technique, it's other people's, or the inverse of it. If an engraver is engraving words into silver, I'm interested in the residue of that – the little curly bits of silver he has excavated – the negative of his practice, rather than the positive. The backs of Turner paintings rather than the fronts. I've got tons of soil from under the Leaning Tower of Pisa – it's like being able to tap into the subconscious of the monument.

What I love about Turner is that he's so obviously a really technically accomplished painter but spent the last few years of his life loosening up and making things very impressionistic – like Monet when his eyesight went. Sometimes having failings makes you evolve a new technique. There are a lot of artists I admire who got into their own later in life and did some of their best work. Now it's almost the opposite going on, with artists having this great productive period and then they all go off later on. I'm very conscious of that and thinking, How can I stop going off later on?

My success, if any, has come incrementally. It's not an overnight thing. I'm very glad of that because it's all very digestible. You have the confidence to say I want to work at my own pace, pick and choose the things I want to do, and screen the things coming in which could be a diversion. I feel quite optimistic about how it's all going. If my work changes because of having my daughter Lily, that's great. (Though I do feel I've got a bit woolly and less focused in the last few months – maybe breast-feeding really does take all your brain cells away.) I love to think that my best work is yet to come. You keep on building up to some discovery you're going to make. A breakthrough: hopefully, that's what I'm working away on.

Does being an artist still feel a rebellious activity?
Recently, I had to get a passport for my daughter, and the form lists all the people who have 'proper jobs' who are worthy of counter-signing the application. I realized I couldn't sign a form for anyone – an artist wasn't bona fide enough. Even getting a ticket for the British Library I seem to need to get a letter of endorsement from some institution. That's the kind of price you pay for the career you've chosen.

But in what other job would I have travelled the world and had access to so many wonderful things? I love being nosy, getting to touch things you wouldn't normally get to touch: to hold in your hand a Charles Dickens manuscript – things that changed history, like the guillotine that cut off Marie Antoinette's head. I've met some fantastic people in the time I've been making work, and I don't think I'd have ever met them in my studio. I like going into the world and exploring things, and the art's just an excuse. When you make something good that has its own life, that's just a bonus.

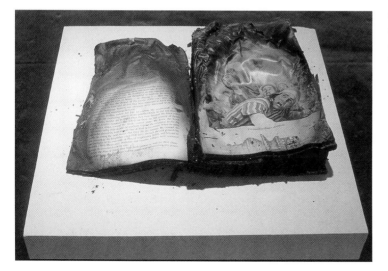

Cornelia Parker. Temple of Dagon is Destroyed, *1997. Bible retrieved from a church struck by lightning.*

Martin Parr

Martin Parr was born in Epsom in 1952 and lives in Bristol. He studied photography at Manchester Polytechnic. He takes intimate views of everyday people in their natural habitats, and has had many major journalistic assignments photographing contemporary British life. His work is in collections such as the Victoria & Albert Museum and Tate Modern, London, MOMA, New York, and the Museum of Modern Art, Tokyo. Solo exhibitions include *The Last Resort*, Serpentine Gallery, London (1986), *Small World*, Photographers' Gallery, London (1995), and a mid-career retrospective at the Barbican Art Gallery (2002). His books include *The Cost of Living* (1989), *Signs of the Times* (1992), *Bored Couples* and *Home & Abroad* (both 1993), *Boring Postcards* (1999) and *Autoportrait* (2000). He became a member of the Magnum Agency in 1994.

Who first got you interested in photography?

It was my grandfather who got me excited by photography. He was an amateur photographer, and I used to go up and stay with him in Yorkshire in the summers, when I was about thirteen or fourteen. He'd lend me a camera and I'd go out with him shooting pictures, bring them back, and process and develop them. There was something quite magical about watching the print emerging from the developer, and it's funny, because I haven't been into a darkroom now for about fifteen years. It's strange that what was so exciting is so mundane now that I don't even do that part myself.

I also saw shows in London, like Cartier-Bresson at the V&A and Bill Brandt at the Hayward, and saw the *Creative Camera* magazines which my craft teacher used to have at school. All these things combined to get me excited by the idea of photography. Then, at about age fifteen, I decided this was what I wanted to do in life.

Have you always been most interested in photographing people?

I photographed many objects and still lifes, but I guess in the end people were my main interest. The recurring theme is to do with leisure – how people arrange things and what people do with their time. I've not spent a lot of time peering after people working – it's people's leisure pursuits and where they choose to go.

It's been fascinating to drag all the old work out for my retrospective show at the Barbican and decide what to put in. You can see more clearly the circle, and my return to some of the more conceptual work of the 1970s. What's particularly exciting, of course, is that my early work, up to about 1982, was unpublished. There'll be a substantial book published alongside the retrospective, so it's exciting having the opportunity to drag out this old stuff no one knows about and put it into the context of the work people do know about and to try to re-evaluate what I've done in this quite substantial career in photography – well, substantial in terms of time...

I did quite a lot of work in colour at college, and this was in the days when serious photography was thought to be done only in black and white. At the Barbican we've re-created my diploma show, *Home, Sweet Home*, from 1974, where I made a living room with different conceptual pieces in it using kitsch frames and a recording playing of *South Pacific*. I've always been very interested in many aspects of photography. I'm a very catholic, promiscuous photographer.

What kind of photographic career was college training you up for?

The classic scenario then would be you'd train up for three years, then you'd become an assistant to a photographer, and then a few years after that you'd become a photographer in your own right. It was very much geared towards the commercial world. There wasn't really an independent world of photography: it wasn't the independent art form we have now. They were very different days from now.

Overleaf:
Martin Parr
Portrait, 1999
Benidorm, Studio Unknown

You have to remember that at this point in time the Tate very definitely didn't want any photography in there at all. It's only in the last few years that the Tate have accepted photography. It's been a long battle, I suppose. In between that time, what started happening, of course, were photography galleries. They reached a peak and are in decline now, because photography is much more accepted, and you're as likely to get accepted as part of the mainstream arts scene.

Have the colour supplements been a creative medium for you?
I didn't really start working for the colour supplements until the late 1980s, just around the time I started to get involved with Magnum. Suddenly, I was exposed to a different type of person who was able to commission me and give me work. Previous to that, my main income was doing my own work and teaching. (I'd started teaching within six months of leaving college.) My last big teaching commitment was as Visiting Professor of Photography in Helsinki from 1990 to 1992, but after I came back from that it was clear I had enough work commercially to pull back from teaching.

It gives a great thrill still, picking up a colour supplement and knowing that a million people could actually be looking at this. Of course, I'm used to being screwed and disappointed by magazines (for example, when the layout hasn't been very satisfactory), but if you take part in that game, you have to accept the house rules.

I'm very much in favour of trying to do something a bit different with magazines, as well as them just printing the work you do. In the early 1990s I suggested this thing to the *Telegraph Magazine*, where I went to a village, Chew Stoke, and spent a full calendar year there. The day before the work was published, we also had an exhibition in the village hall of photographs I'd done

Martin Parr
Surrey Bird Club, 1972.

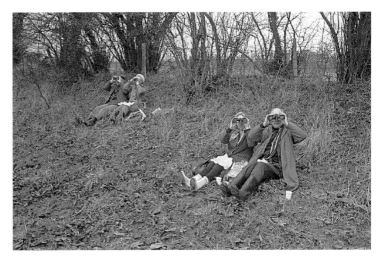

there throughout the year, and invited everyone from the village to a party, and gave them an early copy of the magazine – it became a community event.

The idea is, you can make it work to a different level with different audiences. That's something photography's very good at. I'm very interested in understanding how photography operates in society. Clearly, the audience is very different if you show at the Tate or Chew Stoke Village Hall. I like the idea of both. Photography is a very democratic process – it can function as both high art and low art, high culture and low culture.

When you take photographs you're responding intuitively. You might have an idea from the outset about how these pictures are going to be used, or you may not: it's immaterial. There are two parts to the process: taking the picture and finding ways of using it.

As well as your mainstream publishing ventures like the anthologies of boring postcards, you've continued to make your limited-edition artist's books.
I like the idea of doing things both in an elitist 'art' sense and also in a more 'general public' wider-published sense. I started publishing books in 1982 and I've never looked back. Books are the perfect vehicle in which to view photographs. You can turn them over at your own pace, and it's a great way of making ideas and photography travel.

The artist's books use original prints (which are inevitably more expensive), but they give a certain degree of spontaneity. I took a series of photographs in America in September 2001, as a response to what happened in New York. For me to get this published as a book would be very much more difficult, but I can easily make an edition of five. I like the idea of using photo albums that I find, so I bought some copies of this Stars and Stripes New York photo album, put a hundred photographs in each and sold them through dealers, like the Rocket Gallery.

I'm very prolific, so I want to get something out and finished. I don't want to have it hanging around. Within three weeks of coming back from America, it was finished, out and gone. It's history. It probably won't have another life. I produce so much stuff there's no room. Magnum have also got the pictures, and I believe some of them have been sold, though I haven't seen them published yet. I think we offered the series to the *Guardian Weekend*, and they turned it down. The danger is I do so much stuff, people get fed up with you. Don't think everyone's desperate to get everything I've ever shot. But I'm not bothered. It's behind me now already.

Do you feel more a 'photographer' or an 'artist who uses photography'?
I always call myself a photographer. Sometimes people insist on using the word 'artist', and I don't object. I'm not going to scrub it out in a catalogue,

but if people ask me what I am, I say 'photographer'. Clearly, if you're an 'artist using photography', your ability to get accepted into the art world is much easier.

The status of photography in this country, though improved, is still not as strong as you find in mainland Europe. For example, we still don't have photography reviewers. There are people who write about photography, but there aren't specialist reviewers, in the way there are theatre critics. What the 'artists who use photography' are slowly getting round to acknowledging is that there was already a very interesting history within photography. There is a shift, but it is slow and gradual.

You seem to like working in just about every field.
I do absolutely anything and everything: fashion, advertising, editorial, art world publications, make TV programmes. I'm such a tart, it's ridiculous.

Four years ago I hadn't done any fashion, so I thought I must. Now I have a slow but steady stream of fashion jobs, maybe five a year, and usually done in Europe. I use real people in real situations, and try to make it more believable, because fashion is so stylized. Now that I've found a voice within fashion, part of me says: 'Now that I know I can do it, is there any need to do it?' But, of course, you want to improve and focus this voice you're trying to build up.

Obviously, I like the idea of being in the art world too – producing prints and selling them. That's been slow and steady progress: with the help of dealers around the world, I'm slowly building up a clientele. Being bought by the Tate was probably the biggest thrill. I'm in the V&A, the Arts Council Collection, I've had good slots at MOMA in New York, had a show at the Serpentine Gallery – you can't get much better. I can't complain. I don't really know where else there is to go, really.

Is there any one of those worlds you feel most comfortable in?
What excites me is being part of all these different worlds, and flitting between the genres with relative ease. Advertising is great because you get well paid, so if I have time and I like the idea, I will do the jobs I'm offered. What interests me, of course, is that I can take a picture for an advert and potentially have it put in the Tate. I like the idea that I won't be pinned down to one particular aspect. I'm trying to integrate everything into one.

I like curating, especially if I find bodies of work I think are interesting and undervalued, and I can help get them into the public domain. I can't do everything I'm offered because there aren't enough days. It's a question of working out a timetable. When something comes up that I really want to do, I'll do everything I can to clear the diary. I also book in trips to do my own

work (something I initiate and work on myself over a period of time), and even if I get offered a well-paid advertising job, I'll turn it down.

What do you feel is your most significant work?

Of all my work, probably *Last Resort* has emerged as being the project with a life of its own which can stand the test of time. Because I produce a lot of work, I do understand that many in the end are a bit weak. I'm quite happy to admit that. Inevitably, if you do twenty projects, two or three rise to the top, two or three are no good at all, and the rest are OK. Even before you produce it, you may know it's not as strong as something you've done previously.

As artists get wealthier and more famous, often their work gets worse. It's a pretty standard movement, isn't it? I'm fascinated by the decline of artists. I suspect I'll be in decline myself. It's a fact of life. It's not a big aspect of my life, but it's something I'm mindful of. It's very difficult to get anyone to admit they're in decline and that fame and fortune screwed them up, but it's generally the case.

Often their first work, when they're more energetic, raw and hungry to do things, is most engaging. There have been some exemplary artists like Picasso who go on to do greater things, but for us lesser mortals it's very difficult. Fame and fortune make you lazy. I still regard myself as a very energetic person, but I'm certainly very mindful that I'm inevitably in decline.

That's part of the reason I like to try new things. The danger is, you have a formula and you just repeat it. People ask me to do things in my own particular way, and clearly when solving the problems of photography under pressure you're going to use all the language and the tricks you know in order to solve that problem. Whether you call that 'rehash' or 'using your experience', I'm not sure. It's probably a bit of both.

Inevitably, if you do a radio play or an advertisement, there will be a connection, because it's still the same person doing it. But I'm interested in giving myself a challenge, and not keeping to a formula. Even if I'm in decline, at least I'll have a decline with a lot of variety.

Paula Rego

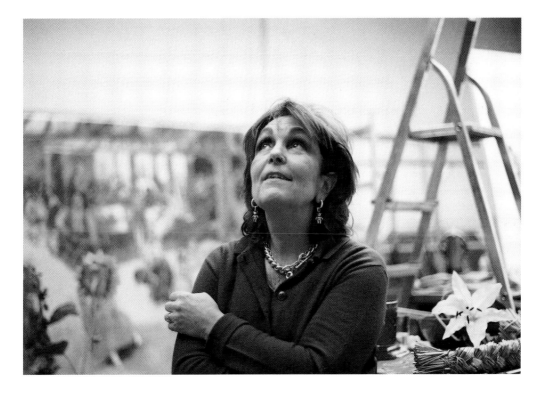

Paula Rego was born in Lisbon in 1935 and studied painting at the Slade School of Art. She moved between Britain and Portugal throughout the 1960s and settled permanently in London in 1976. Solo exhibitions include AIR Gallery, London (1981), *Dog Woman* at Marlborough Fine Art, London (1994), retrospective exhibitions at the Serpentine Gallery, London (1988), and Tate Liverpool (1997), and *Celestina's House* at Abbot Hall, Kendal (2001). Travelling exhibitions include *Tales from the National Gallery* (1991–2) and *Nursery Rhymes* (1991–6). Her drawings, collage, paintings, prints and pastels are in permanent collections at Tate Britain, the National Gallery, London, Gulbenkian Foundation, Lisbon, and the Saatchi Collection. She was appointed the first National Gallery Associate Artist in 1990.

When did you start drawing?

They used to put me in a playroom by myself where I had paper and crayons, and I used to just spend hours and hours drawing. My mother said I made this noise, going 'urrrrrr', while I drew, and when I did that she knew she could just leave me. I think that's quite good training for later on. So I drew from very early on, and then I had a teacher at home to teach me, who was Portuguese, and she made me draw cups, because that's the thing we had to do for exams, cups and mugs. I always got one side different from the other. I couldn't get it right, so she used to elbow me quite strongly and say: 'Look! You can't do anything, you can't draw, you want to be an artist, look at this rubbish!' Then I went to the English school, and they encouraged me and I drew swimmingly. It was just wonderful. From then on I just drew and drew, and I never stopped, really.

What was the family ethos?

Getting dressed well, wearing white socks to go into town shopping in Lisbon, behaving properly. Anarchic behaviour could only happen within the restrictions of your own room, and that usually happened on paper. So I was very well behaved.

Have you always been all right spending a lot of time on your own?

Yes, I'm an only child. I liked it, until I went to art school when you weren't on your own, and it was immensely embarrassing that you had to draw with other people there. There were all these naked people that you had to draw, and it smelled of flesh (naked flesh smells funny with the heaters, you see), and then we had to show what we had drawn. You get used to it eventually, but at first it's very trying.

Did you have to persuade your father to let you go to London?

He said: 'You must get out of here. There is no place for a woman in Portugal.' So they sent me off to England, first to a finishing school in Kent, where I got very impatient because I wanted to leave to go to art school. I got into Chelsea, but then they said: 'Oh, you can't come here. There was another girl who came here and got pregnant.' So I was sent to the Slade, where I did exactly that – I met Vic [Victor Willings] and got pregnant. I went back to Portugal with Vic and had a child.

At art school, were you treated differently from your male contemporaries?

I don't think we were treated differently. I think a lot of girls went there to make good wives for the men (particularly if they were wealthy, then they could support their artist husbands). Not only that, but they knew all the terrible things that being an artist meant so they could support them morally as well as financially. They had to be talented to get in, but they were also rich, and they fell in love.

Overleaf: Paula Rego
Photo: Benjamin Secher

As an artist, what particular things do you need your partner to understand?
I wouldn't have been me if it wasn't for what my husband encouraged me to do and what he taught me. He told me about things I never got at art school (I never learned much there). He was truly marvellous, so for me it was very, very important. It's sad for him, but I wasn't up to understanding what he was doing. I looked up to him and I thought he was marvellous, but I couldn't be more helpful than that.

How difficult was it to do your work while bringing up children?
I worked when I was pregnant and I worked when they were born. I had somebody to clean the house, and I worked when they were at school. At four o'clock I went to fetch them from school. I did quite a lot of pictures. At the top floor of Albert Street I had a tiny little studio. I did all the *Girls and Dogs* there. It didn't make any difference having children – the children weren't allowed to come into the studio.

You're the same person after having children when it comes to doing your pictures. You're a more grown person because you had this experience and it hurt so much. But it doesn't take away whatever ability you had just because you've given birth. It remains with you always. If you lose heart about working, then I suppose you don't care enough to go on. Anyway, I managed to keep going with help. In Portugal it was easy because there were always other people working there. We worked in a barn, and the children weren't allowed to knock on the door unless something horrible had happened. You'd come out and have lunch and then you'd go back and you'd meet them for dinner, stories, the whole lot.

Have you had moments where you've given up heart?
When I had my first daughter, I really thought that I wouldn't be able to continue; I just got stuck. I was trying to paint pictures and not doing too much and Vic was saying, 'Just draw', and I did. I just drew, mostly things in my head. Then suddenly, when I came back to England, all this kind of took off.

I came to London and I set up a studio. I'd already done drawings with men on their backs like beetles and monkeys and so on, then somehow it all came pouring out and I was doing a drawing a day, very, very quickly and very full of intention. That then changed into the collage; I don't know why. I lost touch with the paint, and I began to cut. One is tactile, where you put this paint on, and the other one is to do with cutting, which is also a great pleasure. So I began to cut things out of newspapers and stick them down to make figures, and then I found that that wasn't good enough – I had to make my own material and cut that up. That lasted for a long time – too long. It eventually became academic and too empty. And then a friend came into the studio, where I had these drawings I was doing to be cut up, and she said: 'These are very nice. Why are you cutting them up?' So I abandoned the

cutting up and just did the drawings, and that was a new thing completely. Every change is a form of liberation. My mother used to say a change is always good even if it's for the worse.

Were you being a different 'you' in your drawings than in the rest of your life?

Of course. When I was drawing, I was completely free to do whatever I wanted (even harm people, if I wanted), so it was a form of freedom, I guess. What I do is I spend time on my own sitting here in this studio and I draw images from my head. When I've got a story more or less worked out, I then get people in to sit here playing parts and I set the room up like a stage. For a long time I used to do paintings directly from drawings, but I realized I couldn't do the pastels from my head – it's impossible; there's not enough information with knuckles and things – and I had to have a person in front of me.

Paula Rego,
Little Miss Muffet,
1989. Etching

You like to paint the same model, Lila Nunes.

She's not a model like the usual kind of model; she's collaborating in this thing. She's wonderful because she has a knack of getting herself into the right position. It's like playing when you're a child. Like when you have your best friend come over and you play at things, all sorts of adventurous things.

The scenes you rig up in your studio are very beautiful in their own right. Have you ever thought of making installations?

Never at all, because when you do a drawing, your hand has a life of its own that an installation could never put across. The drawing is alive, and it's like a person, really, while the installation is just a setting. It doesn't interest me at all.

Are the different phases in your work separated by gaps?

No, there's always some technical thing that makes the change. I used pastels in a picture of a man called *The Serpent*, and thought I must do this for the *Dog Woman* picture. And then I got Lila in, because I couldn't do the knee. I began to work more and more, and found that with these pigment sticks I could get something else that I wasn't able to get before, so gradually it just changed from one thing to the other. They don't like people changing, but you do, you know. You're changing all the time.

Up to now I've needed an impulse from within, a lot of emotional energy to do this stuff, and a kind of desire. It's a very aggressive thing. At the moment I don't know if I can do it. It's hard for me, but this aggression sometimes subsides and comes up again. The aggression is a physical thing to do with actually making the picture. It's not an aggression like you're hitting it; it's a sensual aggression, if you like.

Which pieces of work have you felt were major breakthroughs?

Sometimes there are pieces that end up being good, and they're very difficult to do, and I find I'm doing them for months. When I did the monkey beating his adulterous wife, I realized that was different because it was so personal. Then I knew *Dog Woman* was quite different, because it was a woman on her own being cornered, biting. I knew that those two things were changes. When I've been doing lots of pictures, I like to do either etchings or lithographs, because you can get an image quite quickly through drawing. It's wonderful; it just comes out.

Are the more labour-intensive works more satisfying?

They're the same. The satisfaction is either good or bad. The quicker works I did were all done from my head. It's much more difficult to draw with somebody there and get the story, and yet it liberates you from having to be so inventive all the time. So it's a different kind of thing. Your heart beats fast, and it's a big struggle either way. The struggles are never over at the end of the day; even in the quick ones they take longer than that. You come out of the studio and you have a picture of it in your head and it's horrible. You cringe and you think, Oh, God, it's so awful what I'm doing. Then you come back the next morning and you find out it isn't as bad as that and you carry on.

I don't like going back and looking at them. The opening of an exhibition is not so bad because it's a social event, but when I go back on my own and look at them I don't think they're good. But after a bit you like them. *Dog Woman* I like very much, and *Bad Dog* too. They mean a lot to me. I think my abortion triptych is very good, really good, actually...and that was done three years ago. And the drawings I do are OK, so I'm not too pessimistic. I always hope to do better, always improving.

I've done a lot of graphics recently. I've actually got to take it easy, but I try to draw as much as I can. I like it. I just hope I get more ideas. Other people's interventions are so important: who comes into your life and who picks things out for you. They're like helpers in fairy stories, helpers that come in, and sometimes at just the right time; they put their finger on it. The people who try to help you usually don't succeed, but there have been some curators who have asked me to do magic things. One of them is Phillip Dodd and I've often thought of writing to him and saying: Can you suggest something?

What have been the main stepping-stones of your career?

I can't remember the first picture I sold. It wasn't for many years. I only had my first one-person show in Lisbon when I was already thirty-one. I couldn't get my work shown anywhere here. The ICA showed me as part of Six Artists in 1965 and then I went to Lisbon and had a one-person show there. About three or four pictures sold from that show (one to the Gulbenkian, who have been my supporters, bless them, as have other individuals who bought the stuff). My

first show in Britain was in 1981 – that was fantastic because before no one would look at it. They'd look at it and send me around the corner; it was absolutely terrible. Then soon afterwards the Gulbenkian show was brought to the Serpentine and that was very good. By then I was with the Marlborough Gallery, so that was OK. Tate Liverpool was good because the curator was very good at hanging pictures and I began to see the work differently.

What difference did finally having a gallery make to you?

It is absolutely terrible not to have somewhere to show. You feel so humilia-ted. Marlborough is like a family, really. I can show my graphic work, I can show my other work, so it's very good on all aspects. I'm very lucky. I'm not fashionable at all, and the fact that I manage to sell pictures without being fashionable is thanks to my gallery. The work says something to some people, and it's in some good collections, but I've never been fashionable ever.

Have attitudes to artists changed very much?

Artists are taken much more seriously now. Nobody gave a shit when I was young, really. In England in the 1950s about three people looked at art; now everybody does. Everybody takes artists seriously. It's marvellous: we're jolly lucky.

How do you feel about being placed so often in the context 'women's painting'?

I'm pleased: that's what I want to be. My pictures have got women in them and they are about us and that's what I am. There's a lot to say that's never been said, and the subject matter is important. If you have the colours, and everything is aesthetically acceptable, people will look, and when they look they see perhaps something they wouldn't have looked at otherwise, like a girl aborting.

They're not political tracts, so sometimes what comes out is the opposite of what I intend. What seems to be mostly going on is bullying, who's pushing around whom, that sort of thing. And therefore that's where the women come in, because women are usually pushed around, or were, and lots of them are taking their revenge. Whose side I am on sometimes I'm not quite sure, but I guess the main thing is power play.

Have you ever been affected by the power games that go on in the art world?

In the art world, one minute someone's very famous and they're fantastic, and then in a few years they're nowhere. I've seen this happen so often. How come nobody's ever heard of Mike Andrews? He's had a show at the Whitechapel, he was highly thought of, so how come nobody's heard of him? The art world has a very short memory. So it's best not to concern yourself too much with it, really.

How do you tend to describe yourself?

Painter. We never used to say 'artist' because it was so awful. You put something more practical down. Another term I hate is 'creative'; that's as bad as 'artistic sensibility' – creative bullshit. You make things. People ask: 'What do you do?' I say: 'I paint people.' 'What do you mean? Portraits?' 'No, people in stories.' Then their interest vanishes.

Do you always like your pictures to tell stories?

It's nice to have something with a beginning, a middle and an end, isn't it? And a point of focus. They aren't properly narrative in the sense of: 'Oh, I have a story I must tell.' I have an idea and an intention for a story which then tells me. It's a form of discovery. I was doing the story of the lovers Calisto and Melibea, and in the middle of it all somebody sent me a wonderful story by Kafka where a father so humiliates his son that the son commits suicide. Suddenly, I had to put something from this story in the picture. At first it buggers up the whole painting. It's completely ruined. But I insist on making it work. That's the fight that goes on until the picture clarifies itself, and eventually you end up with a hybrid that is a story in itself. Even in the abortion pictures in which I had an agenda to put across, there's an element of grotesque sexuality as well as the suffering, the terrible pain, outrage and the confrontation with the viewer. How could you possibly think of that before you did it? It's in you, and the picture is a way of discovering it.

You seem to draw quite a lot of inspiration from reading.

I read all sorts of things. Poetry is good for unleashing images. That's why nursery rhymes are so good, because you read one and the next morning you wake up with an image in your head. I used to go to the cinema, but I tend to ration myself now. It's priority, isn't it? Because drawing is more important and fun. More fun than anything, actually.

I tell my grandchildren stories at night sometimes when they come to stay with me. I like that. I make the stories up as I go along. Whatever word comes into my mouth, I say it, and it's all a hotchpotch of other stories I've heard and I just carry on in the magic, and they just follow it.

What conditions do you work best in?

With a hangover is good, but I'm not supposed to do that now. I don't do it all the time, but now and again if you have a great big drinking blast and then have this hangover, something happens. But it's not a good thing to make a habit of; it makes you ill. I need space, and I've got a lot of space in here. A door that shuts is important. You've got to have ideas. I don't know where you get those.

Nitin Sawhney

Nitin Sawhney was born in Rochester, Kent, in 1964 and lives in London.
He studied law at Liverpool University. His albums include *Spirit Dance* (1994),
Migration (1995), *Displacing the Priest* (1996) and *Human* (2003), *Beyond Skin*
(1999) was nominated for a Mercury Music Prize and won a South Bank Show
Award. *Prophesy* (2001) won a MOBO award and a Radio 3 World Music Award.
He has written music for films, such as the adaptation of Salman Rushdie's *The
Ground Beneath Her Feet*, and composed in a classical context for the Britten
Sinfonia and the Proms.

Do you find it important to travel to gather ideas for your music?
The last two years I've been abroad so much. Compared with other cities in the world, London is remarkably open, but I still needed to get away from this country for a bit. Most of my life, I've had my identity dictated to me by other people, and I think the only way I was going to break free of that properly was by getting out and experiencing things more first-hand; not buying into this rubbish we're given that the world is becoming closer by global communication networks, which it just isn't. More and more, we're negating the validity of first-hand experience of people from other countries and other cultures. We've started to imagine that these virtual realities we've been given – whether it's on TV, the Internet, mobile phones or whatever – are ample substitutes for first-hand understanding. It's particularly significant when you're in America, where a tiny percentage of people have got passports. The world system we live in so values second-hand information.

My next album will be about how we have become increasingly desensitized to reality; tracing that process through one individual life, from birth, and putting that in a chronologically abstract way into an album. I always start with the idea first – what it's about, and what I want to say. Then I kind of let experiences take over, and the music comes out of that. I'm lucky in one way – that I've trained in lots of different forms of music – but the downside of that is that you can just end up being completely without any anchor at all, doing lots of different things that don't have any significance or meaning. It's important for me to ground myself with an abstract narrative or something thematic that I can hang my ideas around.

Do you ever find the process of composition difficult?
The ideas are the hardest part. Once the ideas are there, everything flows from that. I don't feel there's ever any difficulty in writing music. I always manage somehow to pull together something that I'm happy with, even with commissions, because, to be honest, it's my language, the language I speak. I've spent a lot more time playing music than talking or writing. It feels very natural. It just comes from the emotions, and I'm always feeling something, so it's never that difficult. Because I've had a lot of training, I don't spend a lot of time dwelling on the structures of how the music's built up any more.

Sometimes ideas, for me, are music. There's a track on *Prophesy* that uses a conversation I had with a Chicago cabby – I didn't go out to interview him; it was just a spontaneous reality captured. He was just talking – '...I think there's going to be a backlash against technology...I'm a low-tech man in a high-tech world. The world's changing and I'm not...' – and it was recorded. I had no idea at the time I was going to use it, so I then had to spend a long time tracking him down, find the cab company, and find his name (Jeff Jacobs) so that I could give him a share of the publishing, because they are

Opposite and following pages:
Nitin Sawhney
Photos: Suki Dhanda

his words, after all. It's just as valid as a contrived lyric. It's no good sitting in a room with samplers; you've got to go out and meet people and experience things first-hand. I was in Soweto, and people were warning me about going to a particular village, saying I'd get shot – but when I went and started playing drums with them, people who'd normally view me with suspicion welcomed me as a kindred spirit. Music is such a good way of traversing barriers. It's important, though, that you always treat people with respect, and if you're recording, you ask permission and pay them the same rate you'd pay musicians in any other country.

Do you feel a responsibility to explore political issues in your work?
The only responsibility I feel is to express what I believe in. Music is the manipulation of emotion through sound: that's how I look at it. An album, for me, is an entry in a diary for that year – or a series of entries brought together and compiled. When I release an album, it's like sharing a diary. I've been very lucky that I've won lots of awards, but I still find it a very bizarre process when people actually apply objective judgement to what is intrinsically subjective expression. It doesn't make any sense to me. You wouldn't share your diary with someone and have them suddenly wheel out a hundred other diaries, and say: 'Oh, yes, it's a good diary, but I've got this other diary which is actually a lot more emotional and a lot better.'

A lot of people tell me I'm quite political, yet all I've ever tried to do is look at one rule – that each person is equally as valid as the next person, regardless of where they come from and who they are. It's amazing – isn't it? – the world is so out of balance, that to have that view is considered radical or politically charged. I was talking to people recently about Bush and the Kyoto Treaty and was immediately politicized and put into a bracket. If we had a more balanced society, it wouldn't be considered 'political' to express a common-sense perspective about something like global warming. I consider it a sad reflection on society that to talk of equality is so stigmatized.

You've expressed frustration at your records being categorized as 'world music'.
As an Asian living in this country, you can't express yourself as an artist without being placed in a box. I've sold loads of records and had tons of Radio 1 play, but they see my name and shove me in the 'world music' category. I feel like I'm a citizen of the world, but 'world music' has nothing to do with that. 'World music' is apartheid in record shops, and the way it's promoted is very much to do with marginalizing people on the basis of their nationality. I think 'nationality' is a trick. What is it, exactly? Is it the country you're born in? No, because loads of people are born in different countries from the one they consider themselves to be a national of. Is it the culture? Well, I can have as much in common with someone from Turkey, Israel, Afghanistan, India, America or Japan as I can with my next-door neighbour,

so it's certainly not that. There isn't anything I could say it is, apart from a really good device that gets wheeled out every time some political regime wants someone to kill someone else for their stupid screwed-up ideology.

Music is a universal language. Don't approach it from the angle of thinking there are intrinsically separate forms of music – you can hear the same emotion in a Spanish guitar as in an Indian sitar. I incorporate music that may come from different cultures but is part of the same emotional world. I try not to perceive it as 'mixing' anything. Everything merges together and connects up very easily once you focus on the emotion.

As a child, what did learning to play music mean to you?

I grew up in Kent, where I was the only Asian at my school, and there was a lot of racism and violence there. As a child, learning to play music meant freedom and escape. It meant being able to find a voice that didn't have shame attached to it. The other kids all took their reference points from TV programmes like *Love Thy Neighbour* and *It Ain't Half Hot, Mum*, or Enoch Powell and the National Front. I wanted to be like everyone else and fit in, but if you tried to talk to them about flamenco guitar, or Miles Davis, they'd look at you like you were an alien. Music was the one place I could be myself.

Did music seem a viable career?

I went and studied law because it's what Asian kids did in this country to keep their parents from feeling incredible shame. There was no precedent for a musician – an Asian musician – to do the things I do, so it didn't occur to me that I'd be able to make a living at it. (My parents are quite at ease with what I'm doing now.) I've fallen into things because I just tend to follow my nose. I started playing with James Taylor, who was a mate of mine from school, and found myself in the Acid Jazz movement. I formed my own band, the Jazztones, started a band with Talvin Singh, and did session work on albums with people like Ali Farka Toure and Oumou Sangare. I was Musical Director at the Theatre Royal Stratford East for a while, because I liked the idea of not being restricted by just working with other musicians, but applying music to other art forms.

Were you ever in danger of abandoning music for a career in comedy?

The comedy career began with me and Sanjeev Bhaskar doing a two-man show, which became the *Secret Asians*. It was really successful, which I didn't expect. I loved doing it. Comedy just allowed me to be subversive and spontaneous without any self-consciousness. The BBC came down and said: 'Do you want your own comedy show?' So Meera Syal, Nina Wadia and Kul Vinder came on board and we did *Goodness Gracious Me* on the radio for two or three years. It was going out to massive audiences and won a Sony Award (I won an award as a writer and comedian), and by the time we did the TV pilot it was obvious it was going to be huge, but it felt to me like it

wasn't right. I'm a musician at the end of the day, and I didn't look to get famous as a comedian. Three days before filming, I rang Sanj and said I couldn't do it. Pulling out was a bloody annoying thing to do to the other people, and a bit selfish in some ways, but I'm incredibly happy I did. You have yourself and your instinct – there isn't anything else at the end of the day. Your instinct throws up alarm bells at the most useful times. I think your subconscious protects you. It's all about listening to it.

Live performance is still very important to me. I always say to people that an album is like a film, in that you can play with all sorts of special effects, and live performance is like theatre. You don't try to reproduce all those same special effects on the stage. Quite often it can make more impact to be minimalistic about things, so when I'm touring I don't think of it as performing an album, or trying to repeat something; I think of it as trying to create a theatrical experience. It's much more about enjoying the spontaneity of performance, and that's what makes it challenging and interesting for me each time. Touring does do my head in. The musicians I work with are very nice people, but it can be very tiring when you've got to look after fifteen of them on the road on a coach. The gigs have my name on them, so I'll get the blame if things turn out badly, and everyone else gets the credit if they're great.

You've had a very successful year. Do you ever have to pinch yourself?
I've got a passion for what I'm doing and I feel privileged all the time. If I don't sleep or eat much sometimes, I don't mind, because it's the things that dreams are made of, what I do. To be playing at the Albert Hall, and Paul McCartney has come backstage, Martin Scorsese has come to watch the gig, Radiohead are there, Jeff Beck and Courtney Pine are on stage with me...I can't stop being amazed. I met Nelson Mandela this year – you can't help but feel there's a charmed existence going on.

After years of sleeping on friends' floors and sharing flats, I've just bought a house, and I still haven't come to terms with it. I'm not sure I like the idea of a stable base. I like moving around. I remember a Hindu philosopher who said: 'Always keep yourself light in this world. Don't have too many attachments. Keep your motivations simple. That's the way you stay open and retain your ability to take in the world without prejudice.'

I like solitude, so that's something I look for. Solitude gives you the ideas and the motivation to make you want to collaborate. It comes through sitting down and thinking, feeling and recognizing who you are. We live in a context, but we're also individuals. We need to explore both.

Scanner

Scanner, sound artist Robin Rimbaud, was born in London in 1964 and lives in a non-place of airports and hotels. He studied Modern Arts at Kingston University. His work trawls the hidden noise of the modern metropolis, and his early albums, *Spore* (1995) and *Delivery* (1997), feature soundscapes woven from scanned mobile phone conversations. He has created works in spaces such as SFMOMA, USA, Hayward Gallery, London, and the Pompidou Centre, Paris. A permanent piece, 'Sound Curtains', is at the Science Museum, London. He has composed for dance and soundtracked works by Cocteau, Plath and Shakespeare for BBC Radio, where he was Year of the Artist artist-in-residence on the *Front Row* programme in 2001. He won the Imaginaria 1999 award for digital art for his show *Sound Polaroids* at the ICA in London.

How did your interest in recording sound develop?

I was always somebody who played around with sound. (I think 'play' is a key word – it's really important to keep that entertaining, fun element.) When I was eleven years old, they played us John Cage's 'Prepared Piano' pieces at school – you take a piano and you drop nuts and bolts and screws and rubber bands inside and it changes the whole language of the instrument. I had no idea who John Cage was – I was listening to Abba and Gary Glitter – but I remember going home, having heard this very bizarre music, and me and my brother bashing and hammering our cheap upright piano, and recording the sound. The tape recorder was an important element here – I was beginning to be aware you could keep things, you could take photographs and store images, you could store memories by writing things down, and you could suddenly store sounds. My world changed again when I was about fifteen and I was given an old-fashioned reel-to-reel recorder. Now I didn't have to record just one thing at a time, but I could juxtapose three or four things and keep layering it up. Jumping through to what I'm doing today, what I can do on a computer with digital technology is take almost infinite layers of sound and play them against one another.

My dad was a journalist, and I originally wanted to be a writer, or when I was very young a soldier or a magician. I still am really interested in magic tricks, and I think the whole thing about working with art and sound and music is a type of magic still: you're kind of conjuring. There's a sleight of hand when you make performances, a displacement of reality and an altering of consciousness. I enjoy processes. For example, now that I know how software works, I can take a very simple sound like the clicking of a finger and transform it into something completely otherworldly. It's quite like the way a magician can put a coin in somebody's hand and make it evaporate.

My father died when I was sixteen and it threw me completely. I didn't have a clue what I wanted to do with my life. I remember filling out the careers form at school with something pretentious like 'I wish to escape the accretions of contemporary work'. And my teacher said: 'No, Robin. You have to write down a job'. So I applied to the London College of Printing to do a course in journalism, but I failed to get in. I really screwed up because I didn't have any backup and all the places at university had gone, so I just took a year off and read and read and read.

I studied a modern arts degree at university, which is basically a history of literature with an arts leaning. I was reading a ridiculous amount of books but also working with sound and going to visual arts exhibitions. (I still go to far more exhibitions than concerts, and buy more books than CDs.) I really loved the incredible dense language of T.S. Eliot and Ezra Pound, stripping the lines apart and seeing how it worked. I always enjoy things that need a lot of study and preparation (the magic tricks were the same). I was listening

to people like Brian Eno and Robert Fripp and these mid-1970s experimental artists, and then a very exciting movement started happening in Europe, of cassette exchanges, which I became part of. It's what the Internet is today, but this was twenty to twenty-five years ago, where people would exchange ideas through cassettes.

What was your first job?
I worked for about seven years in a library, and I realize that job was a really important part of my life. Dealing with the public every day taught me the patience of a saint, and I learned so much about music because I had access to a whole world of sound and worked my way through jazz A–Z, country and western A–Z, every genre. More than anything, it taught me how lucky I am now to do what I do. I know so many people who work in the arts who've got parents who are writers or curators or successful people in that kind of field. Ours was a very ordinary family – my mum worked in a kitchen and cleaned people's houses – not very grand at all. Those years made me understand what the grit of life really feels like.

I meet so many unemployed artists who spend their lives complaining: 'I don't understand why I can't get funded for my project...' I'm being a bit tough here, but that idea that you're a born artist and have to have your studio and make work – as if you deserve things to come to you just because you've finished college and now you're 'an artist'...In that respect I'm glad I didn't go to art school. Students are always asking how I make a living, and where I get my funding from, and the fact is I pay for it myself most of the time. I'm sometimes involved with projects that get funding, which is great, but I do come from a self-sufficient background, which means you support yourself. If I need a computer, I save up – I don't go out clubbing every night spending all my money on drugs and alcohol. What I do isn't pop music, but I can make a fine living at it. I don't need to be rich. Nothing happens unless you work at it.

Professionally, how would you tend to describe yourself?
On my computer I have lots of twenty-five-word biogs, and they're always changing. I'm always playing around with it. I tend to use whatever I was described as in my last interview: for example, 'data terrorist' or 'minimalist anti-hero'. I enjoy using other people's take on it because, frankly, I have no idea what to say. It used to be called 'mixed media', but that's such a 1970s phrase. People use 'cross-media' quite a lot. 'I do really odd, quirky things': that's what I often say.

Twelve years ago, in my first reviews as Scanner, the *New Musical Express* called me 'a performance artist'. I suppose that was the only language they had to describe it because they weren't ordinary gigs. I used the scanner device to pull in these indiscriminate signals of people's voices and mixed them into abstract soundscapes. I'd never called myself anything at that

point: I'd been making work for many years, but nobody had ever heard it. One of my favourite phrases comes from an Eastern European interviewer, who called me in rather dodgy English: 'Scanner, the man who sucks off the whole of London'.

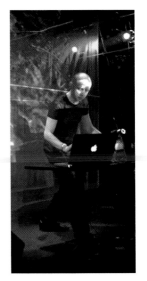

The damaging thing about labels is that if I release a record, what on earth does a record store file it under? I usually get put under 'dance techno', even though some of the records are completely abstract and gentle. I've even been put under 'spoken word' because some of my records use a lot of scanned voices and conversations. I've been put under 'ambient' and 'new age'. When I travel on an aeroplane and the person sitting next to me says, 'What do you do?', I genuinely don't know how to respond. You make the mistake of saying you're an artist, and they say: 'What do you paint?' You say you're a musician, and they say: 'What do you play?' I'm someone in between. So I generally say I'm a hairdresser because people generally don't ask you any more questions.

When did 'Scanner' emerge as a name?
I had bands, and bands need names, and I took the name Scanner because that was the device I was using. I liked it because it was abstract, the letters looked good together, and it didn't tell you too much, it didn't say 'digital arts cyberspace', it didn't say 'avant-garde', it didn't say 'pop music', it was fairly anonymous in its way. Lots of people don't know my real name, and I still find it curious when they go, 'Hey, Scanner' – though I quite enjoy the absurd perversity of being called a machine.

On another level, it's an interesting displacement of your personality. I realize I quite often talk about myself in the third person through the use of this persona, talking about the stuff 'Scanner' does as if it's somebody else. Electronic media is revolutionary in its way because we can all become anyone we like – on the Internet whole worlds exist where people are living under another identity in MUDs [Multi-User Domains] and MOOs or with chat-room names. Half the people I deal with I know only by their e-mail address or their telephone voice, and I never know what they're physically like.

I like names that don't come loaded. There are two different women's names I use when I write for magazines and newspapers: that way I can write enthusiastically about things people have no idea I'm into. I've also released records with photographs on the cover which aren't me, they're just photo booth photographs I found in the street. I've had lookalikes play my concerts. In fact, I did sixteen concerts for a promotional tour where I wasn't physically there – it's quite a playful, ironic look at electronic music.

I did a lot of pirate radio when I was fifteen or sixteen, and the very first

Scanner performance I ever did was a benefit for an anarchist magazine called *Underground*. A lot of the work I was doing around that time was collaborating with hackers, so I do have that kind of history. I have a fascination with the kind of alternative culture which Americans might call 'apocalypse culture'. I still collaborate with characters in those almost invisible networks. I'm always happiest when I get these strange e-mails from people saying, 'Could you help me with the soundtrack for an independent film I'm making about the history of phone freaking?' or something, and I just do it, e-mailing it over to them as MP3 at a really speedy pace.

Does using the name 'Scanner' help you to separate your private and public identity?
I know people who perform in public often try to keep back personal aspects of themselves and keep a clear stage persona. I've tried never to play those roles. All my personas are the same me. I often bring personal things into articles I write, and a year ago I did a one-off performance called 'Diary' where I read from the diary I kept from the age of twelve.

I live in a quiet minimalist apartment and do most of my recording here at home. It's very strange sitting here on my own working on a laptop, thinking that in three months' time 3,000 people will be hearing what I'm doing. It's a very interesting shift in perspective. It was exciting looking at that book on Francis Bacon published recently and seeing the photographs of his studio. Here was a man who was a multimillionaire, living in the most desolate little apartment down in Kensington, just an awful little place. You realize that for a lot of people the value of the space around them is much less than the work they're creating.

Some people expect me to be a quiet little hermit, but I'm very interested in making work that's designed for a public sphere. I could just sit here releasing CDs and no one would ever see me, but I need a direct relationship between the work I'm making and a physical response from people. In London you can get paid pretty well for projects; you go to Warsaw, or Zagreb or Ljubljana and get paid next to nothing, but it's not about that at the end of the day – audiences in places like that give you back a huge personal reward. I've never actually perceived myself as a recording artist. I've only ever seen CDs as temporary broadcasts, not a major statement. They say Mr Scanner's still alive, he's still out there, this is what he's doing. They're almost like sending out postcards.

You always seem to be travelling.
Out of every month I'm generally only home around five days. I'm a small independent unit who's constantly travelling, so my office is basically a mobile phone, a laptop, digital camera, palm pilot, and a cable that attaches me to the wall.

The last seven years have been non-stop, without a break, running down the hallways of every hotel and airport on the globe. In the space of six weeks

I'm at the Adelaide Festival, coming back to England, then flying out for projects in Brisbane and Japan. That's physically very draining, but I accept it as part of what I do. I often wake up and don't know where I am. I feel like the only person who ever reads *Wallpaper* magazine and goes: 'Oh, there's this great new record shop in Tokyo. I should go and check that out.'

I have never enjoyed the physical travelling. I can make a performance in front of 10,000 people and not get nervous, but I get very nervous about catching a train that will get me to Heathrow Airport so that I catch my plane on time. John Cage has been a huge inspiration to me, not only for the creative work but also the way of living – he always grasped at the chance of making work during the dead time of travelling. I'm in transit so often I spend much of my time in 'non-places', but with a laptop I can at least work while I'm travelling.

What are the best and worst sides of your life as an artist?
There are points when I'm sitting in another anonymous hotel, or I'm left standing at a station in Belgium, waiting for someone to come and pick me up, not knowing where to go and not having the phone number of anyone who can help me, when I think, Why am I doing this? But generally something worthwhile comes out of it – a performance, an installation, or a friendship even. The worst thing about being away so much is the stress of getting home and having to catch up with mail, e-mail and phone calls.

Everyone always seems to think the only thing you're doing is their project, when there are actually all sorts of others on the go. Batteries of deadlines arrive, and I sometimes don't know how I'm going to attend to them all at the same time, but I always do – I'm very committed like that. It's very important to sustain a professional approach to one's work. I live a remarkably healthy lifestyle – no tea, coffee, alcohol, anything – so I have a very fresh body at least; it sustains itself well. I'm not a rock 'n' roller, so I don't do gigs and then go and get drunk and hang out with the groupies. I do a show and go to bed early if I can.

Being this committed to my work is a consistent problem with relationships with family or friends (though a large percentage of them are working at a similar manic pace), but friends are absolutely essential to my life and wellbeing, and if someone rings up and says they need me to transfer a mini-disk on to a CD, I will bend over backwards to do it, even if I'm under a ridiculous deadline.

I realize I collaborate a ridiculous amount. It extends the practice of what I do, allows access to a wider alternative audience, and also shifts people's perception of what it is I do. I contributed to a Derek Jarman soundtrack when I was still at college; I bumped into him purely by chance at the ICA, and we became friends for quite some time. The most bizarre situation was working with Laurie Anderson – someone whose records I bought when I

Scanner, **Surface Noise**

was fifteen. I always like to start absurd, so I suggested we work with a hundred violinists and then add a tap-dancer – so we did. It's really invigorating to work with someone so open-minded. I work with dance a lot because my work has a sense of space, which is very adaptable for movement. I've worked with architects and graphic artists too: it's a matter of finding people with a shared approach. I did a record with Bryan Ferry, and I asked him why he wanted to work with me. He said: 'I want you to mess the record up a bit. You're the risk factor. You don't know what you'll be getting.' I've got a speedy brain, and I like to improvise. With collaborations you never follow the same palette.

I really cannot bear the whole ego thing with artists, though, and I will not work with people who act in bizarre egotistical ways. The worst experiences of my career have been with contemporary art galleries – the people running them can be obnoxiously difficult to deal with. There's an ignorance about what you're doing that can be quite distressing. You perform in a gallery, and they come in every ten minutes to ask you to turn it down, because there's this attitude that the 'real artists' are hanging in the gallery, or showing video pieces, and I'm some kind of 'entertainer'. It's a strange division I'm not comfortable with. If I'm invited in, it should be on an equal basis.

I love the opportunity of making work very fast, which was why it was so inspiring doing the Year of the Artist residency at Radio 4, making odd four-minute exploratory radio pieces which went out just before *The Archers.* I'd make them in the day, using some tenuous connection to current art events, like a theatre play about ventriloquism or an exhibition about jet lag. I could get away with murder.

I make no great claims about what I've done. I have great doubts about some of the things I've done, and I don't think I've ever made anything that's really amazing, but I feel like I'm still trying. I've been working on a project in a hospital in Paris – it's the place where you go to identify the body of someone who's just died – and I've been invited to make a soundtrack for it, a twenty-minute piece which gets played about four to five times a day whenever someone dies and their loved ones come to see them for the last time. It's a beautiful space, full of light, optimistic and very calm. The responsibility is phenomenal. I've never had an invitation so difficult, yet one that could have such a positive effect on people as well.

I like to be a catalyst, which is why I've run clubs and put on events. I want to make things happen. Basically, I realize I'm an agitator. I agitate situations and I agitate sound.

Iain Sinclair

Iain Sinclair was born in Cardiff in 1943. He studied at the London School of Film Technique, Trinity College, Dublin, and the Courtauld Institute. In the 1970s he ran the Albion Village Press. In writing and in film he frequently explores the psychogeography of his adopted city, London. His poetry collections include *Lud Heat* (1975) and *Suicide Bridge* (1979). He is editor of the anthology *Conductors of Chaos* (1996). His novels include *White Chappell, Scarlet Tracings* (1987), *Downriver* (1991) and *Landor's Tower* (2002). His essays include *Lights Out for the Territory* (1997). His documentary films include *Ah, Sunflower!* (a film about Allen Ginsberg, 1967) and, with Chris Petit, *The Cardinal and the Corpse* (1992), *The Falconer* (1997) and *Asylum* (2000). He made a book (2002) and a film (2003) about the M25 motorway - *London Orbital*.

Is there such a thing as having a career as an artist?

There is. Life and career are the same thing. Every life has to have a plot and a plan. You have to recognize this early and be quite cold-blooded in the discovery and articulation of that plot. You can't simply cut yourself off, produce some weird and contorted form of your own – and expect a mainstream publisher to place it in the system. That's never going to happen. You'd better make it your business to understand the market. The ability to charm or play the game is useful.

Did you make a specific career choice to be a writer?

I didn't set out to be a professional writer. But fairly early on I came to believe that writing would be a foreground activity. At first I was just writing for small magazines at a very local level – then pushing out, getting involved in university magazines and the underground publications of the 1960s, and making films. Circumstances were such that I could – just – make enough to survive through labouring jobs and the like. That became the pattern of my early, so-called 'career'.

When I first left school, I wanted to work in film and went to the London School of Film Technique in Brixton. My father and his father had been doctors, and I think my parents hoped this was the kind of career move that I would make. But I was never any good at those sorts of science subjects, and I had no inclination to do that, so they weren't delighted when I went to film school. But they were sensible enough not to oppose it because I probably would have done it somehow anyway.

My father actually had his own sixteen-millimetre Bell & Howell camera and projector, and he was quite a keen amateur film-maker and a very good storyteller (he had incredible stories that he told of life that always had a Gothic element to them and a macabre humour). My mother's family had been a farming family from West Wales and drifted into the industrial valleys, working in mines – and they also had a very vivid tradition of writing poetry and telling stories and myths. It wasn't that artistic activities felt alien to them – what was alien was that you could attempt to make a living by it. They assumed these were the things that people did while they got on with their real lives. My difference was that I thought there is no other real life – this is the real life. I had no choice, really. I felt compelled to do it, and I didn't have any particular skills that would have suggested any other career path.

Supposedly, at that time the British film industry was in one of its buoyant moods, so I thought that I'd learn the practical skills – sound, light, camera, editing – and get into some aspect of feature-film production. But 'New British Cinema' was collapsing rapidly, and I soon realized that I would end up in a rather dull cutting room, working on industrial product for years. It seemed to my advantage to go to university, so I went to Trinity College,

Dublin, for four years, during which time I didn't undertake much academic work, but involved myself with putting on plays, making films, editing magazines, publishing and writing. When I finished at Dublin I moved to London and have been here ever since.

Did you try to support yourself through writing at that stage?
The big breakthrough for me was the decision not to bother tailoring my work to suit someone else, not to bother with rejections. Better to do your own work, do it on your own terms, produce your own circuits and methods of production and distribution, use readings of poetry, make contacts. Very rapidly then you got in touch with other people who were doing the same thing. There was a very lively and active circuit entirely outside mainstream publication.

I started out teaching, but that drew too much on the same energies as the writing, so within a year or so I dropped out. There would have been nothing left to write with – you're using your best ideas all the time – and I've never found a way to teach on secondary energy, and just go through the motions. Also, some of the students attached themselves and turned up here and remained in my life. It was easier to work as a gardener, and to have the freedom to think in any way that I wanted – without having to explain or articulate those thoughts. I took casual jobs, focusing on East London. I worked in a cowboy container-loading operation in Stratford. I worked in the ullage cellars at Trueman's Brewery in Brick Lane. I worked for the Parks Department in Bow and Limehouse. In a sense this was also a secondary education for me in that I was learning about this part of London, and about lives (and economic patterns), which I would never otherwise have had access to. In the gaps between these jobs I would generally write and self-publish, because I ran my own small press, Albion Village Press, publishing my own books and those of people I admired. It was all cheap enough to do, with editions of between a hundred and five hundred copies.

With your writing, when have you most felt 'I'm really getting somewhere with this'?
I would say the first breakthrough was a book called *Lud Heat*, which was about the third or fourth one I'd published myself. That was where I found a form I'm happy with – where investigations in prose, and elements of poetry, joined together with photographs. Also, London was revealed as a subject, and the realization that things like patterns in Hawksmoor churches can give you a kind of energy-print of the landscape was a really important stage for me. The second was writing my first novel, *White Chappell, Scarlet Tracings*. I'd always used substantial chunks of prose within the books of poetry, but doing my first book of prose, and finding that it wrote itself, was very exciting. The material had been there so long that all I had to do was turn up at the desk and the story dictated itself. The next stage was my novel *Downriver*, which was on a much bigger scale and included

documentary investigation, where I was going out into various parts of London and behaving like a detective, searching stuff out and converting it back into fiction. That relation between document and fiction was important. I don't think anything subsequent to that has been a breakthrough of any sort. I've basically carried on and refined what I discovered in those three books.

In the last five years or so, there's been a subtle shift in your relationship with the mainstream.
That certainly happened on the back of *Lights Out for the Territory* (which appeared to be a book of walks and explorations about London, but in actuality started out as a series of essays and bits and pieces that had appeared over a number of years which I just reworked and put together into a more direct form). Having a book which says 'here we are in the city and we're going to be seeing this and this' was much easier for people to deal with, and for the first time, I guess, I achieved a degree of visibility. People were asking then for me to do radio programmes or whatever, and since then I've been drawn much more into doing apparently non-fiction books rather than novels or poetry.

Has that increased visibility in a wider world brought other interesting work your way or significantly altered how you spend your time?
Before that point, nobody bothered me. Whatever I was working on, I worked on and nobody cared at all. My time was my own: all I had to do was survive. My time is now divided into the morning, in which I write; and the afternoons are just a stream of endless radio programmes, discussions, interviews, talks or whatever grows out of this work. And that's just as well, because I don't think I could make a living from writing the books on their own; it needs this secondary activity, which to some extent explains and promotes what has been attempted in other forms. That double life means it's just about possible to carry on. I think that things have changed (it's particularly difficult writing novels at the moment), so if I was starting up now I doubt if I would even get published.

Before the *Lights Out* moment, were there times you might have given up?
I was already in my forties before I published *White Chappell*, my first novel, and until the 1990s I was still functioning as a book dealer and writing at the same time. So I guess if *Lights Out for the Territory* hadn't succeeded when it did, in terms of selling quite well, getting attention, and moving things forward, I think at that time I might well have had to go back into book dealing and just tried to find small gaps to write what would have become, I think, increasingly invisible fiction.

I think the mix of doing non-fiction and fiction is a way of sustaining the whole thing and keeping it fresh. It keeps the public interested (inasmuch as

there is a real public for this). I spoke to Peter Ackroyd about this, and he was also saying that his novels, which he quite enjoyed doing, were a diminishing factor, and it was the big non-fiction books which revive the whole thing, get a big readership and allow him to do the fiction.

Do you actually enjoy the writing process?
I do enjoy the writing process, but I find more and more now that there's not enough time for it. Because of various factors in publishing, they want the book quite a long time ahead so they can get out proofs and put the artefact on the conveyor belt. Now I do feel myself to be under the cosh every morning, and I've got to put in a certain number of hours every day, like it or not. I still enjoy the process, but it's lost a bit of its spark. But the process of researching and investigating is great – I never lose any interest in that. Recently, I've been writing *Landor's Tower* (a novel set in Wales) and while I was writing that I was constantly taking days off to go out on to the M25 to walk about in that landscape. Somehow, that one day out there walking and taking in fresh material gave me the energy to come back and carry on with a complex novel set in an entirely different topography. I'm always researching one or two projects ahead.

So for you crisscrossing between projects is energizing?
I'm Gemini, a sort of split, schizophrenic consciousness, so I like working on two things at the same time, and I like, from time to time, working in film again.

I'd stopped doing underground films in the mid-1970s. Then there was a long gap when most of my life was spent book dealing and just making a living, keeping the family together. In the early 1990s I started to do things with the *Late Show* (on BBC2), which existed as a brief period when people could make interesting short films about obscure things, and then I began working with Chris Petit on a film called *The Cardinal and the Corpse*. With tiny Sony DV cameras now, it feels like the freedom I had when I started out with Super-8. Chris and I have come up with the film essay as a form – we tend to gather material for about a year, as if gathering material for a book, then the editing process is intense for about two or three months, which is like writing the actual book. This way of working was never feasible before with film.

Haven't opportunities for interesting film–making all but dried up on TV?
I think if making films was all I was doing, I would be in despair. But for me it's a kind of holiday from the writing, and I end up with miles of images that are very provocative in terms of memory for the writing. Documentary-making on TV is on its last legs. It's horrific because there's nowhere to go. With current technology there's no reason you can't make films very cheaply – the problem is how do you show them? There are lots of film-makers busily at work, but especially now the Lux cinema has gone, there

just aren't any public venues. People are going to have to start renting halls, getting audiences in and building it up again. Really, film is very hard. A few people beat the system, but they're generally people with extraordinary willpower – con men and spielers – and it's their dynamic energy and determination to make it that has been the overriding factor rather than any particular kind of genius or talent.

Is London a hospitable place for writers?

The only sensible economic decision I've ever made in my life was buying this house. When I arrived in London from Dublin I shifted around a lot, with bedsits here, there and everywhere, and ended up in Hackney. I found this house, which was condemned and about to be pulled down, and I bought it for about £2,000. I'd just made this Allen Ginsberg documentary for West German TV and had just enough money. From that point on I actually had a base, and I've never moved, I've never gone anywhere. There have been times when I felt it would be good to move, but also it's good to stay because the longer you're in a place the richer it gets, and after thirty to forty years there's quite a lot of history there, quite a lot of life.

There was an original group of artists who were here in the late 1960s to the mid-1970s, who moved at the point they had children. Again, in the 1980s another whole lot went because they couldn't afford to be in London any more. And it's happened again in the last couple of years as well. People like Stewart Home, who has always been in London and writing about London, has just moved to Aberdeenshire, because economically it's impossible to survive in this city doing that kind of hand-to-mouth freelance writing. And actually buying somewhere to live is now just impossible. From now on it's going to be much harder. You couldn't do what I did.

The general picture is of cycles of energy and dispersal. People shift for social and economic reasons, but when they've shifted, are they able to carry on? Because the energy, the media energy centre is obviously London. (If they've gone to Oxford, Cambridge or Brighton, to all intents and purposes they're still in London; it doesn't really change the picture.) If they've gone to the Scottish Highlands or Wales, everything changes. They're thrown on to their own heart, and there's possibly some local recognition or availability of outlet, but quite frankly as far as the London media's concerned they will struggle unless they're already very well established. This doesn't mean they're not there, but as far as the centre is concerned they've disappeared. I've known some people who in this disappearance have become extremely bitter, drunk, mad, killed themselves. And I've known some people who've carried on quite contentedly following their own vision just outside the public eye. Who's to say that they're wrong?

Some of these people I'm talking about have success on their own terms. They've always had an interested audience within a group of their peers, where their work has been taken seriously and discussed and debated. They haven't necessarily got any public recognition, but they didn't even necessarily want that – peer recognition was quite enough. But then there are cases like Barry McSweeney, who died quite recently, who started out as a very young poet getting public recognition. He was put up for the Oxford Poetry Chair, he was in the papers and he was on the wave of that 1960s thing, and he actually wanted to be a public poet. His poems were to do with drama and glamorous things, and he made great play with the rock star persona. So for him, when all that changed, his publisher pulled the plug, and he was denied his public access: that was really bitterly painful, and I think pushed him into serious drinking and serious bitterness and despair. Yet there are other people who wouldn't have been bothered by it, because they had enough ego and confidence in what they were doing and didn't require public acknowledgement of what they'd achieved.

You see every generation coming to the city with ambition, and doing things in a slightly different way, but there always seems to come a point when they are forced either to give up this kind of work or to move out and carry on somewhere else. Some obviously didn't carry on; they took up other ways of life and stopped. And just a demented crew remained who would keep remorselessly on doing what they were doing. But clearly you can never stand still; you have to adjust. There were numerous points where I would have run into a dead end if I hadn't succeeded in working some transformation (doing the first novel, or *Lights Out for the Territory*, for example). You've got to be aware of continual renewal or challenge and either choose to do it on your own terms or keep pushing and working harder and harder to maintain an audience at the centre.

How do you think you've managed to find a position at the margins and at the centre?

I think it was just the luck of deciding early on that the system didn't depend on someone else's approval. After working for quite a number of years right outside the system, if things went really badly for me and nobody wanted to publish my books any more it wouldn't damage me in an irreparable way, because I've had experience of the other. I could drop back into some other way of making a living and produce different kind of work on my own terms. The problem would be if the form you're going to follow is a 500-page novel. You can't self-publish 500-page novels. That needs mainstream publishers, and if they say no, where do you go? The form of what you do has always got to be realistic. I've always had that.

Publishers seem to be interested in younger and younger writers. Is there still space for the writer who gradually accrues experience and then in the fullness of time distils it?

I could never have anything to do with creative writing schools, these forcing-houses that manufacture a product. That is anathema to me, a very American idea. And equally the idea that you manufacture product from using high-profile media people, assuming that if they can write a funny column they can write a novel; or to publish somebody only because they're young enough to photograph and can be puffed. But it's a very disposable thing; you're probably going to get one or two books out of them and that's it, it's gone. The gradual accruing of experience (and the distillation of it) is the only way that works. People who want instant careers have to start very young and recognize that it's a lottery.

The fact that I was forty before I got to write even remotely full-time was actually a big advantage rather than a disadvantage. In the past, what got in the way was not having the money to be able to spend my time doing the things I'd projected I'd like to do. One has to survive in the real world, and unless you've got some private income you can't spend your time producing material that large groups of people don't want to engage with. But I'm very happy I had to get various jobs, because the material that came out of them was invaluable: I couldn't have written in a bell jar without touching this other world.

In more recent times it is a small measure of success that has got in the way, because as you become known then the demands on you are such that you get less and less time to do the things you want to do. But if there are no demands, then that means nobody wants to read what you're doing anyway, so you're stuck. I'm reasonably happy with the way the balance is. In a perfect world I'd rather just concentrate on producing the books; but I appreciate the fact that publishers want to push you out, to go on the stump and do readings. But that all uses up days and days of time, and at the same time they want the book delivered on time. It's quite stern discipline. It's just a freak of fate that I'm paid to write, not paying to print my own books – but I'd be doing it anyway: it's my life.

Errollyn Wallen

Errollyn Wallen was born in Belize and came to London at the age of two. She studied music at Goldsmiths' College and King's College, London, and King's College, Cambridge. She has composed music for concert halls, opera, dance, theatre and television, combining classical forms with influences from contemporary culture. Her many commissioned works include pieces for English National Opera, the Brodsky Quartet, Royal Ballet, BBC, Royal Opera House and Huddersfield Contemporary Music Festival. The Errollyn Wallen Company presented its first work, *Jordan Town*, at the Edinburgh Festival (2001). *The Girl in My Alphabet* (2002) is the first major CD devoted to her music.

How would you describe what you do?

I'm a composer. That's it. That's me. I make things up, and in terms of making sense of life I can do that best through sound. Personally, I can be unsure of myself, but music's one of those things I'm absolutely sure of. It's not that I'm being big-headed; it's just that I'm so excited and passionate about music. I know how it works.

You thought about becoming a dancer, though?

When I was a child I loved words and I loved music, but the very first thing was dancing. I wanted to be a dancer more than anything (I didn't mind if it meant being at the back row right at the back of the stage), and it was probably the music that was propelling me along. As a composer, the idea of movement is still a big influence. The piece still has to exist on its own terms in sounds alone, but there's often a strong visual key for me. I've collaborated with choreographers, and that's been good. When I was about twelve I said to my uncle and aunt (who brought me up) that I'd like to be a ballet dancer, and that I felt I needed to go to a specialist school. They said: 'We don't know any black ballet dancers, and we don't want you to be disappointed, so you'd better just forget that idea.' I was gutted. Devastated. That was the first time I realized what it really feels like to know that your life isn't under your own control. After that, I found it impossible even to watch dance, and I turned away from it. Then years later I saw the Dance Theater of Harlem perform at Sadler's Wells and thought, God, I want to study with them. So I went to their school in New York, in the year before university. I was really torn then between dance and music. I was also writing a lot. I tried to keep doing it all, and did a course in music and dance at Goldsmiths', but after a year I realized there wasn't going to be enough time to do all these things. I had to make a decision, and either go into composing or dance wholeheartedly. I remember the extreme difficulty – the pain almost – of trying to think what to do.

What were the main influences in your childhood?

I was born in Belize, but I moved to England and lived with my aunt and uncle in Tottenham. My aunt's family were all cockney, and my uncle had wanted to be an actor and used to give us elocution lessons, making us recite great chunks of poetry – Wordsworth and Dylan Thomas. My parents spoke creole, which is really singsong and fantastic, and my dad can put so much meaning in the inflection of just one word. (I feel a bit miffed we didn't grow up speaking that way.) Since childhood, words have held an endless fascination for me. I see words as music. I write a lot myself – poetry and prose, and lyrics to my songs – and I really like setting poems by other people.

My dad sent me recordings of the lives of the great composers, and I loved those stories – the way these composers seemed to live these heightened lives with event after event, and the music reflecting their daily lives in quite a dramatic way. But I never saw those lives as being connected to mine – not

Opposite and following pages:
Errollyn Wallen
Photos: Cathy Masser

at all. It was always drummed into me that I was going to be a history teacher or something respectable like that.

In our house we were brought up with all different kinds of music. My sisters were listening to reggae, soul, R&B and pop, and my dad loved jazz. I took piano lessons, and I must have been quite good at that. I'd learn pieces very quickly, so I'd keep going back to the library, totally unguided, to find anything else to play. I absorbed a lot of stuff, which has influenced me as a composer, even though I didn't know that was what I was, or was going to be. I was quite a shy girl, but I somehow always had this burning need to express myself.

How did you begin composing?
Well, from childhood I was always making up tunes and songs. Formally, I did a Master's degree in composition but with no clear sense of how I would find a way in music. I was just drawn. We were taught in the tradition of Webern and Schoenberg and Berg, and much outside that was considered quite suspect, but I've always been quite good at pastiche, so I just did my exercises. I love that music for its strange angularity and asymmetry, but I found that the range of emotion it expressed was quite narrow to me – it often sounds as if you're meant to cut your throat to it, and, as a composer, I might not always want to express that myself. I did quite a lot of improvising and making up 'tunes', and that was really looked down upon.

I believe when you're composing you're tapping into something that's already there. Anything can be a trigger. Quite mundane things. I really admired the poet Stevie Smith. I used to think it would be nice to be like her, to stay in one place, maybe in just one room all your life, and see where and how far you could travel from that room. It's amazing how you can produce a lot from nothing. There's a bee or a wasp at home at the moment that keeps buzzing in my ear at four in the morning, and it's getting quite frightening hearing this buzzing. So now I'm thinking of composing a piece that would have this sudden sharp noise, like the way I keep breaking out of sleep and hearing that sound.

I think people who are composers are oversensitive to noise in a way, or maybe were distressed by it as children. Composing is a way of controlling and bringing together elements that might otherwise be almost frightening. I've just returned from a trip to New York, and I made myself travel around on the subway as much as possible. I kept getting lost down there, and it's so damned noisy, almost painfully noisy. Then I realized that there was something happening beneath the din. I was really interested in how this place seemed to be breathing like an animal. The atmosphere captivated me, so I'm writing music, not to mimic the sounds of trains, but to go back there again – to that subterranean atmosphere.

I'm a composer in the classical tradition but obviously influenced by everything around me. Because I'm black, people are always calling me a jazz composer, but I know what's involved in jazz music and I didn't come up that route. I love improvising, but there's something to do with notation, controlling and fixing, really choosing and taking responsibility for each note. It's partly the idea that I don't always want to be there – I can just hand people a piece of paper and they can make that piece their own. There's a magic in that for me. I have a different mind-set from a jazz musician, although I deeply respect that tradition. Another term I don't like being applied to what I do is 'crossover' – I've never sought to cross over anything; I've just sought to bring things together, which is very different.

I think a composer should be able to write for all different sorts of people. Within the limits of your expression, you should be able to turn your hand to different things. Extend yourself. I love contrast in every aspect of life. Everything I do links in with something else. I'm quite clear that what I'm doing is building up a body of work. You just have to write one piece, then the next piece, then the next, and through all these pieces runs a thread. They might seem unrelated on the surface, but there's something going on.

You once passed up the opportunity to work as an organist at Billy Smart's Circus. What jobs did you take on?

A big regret not to run away to the circus! When I first left university, I got a phone call from someone forming a music-theatre group, playing in alternative cabaret venues, and they needed a keyboard player. I started off playing for them and ended up writing the songs too. That was my first real taste of how you could make contemporary music go anywhere. We'd play in pubs, stand-up clubs, the fringe, on the same bill as comedians like Rory Bremner and Julian Clary. They were very interesting and crazy times. I also played keyboards with all sorts of bands, Eternal, Des'ree, Courtney Pine, etc. It was a great window of opportunity to see how bands work, how to get a show together, and also to know what that commercial pressure is; but I couldn't do that for long. I like doing my own thing. I set up a recording studio with somebody, to write music for television, films and videos, and then one day I just absolutely needed to write a string quartet. I've now made my living writing classical music for years, and I'm so proud of that.

The hardest thing about writing for the telly is working out what's in the commissioner's mind. Once I did some music for a documentary, and they said they wanted something 'Keith Jarretty'. So I did something just like that, but the editor said: 'This sounds like lesbian vegetarian music. We didn't mean Keith Jarrett. We meant Wagner'. OK, the guy was a fool, but he demonstrates a point. Wagner and Keith Jarrett mean specific things, but people often describe music with a surprisingly limited vocabulary. Some directors don't always know what they want, but it would be better if they

would at least acknowledge and say that. Writing for TV requires the ability to be very patient and to keep going. What I like about it is the challenge of writing music that has to make an impact in a very short space of time. What I don't like about it is the time-wasting that can occur...In the last few years I've concentrated on my own ideas in writing concert music, operas, symphonies, chamber music and in recording. I would love to get my hands on an interesting film, though.

Do you enjoy working on your own?

Very much so. But, in fact, there's little choice in the matter. Although I love working with other people, my actual creating and deep thinking about a work is a solitary activity. It goes with the territory. But the last piece I did, *Jordan Town*, was a collaboration (with choreographer Tom Sapsford and film-makers the Honey Brothers for my new company) and I felt it was a turning-point for me, to make a work that was shared. (Although each of us was in charge of our different areas.) The collaboration was so easy and natural it felt like being a child again. That's what it should be like. I think that in a lifetime there are only a few people you can work with in that way, where you can trust each other and push each other in different directions.

I've always been almost wilfully not precious about where I work. I don't spend a lot of time thinking about the environment I'm in. The real stuff's in my mind. I really love working in a small cosy space with a beaten-up old piano. It's quite an intense life because once I'm into a piece I can't really think about anything else. I become distracted. I think when you're creating you have to descend to depths. You've just got to go there – to the boredom, the banality, the loneliness and all that. Those moments of really feeling in the flow are fleeting, but there's a thrill in the midst of the hardship in knowing that I'm making the invisible real. And I'm doing what I want. I'm lucky.

What are the practical difficulties of your life as a composer?
The material aspects of music I find very difficult – the objects, the paper, things...Lots of people go into composing because they really like the act of writing and making scores. I just want to get straight to the music and to hear it in a live situation immediately. I can be really impatient, and I've taught myself, 'No, you've got to go through the mechanics of the whole business' – things like ruling the bar-lines, endless proofing, getting all the parts copied and delivered. There's a lot to composing that's a hugely laborious and practical chore.

With my group, Ensemble X, I've just been recording this symphony, *Hunger*, which has been nothing but trouble. It's got a lot of percussion in it, with a thunder sheet and different types of drums. The reality is that someone's then responsible for lugging it all through the streets. I was in tears for nearly two weeks because I loved the sound of one particular thunder sheet, which was a piece of metal nine feet by four, but a removal van to take it up for the recording would have cost hundreds of pounds. I was going mad trying out different thunder sheets all across London, and it got out of hand, to be honest. I had to go to plan B, and combine the sound of a smaller thunder sheet with a fantastic little spring drum – and I'm glad I did, in a way, because that drum makes an unearthly sound which I love, and I'm now writing another piece for it. As a composer, you've always got to have a plan A and a plan B and a plan C, and that's often how you come up with new ideas. I'm writing a piece now for percussion, and what's haunting me isn't really the notes, it's trying to figure out how much time it'll take for the percussionist to get from the tom-tom to the vibraphone. These are the practicalities a composer has got to think about. I feel as if I'm building up this bank of sounds and combinations of sounds – it's an endless pursuit. I start by thinking, I need a sound that will cut through and be high, and give this glistening effect. And then you think, Oh, yes, that'll be a celeste. I want a particular sound, and I'll do anything to get it.

The day-to-day practicalities can eat you up and take over if you're not careful. I don't have a publisher, agent or a secretary, and I have to be those people and I'm not always good at the juggling of identities. But if you're not on top of the business and administration, it's impossible to get your projects off the ground. There's no end to it, really: all these things that need meetings and conversations and decisions. The meeting with the person who wants an opera next year; discussing contracts; sorting out the expenses and working out the pennies per mile for my musicians and then, while you're alive, musicians always want your opinion and ask if you could just come over and hear them play this piece just to check. You could just do all these things – important things – and never write any music. I feel as if I have to claw out precious time for my composing. One does gradually develop the curious skill of switching from thing to thing and quickly changing mind-set from one task to another.

When I get a commission, all I'm usually given is a timeframe (a ten- or twenty-minute piece). I relish the freedom of my life, but it can be hard having this time to fill, whether it's working out what to put in that ten-minute commission or deciding what to do with a day. It can sometimes be a burden, learning to use that time intelligently and creatively. I tried an experiment when I was writing a symphony recently, and I had only six weeks. It seemed impossible, but I set a rule that I had to write twenty (good) bars every single day, then I should be able to do it. It's amazing how that frees you up. I had to ignore the super-critical side, which can hinder you. You can't wait for the most perfect phrase you've ever written; you've just got to get something down. I'm also aware that the tighter a deadline is, the more I'm inclined to be perverse and rebellious – I'll start thinking about another, different project, until it becomes the most fantastic thing which I must start immediately. Finishing a piece can be the hardest part of the process. Whatever the difficulties, however, I just don't feel well unless I'm doing music – and I've tried, I've experimented. In the past I've longed to be 'normal' and to be in an office the same as everybody else; but I crave the freedom of knowing that if I want to do something, I can do it. It's important that I live in such a way that I can maintain a direct response to ideas.

Is it difficult to sustain a career as both a musician and a composer?
Both are necessary to me. Although I'm a composer first and foremost, my composing is informed by my performing. A lot of people say they like me singing and performing my songs at the piano with my band, and I should just do that and forget about the classical music, but that would be like chopping off my limbs. In history, so many wonderful composers have also been performers, and I think it's vital for me to keep at the cutting edge of music-making, the live performance.

My music has to have a performance end or it's dead. As I'm composing a work, the performance aspect is always in my mind, thinking of the space it's going to be played in, or the audience it's for. However shy and retiring you are, if you're writing music just to be consigned to a drawer, you're not following through your responsibilities as a serious composer. Music, I think, begins and ends in the air – it's got to be shared.

Judith Weir

Judith Weir was born in Cambridge of Scottish parents in 1954 and lives in London. She studied composition with John Tavener while at school and with Robin Holloway at Cambridge University. She was awarded a CBE in 1995. From 1995 to 2000 she was Artistic Director of the Spitalfields Festival, London. Her three full-length operas are *A Night at the Chinese Opera*, *The Vanishing Bridegroom* and *Blond Eckbert*, which have all been televised and performed in Britain and the US. She has written orchestral, choral and chamber works, music for theatre, and workshop pieces for amateur companies. Her cantata *We Are Shadows*, which combines Taoist philosophy and Scottish gravestone inscriptions, won the South Bank Show Award 2000. Her fifty-minute song cycle, *woman.life.song*, was commissioned and performed by Jessye Norman in 2000.

How easy is it carving out enough time to think?

By definition, composing music you need an awful lot of peace and quiet. It's also so important to have free time to think which is not tied to a particular project. This year I've managed to do it, through last year doing a lot of teaching at Princeton University in America, and being well paid for it. I think in the whole of my life, I haven't had a six-month period like this, where I don't feel pressed by having to go out and earn. It's been very deliberate. I've discouraged people from giving me engagements, and I've kept the time very free. So above all, I've a great sense at the moment of just truly open space. I'm trying to work on a couple of commissions at the moment, and I've just done about a month's work on a lot of sketches. Last week I was looking at them, thinking I really don't think these are very good. So the luxury for me at the moment of having this time stretching ahead is that I don't feel bad or guilty about saying, OK, I may have spent about a month sketching out that stuff, but I'm going to put it away for now and try something else.

Starting pieces is always so hard and never feels any easier. It's not so much about having limitless time, but not feeling nudged constantly by deadlines and appointments coming up. That's the danger of having too close deadlines in my line of work – thinking I must just carry on because time is short. It could lead you to just accept an avenue that's not quite good enough.

The thing I have to say over and over is the amount of time it takes to do these pieces. They really are so labour-intensive. So there's only a certain number of commissions you can take on at a time, and I take on very few because I hate feeling I've got a great pile of them to do. I often wonder, if I had no deadlines, would anything ever get ended? In music, the deadline is very much to do with the first performance of the piece. It doesn't stop when you finish the score: people then have to copy out the scores for the musicians, and learning has to go on. Those deadlines are very important dates for us composers, because so many people are dependent on you finishing that piece.

Sometimes those very long months do pay off, but I've found also that some of my best little pieces are ones that had to be done suddenly. For example, I've a little piece, *El Rey de Francia* (The King of France) – it's just a treatment of a Sephardic Spanish folk song. I was asked to write something suddenly for someone's birthday concert. I had the folk song in my head, and on the same day I wrote the piece, copied the parts out, and sent it to them. It's a lovely piece they still play to this day, and my feeling was of it being absolutely no effort to do at all.

I don't particularly mind being interrupted by the phone ringing or anything, because if I'm working well it's happening anyway. Students always think they must write down that idea immediately, but I always tell them if it's a good idea it'll be in your head in five minutes' time.

How important a part of your career has teaching been?

I think there's an assumption that composers are all Andrew Lloyd Webber, when really royalties practically don't exist in this field for most of us. So many composers take on this bit of teaching, then this bit of teaching, to support their composing but find then all their time has been filled up.

At various times I've had teaching jobs in colleges and universities, and I've done lots of workshops with schools and amateurs, but I've tried to stay out of full-time jobs, though that is hard to do financially. My father was a psychiatrist and my mother was a teacher, and they are both very enthusiastic amateur musicians, but we didn't know anybody who did freelance stuff, so although I received a lot of encouragement at school, the idea of doing things like this for a living didn't exist. That has stayed with me into adulthood, and perhaps leads you to keep thinking you should get into a 'proper' working situation. I do like teaching, and there have been quite a few occasions when I've been offered more full-time opportunities. As life goes on it gets harder actually when these things come up, and you do think, Ah, well, maybe this is the time, but there's something in the back of my head (up to now at least) telling me not to do that.

What are the things that most nourish your work?

I live fairly modestly, and my luxury is the time I spend on composing. At the end of the day, no one asked me to do this. It was my own idea, and I was well informed that you don't become rich on it. Simply to be doing it after all this time is something I can be thankful for.

Having time free is the basic luxury, but I also get a lot of energy from study. Reading time, listening time, research, having interesting experiences through that, are all important, especially since I've also written a lot of the text material for my theatre pieces. I'm just about to start studying Chinese. Several of my pieces have been based on Chinese literature in the past, and I've always been terribly interested, and said to myself that I shouldn't really do this with an ignorance of how the language is actually spoken; but only this year have I had time to sign on for classes. I'm so looking forward to it. It's not that I'll be a fluent speaker suddenly, or that there'll even be more Chinese pieces, but even if I just scrape the surface I think I'll get a lot of energy out of that.

Are you still interested in writing for the theatre or other collaborative projects?

I'm a big theatre-goer, and I've done a certain amount of music for theatre pieces. I guess it's a very enjoyable change from the quietness of normally just working on your own. I tend to get asked in where there is going to be a fairly big musical element, like Caryl Churchill's play *The Skriker* or Peter

Shaffer's *The Gift of the Gorgon*. There can be quite a lot of 'could you make it half as long?' or 'could you do a new bit?' and I don't mind rising to these challenges, but I think probably less and less I'll be involved in just doing the background music for a play because somehow I feel I must use the time to do my own work if I can.

There are different degrees of collaboration. In these theatre shows I'm a hired hand trying to help the thing along. For me, the ideal music theatre setup is where there are several people who have an equal role. In opera, in a sense, it's the composer's idea which is then being worked on by a team of other people. I'm constantly thinking about trying to piece together collaborators. I enjoy the feeling of teamwork and meeting people outside your own narrow discipline. All disciplines can be narrow, but classical music obviously, because of the training, and being a very technical calling, can lead in a particular tunnel direction. Recently, I worked on a tour with storyteller Vayu Naidu – she's a fascinating person to know, and leads me into new areas. I was working with a tabla player, so I learned a little bit about Indian rhythms, and that will surely feed back into my own composition.

To what extent is your work shaped by commissions?

Composers have to work to commission to a certain extent because we're completely reliant on people performing our work. Particularly in today's musical world, for me to just write a piece completely on spec, and then find a good enough performance of it, could be difficult. So you have to be

Blond Eckbert by Judith Weir

somewhat shaped by what people ask. I like to be practical in my work. It's always very exciting if someone asks you to write something you haven't done before – for a brass band, say. Often doing these unexpected requests leads you to another area of specialism.

I think I do have a sense of constantly trying to do different things. After writing a piece that has been particularly successful, you're going to disappoint people if you try to write it again. If I've done an opera, say, I'll deliberately go in a different direction and do a workshop piece for a large group of amateurs. Also, these pieces take such a long time that when you've finished them, I think you're dying to get away from that and do something else.

I've written three full-length operas (though not long by other people's standards), and the work that goes into them...Just writing one page of score can take a day in itself, and that's when you know what to put! So pieces like that, even working full-time on them, have taken two years of writing. That's two years when you turn down everything else, and are probably not socializing very much, working the whole day and into the evenings: so it's always a desperate struggle to get through. At the end, the feeling has always been of exhaustion.

The nice side of an opera is that suddenly a team of collaborators comes in and lifts you off the floor again. So the feeling of exhaustion is tempered by the satisfaction that the piece is going to be done. But certainly having done that a few times in my life, I'm so wary of pieces that size. The circumstances would have to be exactly right before I'd be involved in that again.

Despite the physical and emotional toll, are those major works ultimately more rewarding?
Of course, opera also gives you so much more exposure. You might labour on a twenty-minute orchestral work, but the concert doesn't even get reviewed. Going on the stage with my first full-length opera was a pivotal moment because people obviously had to spend more time looking at my work, and with each main opera I've felt that. Last year, when I wrote a cantata as resident composer for the City of Birmingham Symphony Orchestra, *The South Bank Show* did a programme about it, and that seemed like quite an event. Even though it went out as usual at about half-past eleven at night, there was a definite sense of my work going out to a wider range of listeners still.

I do think there's a certain scale that's right for now (not just for me). On the whole, with these massive gargantuan pieces you have to ask: where are they going to go? Whereas I can see so many contexts, say, for a smaller-scale music theatre piece, which is very flexible and could be put on in all sorts of spaces. I get a big buzz from being able to take work from place to place.

Anything that uses musicians is going to be an expensive art form (particularly music theatre and opera). It's fantastically expensive to rehearse. So many interesting projects (that aren't even extravagant) bite the dust because they can't be put on. Within structures like opera houses, funding for new work has disappeared in recent years, because they can't even afford to put on the basic diet of Puccini. But that's not what funding was meant for: it was meant for the non-commercial stuff. I find myself often advocating what I would call 'serious' music. I suppose that's what I see myself as representing. I'm very interested in all sorts of art forms, and I have a particular interest in non-Western music, but I do feel increasingly that I've got to champion the disciplines of classical music.

Blond Eckbert by Judith Weir

Have performances been more important for you than recordings?

My big career problem, alas, has been that not enough commercial recordings have been made. I will always be so grateful for my first recording, which was of three of my small-scale musical theatre pieces. It was so important to have something people could get hold of and have some inkling of what my work was like. Most recently, there's been a recording of my first main opera, *A Night at the Chinese Opera*, and even though it's been issued twelve years after the show was last seen, it's marvellous, just because it's there. That's the problem with our art form: it's so ephemeral, and catching performances can be so difficult. Maybe it's just for me to persuade myself that not having much of a recorded catalogue doesn't matter, because, really, the important thing is what happens at the moment of performance, for the people who made the effort to be there: it lives with them.

Sometimes commentators criticize you for being 'crowd pleasing', but that's such an offensive term. I'm an audience member myself, and there are lots of intelligent people in that 'crowd'. It's very satisfying after twenty-five years of composing that there are some pieces that I wrote that long ago that are still getting played. Some of my pieces are written consciously in the knowledge they'll just be done on one particular tour, and the idea is not to do them again, but I do hope some of my work has a long lifetime. A piece that works out well this year may work out very well in twenty years' time as well, but I'm very much thinking about what's the right piece now, at this moment.

Peter Wolf

Peter Wolf was born in Harrogate in 1960 and studied history at Bangor University. He lives in London. His theatre plays include *Cargo Cult* (Barbican, 1988); *Eisgeist* (Young Vic, 1998); *The Golem* (Bridewell, 1999); *Into the Mystic* (Riverside Studios and Manchester Royal Exchange, 2000); and *Blood and Sperm* (Gielgud Theatre, 2001). He has written two libretti for composer Norbert Zehm, *Silence and Poverty* and *Silberkreuzung*. Drama for BBC Radio 4 includes *Volcano* (1996), which was runner-up for the Writers' Guild Award for Best Radio Drama, *The Man in the Elephant Mask* (1997), *Strange Meeting* (1998), *Red Star Belgrade* (2001), *Black Queen to King's Castle* and *Out of Hours* (both 2002). His radio play *Crossing the Line* (2001) was nominated by the BBC World Service for a Special Drama Award at the 2002 New York International Radio Festival.

What do you find the hardest challenge about scriptwriting?
You have to be thick-skinned and bull-headed enough to do the work but sensitive enough to understand the human condition, and that's a really difficult combination.

The first stage you have to get past is getting a commission. You get your package together and send in the proposal, and six months later it comes through, and you're left thinking, How on earth am I going to do that?, because the proposal is geared towards getting the commission rather than something you could actually write. There's a beautiful simplicity to pitching a perfect one-page synopsis: I love that challenge of seeing how much you can fit in without making the lettering too small. It's like writing a haiku.

At the beginning of whatever you're doing, there's an amazing sense of freedom, where you think, Oh, yes, I can do this, but you never give yourself enough time. I have to give myself false deadlines, and shatter myself to meet them even if it doesn't have to be in for months. I think the pressure improves it. If you go over something too much, you can really deaden it. It might be really smooth and move along nicely, but all the life will have gone from it and it doesn't mean anything. I used to laugh in despair at my first drafts, but I've learned not to be so hard on myself. You have to get something down, and then find ways of working in complexity and different layers of meaning. I'm always having to fight the Victorian Romantic idea that 'I am an artist – I get inspired, conjure things out of my head, and then shower them down on other people'. My first drafts are usually the ravings of a delusional fantasist. I think it was Beethoven who scratched on to his piano 'Ever Simpler'. And what he should have scratched underneath is 'Ever Simpler but from a Complex Perspective'.

My journey is technical complexity. That will keep me going for the next fifty years, always trying to get better. If you can set yourself challenges all the time, you've always got something to kick against. I programme myself to think it's going to be twice as hard today as it was yesterday. It's the nature of the arms race around me that if everyone else around me is getting better at their jobs, then I'll have to try to keep up. I'm a bit of a Stakhanovite. The thing that has kept my career going is absolute fanaticism.

When did you start writing plays?
In my early twenties I went off as a guitarist to tour California with a band called Ludo Youth. It was a strange time – the British invasion of happy clappy mad pop had really happened with Altered Images, Culture Club and Depeche Mode, and we were sucked straight into it. We got involved with a small-time mafioso who never paid us anything but got us huge concerts. We came back exhausted, and I realized I had to try to put the depth of that experience into something, but I didn't know what. My wife, Leona Heimfeld,

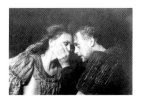

*Andrew Woodall and Hollie Garrett in **The Last Crusade** by Peter Wolf, King's Head Theatre, London, 1989*

who'd also been in the band, started working at the RSC, and she needed to find some plays for a new writing festival. It sounds so terribly nepotistic, but there you are. I'd been pontificating to everyone about a subject I was interested in – cargo cults – put it all down in a script, it got accepted, and I had my first play at the Barbican. After that I did the more conventional fringe stuff, building up my experience.

Then your life suffered a major jolt.

I'd been writing these apocalyptic plays, and suddenly the same kind of thing was happening inside me. In 1990 I got this unbelievable, horrendous illness, which looked like glandular fever but completely shattered my entire immune system, and nobody could do anything about it. I was like one of those people who are allergic to the twentieth century. I couldn't talk, I couldn't see and I bloated up to about twenty-five stone, with my body so full of fluid that I was like a huge waterbed. I'd been brought up to think there was some order to things, but there was no safety net. Doctors accused me of being mad. I couldn't sleep, I was in perpetual horrible pain and I wanted to die. Luckily, my wife stood by me. I saw people like Derek Jarman carrying on with their work although they were very ill, and somehow in 1994 I found that the tap of creativity had been turned back on.

I was in such pain I disappeared far inside myself. When you can't see or speak, you have to find places to go. I realized it was a place you can either be horrified by or explore. Luckily, I explored it. I couldn't hold a pen at the time, and I used to write one word every hour. I'll never be well, but I've made slow improvements, and I've got good at symptom management.

Since your illness, you've chosen to write principally for radio.

When you're ill, the broadcast media means an awful lot to you. I would listen on headphones to radio drama and realized it combines some of the best elements of novels (such as the inner consciousness of the narrator) with things you could never do on film because of the cost. I'd spoken to the radio producer Cherry Cookson before I got ill, thinking it might be something I'd explore someday, and I got back in touch. I was very lucky that the first play I did for Radio 4, *Volcano*, Juliet Stephenson starred in (and got a Sony Award for). It was an incredibly high-profile start (like my theatre start at the RSC), and that has helped carry things along for me. It's very freeing to be working with someone that you're confident enough to show your work to with all its worst excesses: and Cherry's the best – one of my real guardian angels.

A lot of people seem to shy away when opportunities arise, but I've always been able to jump in at the deep end. For years I was so starved of company that it taught me to really embrace it when someone offers you a different approach. If you can meet the right people at the right time, it can suddenly move you into a new dimension and you've got a whole new impetus. It's important to

balance the drudgery with inspiration. It's a nightmare if you are just existing in the present project – you don't feel a sense of your own growth.

You were recently in a mentoring scheme, paired with playwright Mark Ravenhill. What did you get out of that?
My big struggle has been how to expand my mind without being able to expand my physical experience of the world.

Mark was brilliant and really dragged me into the modern world. I was like Rip Van Winkle – hidebound and living in the past. I hadn't been able to get out to see any stage drama since 1990, and all the theatre contacts I'd made in the late 1980s were drying up as people moved on, so I thought I'd waved goodbye to the theatre. The first thing Mark did was give me a crash course in what theatre had been doing in the years since I'd been ill – and I realized that people were thinking technically about theatre very differently. He's always saying don't write for posterity, write for today – don't write about today, write about tomorrow morning. His philosophy is to find a way of expressing what's in the air – to be a sociologist as well as a creative person.

I started thinking about neophilia – the love of the new – and realized that it's the modesty of ambition that makes theatre exciting to me nowadays. The Brentons and the Hares could almost believe they were going to change society profoundly – some of them were writing for the revolution. But I realized I didn't have to pretend I was one of these people who had all the answers. (You hear these people on Radio 3's discussion programme *Nightwaves* and they sound like William Blake – I'm not one of them; I'm not a prophet.) My life was the dimensions of my bedroom for many years. What Mark said was: put yourself in the audience and look at yourself distantly. I think you have to put yourself to one side and get away from the 'Victorian poet' model where you are the universe. You have to do everything you can to take your ego out of the equation.

In what ways did your illness change your writing?
The great thing about being bedridden is that your psyche can grow, surprisingly. I don't have a good idea and then go out on to the tube and see 5,000 other people and think I don't count. I don't have to see the anthill and think I'm nobody. People in their early twenties are very good at believing they are important, but I suspect that a lot of dramatists dry up or can't hack it any more because they lose belief that what they write matters.

My brain has been completely rewired. All the things that made up my identity got unplugged and my brain almost got wiped clean. It was the ultimate catharsis, a huge dark chasm. I was sure I'd die half the time, and I felt the unbelievable terror of knowing we are our biochemistry. I think I'm happy for my personal life to be more conventional because the stuff that

was stirred up in there would take me hundreds of years to write, it's so mind-boggling. The thing about pain is that it focuses your mind, and the more extreme my focus on writing, the easier it is to lead the rest of my life. (I think writing is actually a conservatizing effect on the rest of my life. I've found that once I've written about a drug addict, for example, I'm not particularly interested in being one.) My inner life and my outer life are probably about fifty per cent each. My writing is this vast wilderness that I'm only beginning to explore. Maybe in the end I'll just be writing for myself, but I know that until the day I die I'm going to write.

Whenever I complete something, I get a feeling of real joy that I've got one over on my illness. That's a very positive influence a number of writers don't have. It's revenge on my illness, and revenge is a wonderful reason to write. Maybe the motive for writing works if it is fiendish enough. I've met people whose motives for writing are very nice and generous, but it doesn't seem to give them that obstinacy that maybe you need. There has to be some grit in there. I think Beryl Bainbridge described it as needing 'the right damage'. Sometimes people say I should see a therapist, but I don't want any therapist wrecking my weirdness.

What writing rituals have you developed?

I think most writers have little fetishes going on. In *Shopping and Fucking* Mark Ravenhill had all his characters named after the members of Take That. People think those sorts of things are trivial and all about amusing ourselves, but there's something in the process which subtly liberates something else. For example, if I'm writing a three act-er about Anne Boleyn, I make sure that when I write act one, I only do the research up to a third of her life. That way, I'm just as surprised as everyone else by the next act. Even though I already know she's going to get her head cut off, I somehow manage to con myself into not knowing that.

I write Stalinist messages to myself all over the walls, saying things like 'today you will use no adjectives'. And you know how paper gets all horrible and yellow...I used to keep it for years, but now I throw it away. I even have a shredder. When I write something, I make a copy of the disk, but I don't even run it off. I can't stand the clutter.

I'm very good at creating in the morning, and in the afternoon and evening I get better at rewriting. (This isn't something I've tried, but they say you should write the first draft snorting coke and the second draft smoking dope.) There's a rush of inspiration in the morning, when I can really attack things and make them fresh, and then the later it gets in the day the more detached and reflective I get. And if you can get the balance of creating one piece of work and then finishing off another, you don't half feel clever.

The balance of how you make your voice unique and how you make it part of the pantheon is stuff I worry about. I still see writers going mad, holding scripts, saying: 'This is beautiful. Why does the world hate it?' I see their

terrible example of being marooned on the rocks with no career, and I have tried instead to get as objective as possible about my own work, and pretend I'm some literary manager or something looking at it. When I started, I used to send out scripts and wait for people to write or ring back, but now I've become much more interested in tailoring my work very specifically to what somebody might require at a particular time.

What most dents your confidence?

If you have a success, the terror is how on earth can you follow it up. But my successes have never been too daunting. I think it helps to cut the roller-coaster peaks and troughs of a career – you need the tunnel vision of an Olympic hurdler. Starting a new piece of work every sixteen weeks was the only way I could stop feeling the pain of rejection. Quite simply, if someone rings up and says something was crap, I can say: 'Watch next month's episode.' The greatest insulation coat you can have is a good body of work that has been produced. (I always think of that Woody Allen film *Stardust Memories*, where people keep coming up to him and saying: 'I love your plays – particularly the earlier, funnier plays.')

Over the length of a career, it's the law of ever-diminishing misery. The more you've done, the less each individual blow hurts. Early on in a career, when you've had only three reviews and in one of them somebody hates you to death, it's devastating. I had to look out all my reviews recently, and they've been about seventy-five per cent positive. I think now if someone slags me off I can almost laugh.

It's quite a brutal thing, actually, hearing the strange little ideas that happened right inside your head being shouted out by actors. You have to try and re-enjoy the thing as it's being performed as something quite different from the thing you wrote.

Of course, your ideas can be stolen. It's happened to me – that's the business, stealing ideas. I used to think it was immoral; now I think of it as a compliment. I've even lifted stuff myself. Ultimately, an idea isn't yours; it's only your take on something. You could buy the synopsis to *Psycho*, but that wouldn't make it a good film: Hitchcock did a very specific thing with it. I never get that paranoid because I can always come up with something else, but it must be horrible if you're clutching this one idea to your heart. I have an ideas book and a dictaphone by my bed just in case, and if I can come up with about twenty ideas a week, maybe two of them might be OK.

Whenever I'm stuck for ideas, I remember the film *Barton Fink* and John Goodman running down a corridor on fire holding a shotgun, shouting: 'I'll show you the life of the mind!' That always gives me the raw fuel to blast through the great wall of apathy that is my imagination.

Stuart Pearson Wright

Stuart Pearson Wright was born in Northampton in 1975 and studied at the Slade School of Fine Art, London. An upbringing in Eastbourne has left him with a particular interest in painting elderly subjects. His paintings often have a darkly comic edge and a strong sense of narrative. He won the BP Travel Award in 1998 and the BP Portrait Award in 2001, with a portrait commissioned by the British Academy, *Gallus gallus with Still Life and Presidents*. His portraits of actor John Hurt and dancer Adam Cooper are in the National Portrait Gallery, London.

Do you think painting portraits is a good way for an artist to get established in the world, since you get opportunities to meet so many eminent people?

One of the things about portrait painting I do enjoy is that it gives me an excuse to write a letter to someone I admire enormously, or to go up to them in the street and essentially ask if I can spend twelve hours chatting to them. I saw John Hurt walking down Old Compton Street, and I admire him very much, so I went straight up to him and asked if I could paint him. I met him backstage when he was in *Krapp's Last Tape* to show him another painting I'd done. He really liked it and agreed to sit. Since then I've got to know him a bit and have been out to stay with him in Ireland and painted his family. Through portrait painting I've had the opportunity to meet practitioners of other art forms, which has been very interesting for me. Mike Leigh got in touch with me because he saw the painting I'd done of the actor David Thewlis, and now I'm working on a portrait of him. Jeffrey Archer bought the Thewlis picture (*Tisbury Court*), and he asked me round for tea (before his downfall) so that I could tell him about the genesis of the painting; so I've seen it in residence on his wall (he doesn't have it in the sitting room with the Monet). He said it was his hope to amass a collection of my paintings and give them to the Tate, but I'd have to take him at his word for that...

How important has it been for you, winning the BP Portrait Award and the BP Travel Award?

It created a career for me, essentially. As I was quoted as saying at the time, it's the difference between a career and a job in Burger King. I was only twenty-three when I won the Travel Award, and it created the opportunity for me to acquire some commissions. Without it I'd have been like so many people leaving art school, who get jobs out of necessity, then don't have the time to get work together for a show to break from that. It forced me to really examine my working methods and develop a way of collecting information for the purpose of making a picture, because at the time I hadn't figured out how to put a narrative painting together. Also, it gave me a fabulous opportunity to have an exhibition in a national museum where huge numbers of people would see it, and in the context in which pictures should be looked at – without price tags.

For a time I created a little notoriety for myself, but it wasn't entirely positive. I received a lot of negative comments and misrepresentation in the press over some unguarded and somewhat flippant comments I made about Sir Nicholas Serota. When I was short-listed for the BP Portrait Award, a journalist rang me up, knowing full well I'd won the first prize but not letting on. He plied me with questions, and as far as I was concerned we were having a private chat. It sounds naïve, but I hadn't had dealings with journalists before. I didn't think anything I said would be of interest to anyone, since before that time no one had ever listened to me except

Overleaf: Stuart Pearson Wright
(Self Portrait)
Homo sapiens and
Musca domestica, 2001
Oil on linen

(occasionally) my mother. Things I said in confidence were taken to create a headline, then I was barraged by the press. Other journalists fabricated aspects of the story, making out I'd stood up in the Portrait Gallery and made a vitriolic outburst upon accepting my prize (whereas I said nothing at that point; the comments were from that telephone call). I regret that I made a personal comment in print, because I don't think that's polite. Given the opportunity, I would have modified the comment, suggesting perhaps that Nicholas Serota should be running Tate Modern only, and that we need another director running Tate Britain. However, I'm pleased that the story made the headlines, because there's a gross inequality of opportunity for different kinds of artists in this country, and the issue needs addressing. It is, though, intensely frustrating to be misquoted.

The actress Kathy Burke saw the picture I originally entered for the Travel Award (*Winter*) and rang me up and asked if she could buy it. Since I was about fifteen I'd been painting portraits to commission of friends of the family for about £30, but this was the first picture I'd sold for a significant sum of money. It was just after my father died, and there's a tragic irony in the timing of it – it's one of my greatest regrets that he never got to see the beginnings of me making a living and supporting myself doing what I wanted to be doing. It would have made him so proud.

Stuart Pearson Wright
Gallus gallus with
Still Life and Presidents, 2000
Oil on linen

I don't think he had much faith in me. He was a butcher's son from the East End of London, and I think what I was doing was so entirely alien to him. I think he thought painting was something old ladies do on a Sunday – that it was in some way suspiciously effeminate. At my careers interview at sixth-form college I said I wanted to be a painter, and the tutor said: 'Well, yes, but what do you want to do as a career?' He decided to humour me, however, and went to the computer in a very patronizing manner, and printed out this sheet which said: 'Artist: the chances of being a successful artist are equal to those of being a famous footballer.' That was it. Nothing constructive.

I'm an ambitious self-publicist out of necessity. I've never been one to miss an opportunity because I've never had any illusions about how hard it is to survive as a painter. 'How's it going to put bread on the table?' my dad always said to me. It's been an extra driving force to be able to prove the sceptics wrong.

Did you ever get any advice on how to price your work?
When Kathy Burke wanted to buy that picture, I didn't know what to charge. It had taken about six months to paint. I remember having this conversation with my brother and my mum in the kitchen, and they were randomly suggesting figures. The price I chose was a complete stab in the dark. It's tricky, because a contemporary painting is worth what someone is prepared to pay for it and not a predetermined figure.

I don't get involved with commercial galleries because I can't bear the art market. I survive by painting commissioned portraits. I've no time for agents because I don't like middlemen making decisions on my behalf. I've always been exposed to buying and selling because I grew up with my family trading in bric-à-brac and antiques, so I have no real problem negotiating prices for portraits. There's the time factor, and the question of demand. If you've got forty people a week ringing up and wanting commissions, you put your prices up higher and higher.

I like to have the freedom to shoot off to Belgium, say, and draw buildings there for a week, if I want. I'm the sort of person who always wants to be in charge of what I'm doing and where I'm going. One of the big failings of art schools is that students aren't given any teaching on how to survive as a one-person business, which is what it is.

What's the difference to you between working to commission and doing your own work?
It's like a double existence. I see a very clear distinction between the two strains of work I do. I've recently made the decision not to sell my narrative paintings because it upsets me so much that one can't gain access to many

contemporary figurative representational pictures. It infuriates me that I can't see Sarah Raphael's paintings or even find catalogues on her, and I don't want my own paintings to disappear into private collections in the same way. A few months ago I decided not to sell them any more unless it's to public collections. I'd rather hold on to them or if necessary give them to local galleries. I don't suppose the Tate will want them.

I have to earn a living, obviously, and run a studio, so I sell commissioned portraits. If it's just a face, it limits my personal involvement to a certain extent and keeps my time involvement fairly small. I don't feel I'm selling my soul as much as I do if I sell one of my narrative pictures. The images in my painting *The Tragedy of Maurice and Tabitha*, for example, came from a dream I had. It's a highly personal vision, and the notion that someone might bargain, sell and buy it really nauseates me. I paint pictures in the hope that people will see them and be moved by them, and I feel very strongly that art should be freely accessible to everybody. Art thrives on society and society thrives on its art.

Of course, if I find I haven't got any commissions I'll have to adapt to circumstances. Perhaps I'm espousing ideals someone older and wiser will consider ridiculously romantic, but I think it's important to start off with ideals, even if they become modified at some later stage.

Does painting portraits ever feel like a chore?
That depends on the sitter. Some sitters don't engage with the process of having their portrait painted at all. They'll think it's a good opportunity to catch up with all their phone calls. If someone doesn't sit still, it makes it almost impossible to come up with a decent picture. Portrait painting has a history of being used to place someone on a pedestal, and as a genre it has to evolve with the times. That doesn't mean we all have to put our brushes down and pick up a video camera (not that there's anything wrong in doing that). What I'm doing stems from an interest in humanity as a species – a biological and psychological phenomenon. I like to examine someone as an organism, and as a thinking being. I believe every person is valid and important. I'm not concerned with the sycophant's art of flattery.

Is it a substantially different process painting someone you know and someone you don't know?
I don't have to read someone's book to be able to paint them. If something of their character comes over, it's at a totally subconscious level. I'm responding purely visually. A face is essentially a three-dimensional object in space with light hitting it. I can paint in complete silence or with someone jabbering away, as long as they keep their mouth still while I'm painting their mouth. The finished portrait will be an amalgamation of 150,000 different expressions rolled into one, so you get a general overview, which is what makes a painted portrait so different from portrait photography. It's like leaving the camera on with a twelve-hour exposure.

How would you characterize the paintings you think of as 'your own work'?
I've always drawn and painted people since I was a little kid. I was born through donor insemination, and I've never known my genetic father, so I've always been fascinated by looking at faces. When I was three or four, a friend of my mother's drew these people on paper for me and cut them out. That was one of the pivotal moments of my life. I experienced a very strange reaction to the fact that these little figures looked solid from the front, yet from the side they were flat bits of paper. I was incredibly intrigued by that paradox, and every time I represent an object in a painting, I'm trying to re-create the feeling I had at that moment, when I saw this thing that was simultaneously three-dimensional and two-dimensional. One of my principal concerns is the contradiction between appearance and reality – illusion and reality. I try to set up an expectation of sorts and then contradict it.

Another pivotal moment that helped generate this fascination was when I was about five. I woke up one morning to find a strange man in my bed, who said good morning, pulled back the cover, and I then realized he had only one leg. There was a leg over the other side of the room, and he hopped out of bed and strapped it on. (It transpired he was a stepbrother I'd never met who had arrived late the previous evening and had been told to sleep in my bed because there wasn't anywhere else.) That had a very profound effect on my psychology.

I always list very assiduously the various people who've been in any picture, on the back, like a cast list. In my conceit I imagine that in a hundred years' time, if someone was to find a painting in an attic somewhere, they might be able to look up who the people were and find the reality behind the fantasy.

Where do you work best?
After my degree show I found it difficult to get enough space to paint in London. I kept moving from place to place, then started working in the space above my mother's antique shop in Eastbourne. Then I realized I could get a mortgage, so after ten months of negotiations I've finally bought a derelict property in Bow which I'm in the process of rendering habitable. I don't really want to live in London; I'd rather stay nearer the sea. But I can't seriously consider having a career without having a base in London. It's a pity, but people are busy, so they're very reluctant to come down to a place like Eastbourne for sittings.

I love isolation. It's very important for me to have time and space to myself when I can sit and read or write as well as paint. It's all part of the process. I'm not some kind of machine that paints pictures. I benefit from contemplation, but it's a great antidote to that, having someone interesting come into the studio environment to be painted, so that I can experience a little bit of their world.

Catherine Yass

Catherine Yass was born in 1963 and lives in London. She graduated from the Slade School of Art and Goldsmiths' College, London. Her photographs combine positive and negative images to give disorientating views of objects and spaces, through abstracted light and saturated colour. She has exhibited widely in Europe and represented Britain at the Indian Triennale in Delhi in 2001. In 1999, she won the Glen Dimplex Award, Irish Museum of Modern Art, Dublin. Exhibitions include *Synagogue* (Art in Sacred Spaces, London, 2000), shows at Jerwood Gallery, London and New Art Gallery, Walsall (both 2001) and *After the Descent* (aspreyjacques, London, 2002) for which she was nominated for the 2002 Turner Prize

You've photographed lots of 'hidden spaces'. What's the appeal?

It is very pleasurable to think I'm seeing something that other people don't see. I've photographed in a psychiatric hospital; inside the Bankside power station before it was developed for Tate Modern; I've been underneath a huge Victorian bridge at dawn when you weren't supposed to be there; in a prison, in a sewer – places you wouldn't normally get access to. Of course, the other people in these places feel completely normal being there – I think that's what I like about the spaces, that they're self-contained microcosms of the world outside.

I photographed the machinery backstage at the Barbican, and I liked the way that everything that's happening on the stage always seems so simple, but it's got all this complicated stuff going on behind it. What's on stage is an illusion, but when you're watching you're willing to suspend that and think of it as reality. Backstage, it looks so mad and abstract, with all these cogs, that it's even more an illusion than what's on stage.

When you look at one of your own photographs, are you reminded of the convoluted process you went through to get access to the space?

Every photograph I take is not just one moment; it's the result of all the time spent having conversations and visits, which has led up to the taking of it. There are all the people behind the scenes who have made it possible for me to be there, and then there's everybody who has helped with the production. You work with an electrician, a lightbox maker, a printer, a mounter, Perspex people. Then there are all the photographs I take that don't get shown – I have drawers full. For each final photograph, I'll have shot loads of film. I suppose people don't see all that. But I think that when someone looks at a piece of work, they know that something has gone into it, even if they can't lay their finger on what it is.

I'm doing a project now with these underground tunnels in London (I don't know if it'll come to anything). You have to go through endless authorities, with tortuous phone calls where everyone tries to pass you on to someone else. Then, when you're getting somewhere, the person you've been dealing with will leave their job and you have to start again. I always show people my work before I start, to put their minds at ease and make it clear it's not a documentary, and I'm not revealing terrible secrets about them. If you go into someone's territory, you have to defer to them in a way. Even if you think you know something, you have to let them tell you, and then usually you find you didn't know it after all.

You recently worked on a Sci-Art project at the William Dunn School of Pathology in Oxford. How did it feel as an artist working in that scientific environment?

People so often talk about the divide between scientists and artists that it's

Overleaf: Catherine Yass
Photo: Richard Kelly

made all the scientists a bit scared that they're not going to be able to know how to respond to an artist. It's probably the same with me – I might be scared that I'm not going to understand scientific concepts, even though I can at a basic level. It was actually quite a welcoming situation. I would wander round the labs, ask if I could take photographs of a place, ask questions, and arrange times for people to give me 'tutorials'. Mainly, I felt that they were getting on with their research and I was getting on with mine.

The School of Pathology is working to find out the DNA make-up of viruses, and they asked me in because they thought I might be interested in the ways the lab uses colour. They work with shape recognition (the HIV virus or whatever will pretend to be an antibody so that the immune system won't recognize it), and scientists will tag a particle with a particular fluorescent colour in order to trace what's happening. They also look at black and white results using colour filters, so that a load of grey tones in the sequences become a lot clearer to read.

I decided to take the laboratory itself as my subject for investigation. In the same way the scientists were looking at the shape and composition of viruses, and how those fitted together. I got really fascinated by all the lines of bottles and started wondering if they put certain bottles with each other purely for practical reasons, or for unconscious aesthetic reasons. (They reminded me of the composition of old Spanish still-life paintings.) In my work I manipulate colours by overlaying a positive that has been processed as a negative, revealing properties and patterns that are latent in the forms. It's a bit like the way the scientists were artificially colouring images to reveal the ways in which shapes interact. I started aping the scientists in a way and making all these little filters with stripes of colours, which look like little bits of abstract expressionism. I was also interested in the relationship of photography to death and disease, because of that sense of freezing a moment. The effect of using the filters is to make the colours inside the bottles look almost poisonous and rather menacing.

When scientists get involved with these art-science collaborations, one of the questions the scientists get posed is: 'how has the artist enhanced your practice?' There was one moment when I did help an experiment unwittingly, because I could tell them precisely which colour they needed – but they would have got the results in the end. My presence didn't change any of the results – it would be weird if it did. As for me, OK, I've learned this and that about how diseases work, but I'm sure that for impacting on my life, the most valuable things I've learned are to do with seeing the scientists' methodologies, and perhaps they've had an insight into how an artist works.

I think our spirit of research is the same. I would test this filter, then that

filter, this exposure and that exposure. It was no different from a scientist testing one chemical, then another. Yet they have to do a hundred tests and the results have to be the same every time before they can pass anything. I might do lots of tests and use the mistake. It's a strange thing about photography that even if you do the same thing twice with all the same conditions, it usually comes out different because the light will be slightly different on different days. There are so many variables, and if you tried to make them all constant, you'd have really boring art. That's probably different from the scientist, who really does have to keep all the constants. If an artist and a scientist have a common point, it is probably in the need for some kind of imaginative thinking to interpret the material they have.

Schemes like the Sci–Art Awards offer interesting opportunities to work in new fields, but is there a danger of having your work shaped too much by the projects and commissions on offer?
I've been really lucky that I've been offered lots of projects, and I've tended to take a lot of them up, but quite often what comes up doesn't fit in with how you're thinking at the moment. Sometimes I've felt my work getting disjointed, and I've had to pull back and try to make sure I only take on projects that push my work in a certain way. I suppose I've got a set of concerns I'm bugged by and take on whatever's closest to them, really. At the moment that seems to be physical spaces which say something about an unconscious state of mind. The art is to turn offers into what you want to do, but it doesn't quite work like that, so actually at the moment I'm trying to research my own projects more.

Sometimes you take on something you think isn't that promising, but it takes you somewhere you didn't expect, which is really good. I did a Christmas stamp for the Royal Mail, and it pushed me quite a lot to make a work that could register on such a small scale. I think the reason I took it on is that I love the intimacy of the idea that everyone is going to lick the back of your picture! The Christmas tree I did for the Tate was quite nerve-racking. I had a line of blue neon going through the middle of the tree, which was technically pretty complicated, and there was no way of knowing if it was going to work. I don't know where that took me in relation to the rest of my work, but I enjoyed doing it.

Commission briefs sometimes come through the post saying things like 'the artwork should reflect the education policy of this institution'. Suddenly, you're supposed to represent everything about a place, and you can't do that as an artist – it's not your job. One real problem is that people keep asking you to come in for meetings, when they're being paid and you're not. They always want you to come and give talks too, and you feel really mean if you ask for a fee, and then you have to remind them, which is really embarrassing. Maybe I like going into these places just to reassure myself I'm not part of an institution?

What are the demands on your time that take you away from making work?
When you do a Sci-Art project, I would say once a week there's someone who wants to interview you about it. It's good that lots of people are interested, but it is exhausting. I stopped teaching to do the William Dunn project, which was quite a hard decision. From when I left art school I always thought I wanted to be financially independent of sales, so I wanted to teach to have an income. But, actually, if you teach one day a week you don't get a huge amount of money, and it's such hard work. If you put all those days into making artwork, you might not make more money but you achieve a lot more for yourself, I suppose. Also, I found that you never really forget anyone you teach, so after ten years that can really build up. I loved it, and got really involved with it, but I couldn't keep up that level of intensity. I was a judge on the 2001 Citibank Photography Prize, and I really didn't like being in that position of being a judge. But I think if I refuse to do that kind of thing, who else is going to do it? Maybe I've benefited from having good artists on judging panels before, so maybe you owe it, in a way.

I've usually made sure I work quite independently, but recently I've been having more discussions with my gallery. I'd been taking on so many projects I was exhausted, and they've been telling me just to stop it and do fewer things, which is really good advice. Certainly, a gallery has to sell your work, so they'll be very frightened of you doing anything too different, and that can be difficult, but they can also recognize the need to change. Usually, if you just go and do it, and other people like it, it will still get recognized.

Fitting your life together with your art can be pretty difficult. If you've got a deadline and you're an artist, you've just got to be on the case – nothing else can come in the way, or you won't make a good work. Lots of jobs have deadlines, but it seems if you're an artist it's just down to you – you can't excuse yourself, saying: 'Oh, my boss is making me come in.' And it can seem quite insulting to your family if you're saying: 'I just want to be there twenty-four hours a day.' I suppose the people around you just have to understand.

Sometimes there isn't as much time to experiment as you'd want. The hardest thing is to make this little space for yourself where you can think and not get inundated with other stuff coming in.

Acknowledgements

Completing this book required the forbearance and generous assistance of a multitude. Heartfelt thanks to all who shared conversations and information, including: Alison Abrams, Pete Ayrton, Andrey Bartenev, Ann Berni, Paul Bonaventura, Sonia Boyce, Fiona Bradley, Tracy Brunt, Dominic Cavendish, Deborah Chadbourn, Celeste Dandeker, Bronac Feran, Javier de Frutos, Gemma Davies, Caroline Halcrow, Jill Hollis, Stewart Home, David Johnston, Roshini Kempadoo, Pete Keighron, Rob La Frenais, Jonathan Meth, Simon Miles, Caroline Miller, Michael Murphy, Shazia Nizam, Adrian Palka, Tom Palmer, Eric Sawden, Michael Sims, Sheridan Wall, Tony White, Jane Wilsher, Alison Wright; and especially, David Chapman.